'He turns revolt into a style'

THOM GUNN 'Elvis Presley'

George Melly

Revolt into Style

The Pop Arts in Britain

ALLEN LANE THE PENGUIN PRESS

Copyright © George Melly, 1970
First published in 1970

Allen Lane The Penguin Press
Vigo Street, London W 1

ISBN 0 7139 0166 7

Printed Offset Litho in Great Britain by
Cox & Wyman Ltd, London, Fakenham and Reading

Set in Monotype Times New Roman

for my son Patrick

Contents

Acknowledgements

Among many people whom I pestered for information and advice I should especially like to thank my wife Diana and David Sylvester for their tactful but firm criticism of the proofs. It is entirely due to them that, whatever the book's failings, a vast number of errors, both factual and aesthetic, are no longer there to shame me.

<div align="right">G.M.</div>

The publishers wish to express their grateful thanks for permission given to reprint material from the *New Statesman* (pp. 63–6), *New Society* (pp. 66–7), and the *Observer* (pp. 104, 134–8, 165, 170–71, 173 and 181–2); also to the Fulcrum Press for the quotation on p. 220 from Roy Fisher's *Collected Poems: Ghost of a Paper Bag*, 1969. The lines by Roger McGough quoted on p. 231 appear in *Penguin Modern Poets 10: The Mersey Sound*, 1967. For permission to quote from songs we would also like to thank Fabulous Music for Peter Townshend's 'My Generation' (p. 24), Mirage Music for Mick Jagger and Keith Richards's 'Mother's Little Helper' (p. 83) and 'Stupid Girl' (p. 88), and Northern Songs Ltd for 'Eleanor Rigby' (p. 80), words and music Lennon and McCartney © 1967; 'All You Need Is Love' (p. 106), words and music Lennon and McCartney © 1967; 'A Day In The Life' (p. 112), words and music Lennon and McCartney (©) 1967, and 'Revolution' (p. 120), words and music Lennon and McCartney (©) 1968.

Introduction
What is British Pop Culture?
An Attempt at Definition

'When I make a word mean a lot, I always pay it extra.'
Humpty Dumpty in *Alice Through The Looking Glass*

The word 'pop' is clearly an abbreviation of the word 'popular'. One of the meanings of the word 'popular' given by my dictionary is: '. . . adapted to the understanding, taste or means of the people'. This seems to me an adequate if partial definition of what I understand by the phrase 'popular culture', but useless as a definition of 'pop culture'.

Etymology and semantics are often at odds, but if pop culture is in fact more than a recent phase of popular culture, the first thing to establish is what separates the meaning of the two terms and what, if anything, they share in common. The most obvious way to begin would be to offer a definition of pop culture, but I am unable to propose one. 'Pop music', 'Pop art', 'Pop fashion', 'Pop telly'; it's true that in each case the adjective colours the noun and, at the same time, suggests some common ground, some common meaning, but to map out that ground, to pin down that meaning, is like trying to stare fixedly at a spot before the eyes. There is no adequate hold-all sentence. I will proceed by degrees.

Both popular and pop culture are of working-class origin, and both arose out of a given situation both social and economic. The principal difference is that popular culture was unconscious, or perhaps unselfconscious would be more exact, whereas pop culture came about as the result of a deliberate search for objects, clothes, music, heroes and attitudes which could help to define a stance.

From this it can be said that, whereas the older popular culture stood for the spirit of acceptance, pop culture represented a form of protest. Superficially, and given our current prejudices, this would suggest an advance but, initially at any

3

rate, I don't think that this was the case. Popular culture may have had a vacuous sentimental side to it, an easy tendency to respond to stock stimuli with stock responses, but there was a wry toughness, a flamboyant and warm vulgarity which came across as a form of courage. On the other hand the protest in early pop had neither target nor aim. It was *against* a great deal, but *for* nothing. It was parasitic rather than creative, and motivated by material envy. The explanation for this unpromising start lies in another important difference between the two cultures. Popular culture, although naturally subject to regional differences and increasingly corrupted by the early mass media and the spread of gentility, had grown slowly and naturally from a settled if frequently deplorable environment. Early British pop was confined entirely to cosmopolitan working-class adolescents. The soil it sprang from was poor and sour, enclosed on one side by a brief and inadequate education, and on the other by conscription into the forces. The seed had been planted during the war when circumstances had broken down the old working-class patterns, and it was fertilized by the big money from dead-end jobs. It is therefore hardly surprising that its first flowering should have seemed rank if vigorous. It was called Rock 'n' Roll.

My own conviction is that pop music has always formed the heart of pop culture, and that the rise of Tommy Steele in the middle 50s is the first British pop event. If I am right, it would seem logical to start with the music, and in a subsequent chapter I shall try and trace its history.

But before doing this it seems to me important to sketch in other less central factors which have nevertheless affected the development of pop culture or, in their turn, been changed by it. For whereas the old popular culture altered very slowly and appealed throughout its long history to basically the same class, pop has rapidly permeated all strata of society, and at the same time succeeded in blurring the boundaries between itself and traditional or high culture.

It is of course true that in the past many artists and critics belonging to high culture have taken an interest in popular

culture. Lautrec and Sickert painted the music halls, Max Beerbohm and T. S. Eliot have discussed its stars with elaborate if ornate seriousness, George Orwell broke new ground, and incidentally founded a minor industry, by examining the neglected byways of popular culture; the Surrealists too, from their own position, treated the commercial cinema as a poetic phenomenon, but for these and people like them popular art acted as raw material. The pop intellectual doesn't raid pop culture. He hopes to create pop art, and tries to live the pop life; to use a Negro expression, he is trying to pass.

Yet because pop has won converts in certain traditional strongholds it would be naïve to imagine that it has conquered universally. On the contrary, the opposition is both powerful and widespread, and includes not only those reactionaries who reject all modern culture, but many left-wing critics who suspect a deliberate plot to brainwash the working-class young. Naturally the Leavisites see pop culture as a threat to their attempt to establish and preserve an absolute measure of excellence, but equally most of the guardians of traditional popular culture are equally hostile. Nor is the opposition confined to academic circles. The jazz world rejects pop music more or less completely, and although financial envy should be taken into account, this is by no means the main ground. The folk world, too, is extremely suspicious, believing, and with considerable justification, that pop constitutes a permanent seductive threat to many weak but talented adherents of the ethnic canon.

Furthermore, a large section of the nation is either unaware of the existence of pop culture or thinks of it, if at all, as a noisy fringe of show biz or the source of jokes about electric guitars and long hair; and finally a considerable amount of traditional popular culture still exists, although admittedly mostly for the benefit of the old or middle-aged. Yet despite the hostility or indifference it would be absurd to try and play down the effect of pop culture on our society as a whole. Not only has it attracted people from every class and of every level of intelligence, but it has had the effect of a stone thrown into the

middle of a pond. The ripples round the edge may be faint, but they are there.

The first basic question to ask about pop culture is how it ever succeeded in achieving such a widespread influence. Its enemies believe that it was all a question of commercial manipulation based on the original admittedly spontaneous outburst of Rock 'n' Roll, and the immediate recognition that here was a sellers' market with nothing to sell. They see the invention of the new pop industries, records, cheap clothes and cosmetics, transistor radios etc., as the centre of pop culture rather than its by-products. They suspect deliberate psychological harnessing of adolescent sexual feelings to pop music, and believe it to be a cynical method of turning mass-hysterical masturbation to profitable account.

On a more general front they attack educated adults who appear friendly or enthusiastic about pop culture as subscribing to a spurious cult of youth for youth's sake, or pretending to enjoy pop music as an *entrée* to easy sexual gratification or access to drugs. They see pop culture as a stain spreading outwards from a deprived semi-delinquent source to spoil the whole of our society. They blame it for the glossy sadism on television or cinema screen, for the waning seriousness of the posh papers, for the insatiable appetite for novelty, for total political apathy.

In brief then they consider the success of pop culture to be based on the corruption of standards deliberately engineered by skilful vested interests for their own gain.

Only a P.R.O. for pop culture would deny the basis of truth behind many of these accusations. The effect of a top pop group on an audience of pubescent girls is clearly masturbational: 'Not a dry seat in the house', as the in-joke had it. Pop culture is a-political, and suffers from a severe Peter Pan complex. The whole pop scene is surrounded and frequently penetrated by exploiters both commercial and sexual. Pop has imposed the idea of instant success based on the promotion of a personal style rather than a search for content or meaning. Most damagingly, even on its own terms, pop is in many ways an ersatz culture feeding off its own publicity and interested to an

obsessive extent with its own image reflected in the looking-glass world of the mass media.

Yet to think of these faults and vices as the whole of pop, and to dismiss it out of hand on their account, is to miss the point. Equally irrelevant for the moment would be to spend much time in trying to refute the attacks on the basis of an objective valuation of the products of pop culture. The immediate interest of pop, the justification for taking it seriously, seems to me to be this:

It presents, with an honesty based on indifference to any standards or earlier terms of reference, an exact image of our rapidly changing society, particularly in relation to its youth, in a compact and easily accessible form.

Like all wide statements this one needs considerable modification. There are large areas, both social and intellectual, which lie outside the range of pop. Its viewpoint is largely confined within an age limit extending (currently) from fourteen to the late twenties. There is an intellectual wing to pop culture which is conscious of standards and, even more obviously, of terms of cultural reference. There are, or have been, several movements, the most obvious was the satirical explosion of the early 60s which were largely hostile to pop culture, but seem to me part of it.

Naturally these exceptions or modifications to my central thesis will have to be taken into account, and their effect evaluated, but they remain no more than exceptions and modifications. Pop culture is for the most part non-reflective, non-didactic, dedicated only to pleasure. It changes constantly because it is sensitive to change, indeed it could be said that it is sensitive to nothing else. Its principal faculty is to catch the spirit of its time and translate this spirit into objects or music or fashion or behaviour. It could be said to offer a comic strip which compresses and caricatures the social and economic forces at work within our society. It draws no conclusions. It makes no comments. It proposes no solutions. It admits to neither past nor future, not even its own.

This living in and for the present is what separates pop culture from traditional culture, and at the same time provides both its strength and limitation. It is to be explained by the fact that pop

is a young, almost adolescent culture, and that young people tend to reject their past, as a time before they had won their independence, and to fear their future, as a time when they will be forced or tricked into assuming responsibilities. This argument is further strengthened by remembering that pop culture is of working-class origin; and even today, when it has widened its social appeal, both its audience and executants are largely of either working- or lower-middle-class origin. For working-class adolescents pop represents life as a dream. It's theirs alone, even though they know and resent that it will have to end. It is significant that adult pop, the swinging life as mirrored in the advertisements in the colour supplements, is a middle- or upper-class fantasy. For the working- and lower-middle-class pop public, pop culture is a transitory moment.

But for the adolescent with potential pop talent in any field, pop culture offers the only key to the instant golden life, the passport to the country of 'Now' where everyone is beautiful and nobody grows old.

The object of this book is to describe this country: its boundaries, cities, taboos, revolutions, and its history. To admit to this last is to commit an unforgivable solecism. The country of 'Now' denies having any history. The words 'Do you remember' are the filthiest in its language. Given the right persona and appearance it is possible to grow quite old, well into the thirties at any rate, and remain acceptable. It's not too difficult to wear the right clothes and make-up, to keep up with the slang of the week, to learn the dance of the month, to be welcomed at the restaurant of the year, but it is essential to conceal a past.

Superficially modern pop culture would appear to refute this assertion, to be permeated through and through with eclectic nostalgia, but in fact this is a subtle method of rejecting the past. Early or primitive pop looked exclusively towards America as its source and inspiration, and while it was true that this America was largely imaginary, it represented the present. Following the success of the Beatles, States Worship has been largely replaced by a cool if deep chauvinism, but as it is

impossible to think of England as having no past, this is dealt with by treating history as a vast boutique full of military uniforms, grannie shoes and spectacles, 30s suits and George Formby records. By wrenching these objects out of their historical context they are rendered harmless.*

The originators of pop culture in the middle 50s agreed instinctively with Henry Ford's dictum that 'History is bunk!' The modern pop variant, 'History is junk', means exactly the same thing, although its application is obviously more sophisticated. Sophisticated but, to those of us who are friendly but uncommitted to pop culture, extremely irritating, This passionate devotion to the minutiae of style, the constant struggle to be 'in', the automatic application of the law of instant obsolescence to everything whatever its original function or intention, is the side of pop culture which repels, and is intended to repel, the potential fellow traveller, the pop 'white liberal'. Furthermore, without this fanatic rejection of the past and equally obsessive worship of the present, pop culture would be unable to function, and would split to become a poor relation of traditional culture in its upper reaches and a modern branch of popular culture in its lower.

There are in fact signs that this is what may happen eventually anyway; there are even indications that it is beginning to happen now. If this turns out to be true my book will become an obituary rather than a diagnosis, but I don't feel that this will destroy its relevance. For better or worse pop culture has changed everything, and nothing can ever be the same again. It has acted as a catalyst.

For better or worse, that's what has to be decided. I have already listed briefly what is thought to be wrong with pop culture, but when it comes to defending it I have done nothing except to suggest that it has provided a useful thermometer for reading the temperature of a society in the grip of feverish

*Written in December 1966. By the time this book is completed and published these particular objects will certainly be back on the scrap-heap. The same will be true of many other instances I shall give, but as this isn't a pop book but a book about pop, I shall let them stand.

social change. But if its effect on that society has been for the worse, it is no justification to say that it provided a handy short-cut for lazy sociologists. What, if any, are its positive qualities? What, if any, are the beneficial effects it has had, or will have, on our culture and on our society?

Its first quality has arisen directly out of one of its obvious defects. Having no cultural roots, no sense of the past, it has been forced to use as raw material whatever was to hand, and this has meant that it has to some degree helped all of us to come to terms with the environment we live in. The art critic, David Sylvester, in an article on pop art in the *Sunday Times Colour Magazine* defined what I am trying to say very clearly when he described traditional culture as 'a wine culture', and pop culture as a 'coke culture'. Until pop the tendency of most artists in every medium was to work within the tradition of a wine culture while living in what was increasingly a coke culture. Even those artists who did use modern imagery were for the most part out to shock, or to demonstrate the spiritual desert of modern life in contrast to the certainties of the past.

What pop has so far achieved is the means of looking about us without deliberately locking up our cultural responses. It has helped the artist or writer to come to terms with his daily environment, and to use it, if he wants, as his material. But the importance of this bridge between art and life goes further than providing the means for the artist of leaving his ivory tower to pay a visit to the supermarket. The traffic is two-way. Pop culture has not only introduced contemporary life to art but also kicked art out into the streets to fend for itself. Not only have the supermarket or record store become places of a certain fantasy, but posters, typography, clothes, objects, etc. have grown increasingly inventive while remaining widely acceptable.

There is, however, no question that the fruit of this liaison has proved, like the fruit in the supermarket, to be well-packaged and brightly coloured but with little real flavour. Pop culture has to date been largely a question of surface and marketing, and if the only positive gain was the new-found pleasure of an aesthete contemplating a petrol pump, the case

for the prosecution would be proven. There is, however, more evidence to be called for the defence.

If it is desirable that we move towards a classless society, it is essential, if that society is to be more than a faceless ant-heap, that a classless culture should evolve, and pop culture – crude, wasteful and mindless as it has for the most part shown itself to date – is the only serious claimant. Its main qualification is that it is a true culture, a direct expression of the aspirations and dreams of society as it is, rather than an attempt to impose a 'desirable' culture from above.

In consequence its faults are those of a society from which it draws vitality. If it seems materialistic in the greedy childish sense this is because it reflects a society which is greedy, childish and materialistic. If it expresses itself through noise and speed this is because noise is tolerated and speed worshipped. Equally its virtues – an offhand and mistrustful attitude towards authority, a cool refusal to pay homage to traditional bogeymen and shibboleths, sexual tolerance and racial indifference – are also a reflection of that section of our society which has produced and supported it, while both virtues and vices have demonstrably spread outward from the hard pop centre to colour, in more pastel shades, our entire mental climate.

The mistake which most critics make is to persist in trying to evaluate pop culture as if it were something else: the equivalent of insisting on considering a bicycle as if it were a horse. And this fallacy is by no means confined to the opponents of pop culture. Many sympathetic critics have subscribed to it with equal conviction. What the critics have done is to set up their traditional critical equipment and used it to try and prove or disprove that pop culture is *Art*: that is, a deliberate attempt to abstract and arrange certain formal or moral ideas which, although drawn from a temporal situation, aim to achieve some universal or timeless significance. In fact, pop culture at its purest has no such pretensions. Commercial intentions aside, it proposes nothing beyond an immediate and spontaneous reaction to life at any given moment. The pop artist is ideally a seismograph, and the division between pop life and pop art is,

in intention at any rate, a difficult line to draw. The aim is total environment; dream and reality interchangeable and indistinguishable. This is not to say that some elements in pop may not turn out to be art after all. In this extremely self-conscious and analytic age it is very possible that art could have resorted to this form of 'double take'. We may find that certain Beatle records, for example, have an eventual value far beyond the inevitable period charm which all trivia acquire in time; there is no reason for doubting that a transitory form sometimes attracts or gives birth to a genius who is able to extend the medium in which he works. Early jazz, for example, had no aspirations beyond providing social music aimed at a particular people in a special situation, and yet such artists as Louis Armstrong or Bessie Smith are undeniably great artists in the traditional sense, and the continuous interest in their work has little to do with the nostalgic charm of most of the music of its period. There is, however, no excuse for using these exceptions from a popular art of the past, or even tipping the possible exceptions in today's pop culture, in order to frog-march pop off the discotheque floor and into the museum. Either pop culture means what it says or it doesn't, and if it doesn't it has no point at all.

The question we must ask is this: is pop culture's claim to deliberate built-in obsolescence genuine or hypocritical? Is it an inferior traditional culture hiding its defects by going slumming, or is it a democratic culture with the spontaneity of the old popular cultures, but with a certain degree of intellectual detachment or even of objective criticism within its own defined limits?

If the answer is difficult to decide on, if 'Yes' and 'No' seem equally wrong, and 'partially' or 'perhaps' merely evasive, the reason lies in the ambivalent nature of pop culture itself, and the cause of that ambivalence is the fact that two separate but almost indistinguishable armies are by now drawn up under its banner.

These two armies wear identical uniforms, use the same passwords, and shout the same slogans, but their background

and point of departure were originally by no means alike; and if the contradictions of pop are ever to be resolved, it is necessary to try and separate them now.

One army are the sophisticated descendants of the crude volunteers of Rock 'n' Roll, and I have already indicated the social forces which led to their revolt; but the other army are the intellectuals who joined pop culture with cool deliberation and, while they have already been mentioned earlier in this chapter, it is now time to see what they are doing here.

*

If pop music is the centre of the working-class and more important wing of pop culture, pop painting seems to occupy the same position in relation to the intellectual development of the movement.

It is impossible to nail down the exact moment in which a movement is born. All movements of any value are initially invisible like the germs of an epidemic, and are 'caught' at approximately the same time by a number of people often unknown to each other, and even in different cities. Easier to record is the naming of movements, but this too leads to violent arguments from artists who consider they were ahead of the movement in question: the real as opposed to the putative fathers. Pop art is no exception to this rule. There were painters in both America and Britain who were in effect pop painters before 'pop art' had been defined and named. There were artists who emerged *after* the Christening, but claim to have reached their conclusions without being influenced by the theorists or even being aware of their existence. Acknowledging this, it is still possible to write that the idea of pop art was evolved at the Institute of Contemporary Arts in London between 1952 and 1962.

It was in 1952 that a group of young intellectuals formed what they called 'The Independent Group' and began to meet regularly at the Dover Street premises of the I.C.A. to discuss what Mario Amaya has defined as '. . . the paradox of the creative individual in a mass-think society'.

13

At first this activity seems to have been an attempt to resurrect the concept of the artist as a Universal Man in the context of an increasingly complex civilization, and with this in mind various aspects of science and technology, philosophy and linguistics were discussed side by side with such 'debased' forms of popular culture as American comic books; but as the majority of the group were artists, they found their interest more and more centred on the despised aesthetics of a society geared for profit and turn-over, and in particular with the mass-produced dream which had evolved to help sell the ever-growing flood of products and objects: the lumpen-fantasy world of long-limbed compliant girls, fast cars, penthouses, streamlined violence and neon lights reflected in private swimming pools. Almost accidentally the group had brought to light a potent myth.

At the beginning of the 50s to someone outside but aware of the group at the I.C.A., their enthusiasms appeared deliberately perverse. I remember, for example, how amazed I was when the painter Lucian Freud, who although never a member of the group has always lifted a sharp nose to the wind, told me that he found American cars beautiful. At that time I rated myself as impeccably avant-garde, an anti-aesthete for whom Breton's 'frisson' was the only test I need apply, whereas in fact I was conditioned by the aesthetic prejudices, not to mention moral preoccupations, of Surrealism itself.

'Human psychism,' wrote Breton in 1936, 'in its most universal aspect has found in the Gothic castle and its accessories a point of fixation so precise that it becomes essential to discover what would be the equivalent for our own period. (Everything leads us to believe that there is no question of it being a factory.)' In effect this is what the I.C.A. group were up to, but they ignored the bracketed doubt and enthused, if not over the factory itself, at least over its products and their shiny packaging.

Later in this book I shall be describing, although briefly, the development of British pop painting and its derivatives, but confine myself for the moment to its beginnings. The theoreticians and artists of the I.C.A. played no part in the formation

of British pop culture during its formative years; such intellectuals as were to be found in the popular musical field were at that time entirely committed to either Modern or Revivalist jazz; but what is significant about the I.C.A. activity in relation to the beginnings of British Rock 'n' Roll, is how closely it provided a parallel. For just as it was the aggressively American music of Presley and Haley which sparked off the British teenage thing, so it was 'a trunkful of American magazines which John McHale brought back to England in 1955 from a trip to the U.S.'* which led to the Independent Group deserting their generalized interest in modern mass culture in favour of an almost exclusive fascination with the American dream. As you might expect, the working-class adolescents who 'went ape' for Presley were naïve and uncritical, whereas the intellectuals' enthusiasm for the subculture of billboards, pin-ups and auto-styling implied a certain irony, and the whole-hearted rejection of 'good taste' in their assessment of pop imagery was in itself the attitude of a dandy in the Baudelairean sense. Even so, the parallels are striking, and in fact the I.C.A. group were a year or two in advance of the teenage revolution.

In advance, but not an influence: the intellectuals may have foreseen the advent of pop culture, but this was the equivalent of a party of astronomers setting up their instruments in advance of an eclipse. To believe that the group at the I.C.A. were in any way responsible for the advent of British pop culture itself is to react like a native tribe who are duped by a missionary with foreknowledge of an eclipse into thinking that he has actually brought it about.

A great deal of this initial confusion has arisen because the word 'pop' has come to be applied indiscriminately to the pop culture which has grown out of the adolescent working-class revolt and to the intellectual attempt to come to terms with the Americanization of our society. A subsidiary cause of this confusion is that the intellectual meaning of the word has altered considerably over the years. When the critic Lawrence Alloway first coined it in about 1954 he used it strictly in relation

* Mario Amaya, *Pop as Art.*

15

to mass-produced culture and its artifacts – films, magazines, packaging, music, posters etc. – and not at all to describe the work of those painters who had begun to draw upon this imagery as their source material. Indeed, at that time Alloway's enthusiasm for *art* was reserved almost exclusively for American Abstract Expressionism: the apotheosis of the act of painting, and the antithesis of the imitation in paint of the impersonal mechanical methods of reproduction favoured by the fledgling pop artists, let alone their later annexation of these methods.

It was a misunderstanding of Alloway's use of the word 'pop' which led to certain critics applying the word to the new school of Neo-Realists on both sides of the Atlantic; a misunderstanding so widespread that finally Alloway was forced to accept it, a penance made somewhat easier by his eventual enthusiasm for the work of the Neo-Realists themselves. Even so, to begin with he felt no love for the school of which, in popular legend, he has become the first prophet, and in Britain at any rate Richard Hamilton is of far greater significance.

On a theoretical level, however, Alloway did recognize and define certain important trends which it is useful to emphasize at this point. He understood that the difference between 'pop' culture and 'popular' culture is this. The old popular culture, stretching from, say, the painting on canal barges or fairground booths to the decoration of public houses and the words of music-hall songs, was produced by the people for the people. It was naïve. On the other hand, the new pop culture was often produced by comparative intellectuals for the people. It was an ambivalent thing, part tongue in cheek, part sincere, but never unconscious. Even when the original material was naïve, as in the case of Presley, it was 'groomed' and 'processed' like any other product, and from quite early on a crude but knowing use of psychological motivation was brought into play.

It was this realization of the ambivalence behind the apparently mindless surface of American pop culture that attracted a whole generation of British intellectuals. Alloway and the little group at the I.C.A. may have analysed that interest, but

everywhere there were small groups and individuals who understood instinctively that there was something in it.

During the late 40s and early 50s it seemed completely natural for young intellectuals to feel and express enthusiasm for certain aspects of what would have later been recognized as pop culture which an earlier generation would have rejected out of hand. For example, many of us subscribed to a cult of 'the funnies', those ten-minute animated cartoons which, with the coming of the double feature, were mostly to be found in the news theatres; but it must be made clear that we were far from indiscriminate in our enthusiasm, and the virtues and failings of the various schools were discussed with almost Leavisite severity. For if Disney was rejected as dated in technique and sentimental in content, we held certain reservations about the extreme modernity of the U.P.A. cartoons which, despite the brilliance of the dialogue and animation, seemed a shade too knowing in their use of texture and visual shorthand, and a little too pushing in making sure we didn't overlook their aesthetic derivations from Klee or Dufy. There were some of us who admitted to a certain mocking affection for the ludicrous 'Terrytoons' with their jerky animation and non-synchronized music, but this was an acknowledgedly perverse taste and the central school of thought was for the most part in favour of M.G.M.'s 'Tom and Jerry', and completely unanimous in its enthusiasm for the Warner Brother series, 'Sylvester' and 'Bugs Bunny'. These seemed to us everything an animated cartoon should be: the animation cut to the bone but perfectly adjusted to transmit the sado-masochistic fantasy which was the whole point of the genre, the dialogue spare but witty, the backgrounds brashly sophisticated. To return to my earlier assertion that pop culture is an ambivalent thing, there was the occasional discreet indication that behind the continuous orgy of stylized brutality (each physical outrage miraculously healed in time for the next outburst of inventive mayhem), a certain intellectualism lay concealed. To give an example, in a particular 'Bugs Bunny' cartoon it was possible to see hanging on the wall of a house belonging to Bugs's enemy, the bald and dwarfish

Elmer Fudd, a detailed reproduction of Henri Rousseau's *The Sleeping Gypsy* while below it on a shelf lay one of Henry Moore's early string sculptures. This had of course nothing to do with the value or triviality of the cartoons in themselves, but it nevertheless provided a reassuring clue that their creators possessed what was, for those days, a comparatively avant-garde taste, and helped to ease the conscience of those of us who found it difficult to equate our intellectual pretensions with our enthusiasm for this ignored or despised art form. With *The Sleeping Gypsy* as a palliative we could return to discussing whether the face of the coloured domestic whose lower limbs and arms persecuted Tom for his deficiencies as a mouser had at any time been made manifest, with less guilt. In retrospect this may seem to have been an indefensibly snobbish attitude. Either the cartoons were interesting or they were not, and the entire collection of the Museum of Modern Art on Elmer Fudd's walls should have made no difference one way or the other; but it should be remembered that in those days there was no precedent for such enthusiasms. There was no theory of pop culture under which we could claim sanctuary.

For the young intellectual in post-war Britain the split between high culture and what was to become known as pop culture seemed absolute, and any interest in some aspect of pop culture implied a desperate intellectualizing to justify that interest or else a defiant over-compensatory arrogance which forestalled any criticism by implying that it could only come from stuffy fools. Both these forms of defence were common among revivalist jazz enthusiasts, the most widespread of all post-war intellectual passions; and yet jazz was after all comparatively established with a tradition of pre-war intellectual adherence and some knowledgeable advocates among acknowledged cultural figures.

In other fields there was less attempt to synthesize. As an intellectual certain pleasures were enjoyed, certain interests were discussed; as a non-intellectual other pleasures were enjoyed, other interests were discussed. It is true that a nostalgic affection for some dying forms of popular culture was permiss-

ible: the music-hall, the circus, ornate public-house architecture, fairgrounds and so on, so was a 'perverse' love for Victoriana with the inverted commas clearly indicated but, in relation to our own time, popular culture was elsewhere: in a French provincial kitchen, a Spanish bull-ring, a Cornish fishing village but, in modern cities, culture still implied high culture either historical or avant-garde.

In fact the shock of the theory of pop culture for my generation was that it maintained that the division between pop culture and traditional culture was at most arbitrary, and the effect of this when it came was to alienate some of us completely and to produce a curious species of youngish reactionary dedicated to restoring and upholding the standards and traditions not of their fathers but of their grandfathers. But for others of us pop seemed the justification, at any rate in retrospect, of certain ideas we had been groping to formulate, and for a style of life we had been trying to live.

To give an example the split between our real preference for American films and our lip-service to the superiority of any pre-war French film was at last resolved. American films were, it seemed, not only more enjoyable but better.

But then any movement is in fact partly retrospective, a summing up or codification of widely held ideas rather than a startling new insight and the shock it gives is really one of recognition. All the pop theorists did was to provide an intellectual justification for the immediacy and fluidity of our post-war way of life and more radically, for most of us had already come to terms with the way we chose to live, suggested that we re-examined our aesthetic premises and own up about those areas around us which we affected to despise but in fact rejoiced in.

It was this which led to the curiously nostalgic atmosphere of so much of British pop painting. There was a great deal of our own childhood which carried a powerful charge but which we had rejected as outside the acknowledged sources of Proustian memories. Pop widened or altered the emphasis of our open terms of reference, it narrowed the nostalgic time-lag, but in this

country it never succeeded in destroying our national obsession with the past.

On the other hand, pop culture has succeeded in weakening, although not of course in destroying, the other great British obsession, that of class, and the will to classlessness was an important factor in its early development. The bias of pop towards a visual or musical, rather than a literary, form of expression is significant here: in part no doubt dependent on the development of non-literary media like television, but equally linked to the rejection of an educational structure in which social origin is revealed through the manner of verbal communication. The recent trend towards the use of words, as in the later Beatle songs, is a sign of confidence rather than of abdication.

There is, however, a less sympathetic side to the anti-literary prejudice of British pop culture, a smearing by association of traditional cultural standards, a refusal to admit to any form of moral judgement on the flimsy grounds that it must be a class judgement at the same time, a deification of sensation at an immediate level which is in itself profoundly pessimistic. The whole theory of 'camp', a comparatively late graft as far as British pop is concerned, is hardly more than a sophisticated means of keeping any form of qualitative judgement at bay by agreeing enthusiastically with adverse criticism. By this method anything can be justified, but camp is a recent perversion of what was originally a generous impulse to found a democratic culture based, not on patronage or 'raising standards', but on seeking to recognize what was significant or beautiful in the despised artifacts around us.

However, as I suggested earlier, it was not the pop intellectuals who made the first effective move towards the creation of a neutral zone in which the idea of an experience operating in 'the gap between art and life' could put on flesh. This was the work of the uneducated but moneyed adolescents of post-war London, and they managed it without any justification other than an instinctive reaction to a new social and economic situation.

At about the time that Rock 'n' Roll had begun to attract some attention, Richard Hoggart was correcting the proofs of *The Uses of Literacy,* that warm, perceptive, occasionally sentimental monument to the working-class culture of his youth. Throughout the book Professor Hoggart expressed his concern at the way things were going. He saw the old simple-minded but honest standards on which popular culture was based threatened by cynical forces bent on manipulation for profit. Towards the end of the book he becomes more and more agitated, running round his subject like a sheep-dog who senses some danger to his flock but isn't sure what it is or where it will come from. He growls now at the increasing sophistication of working-class magazines, now at the sex and violence paperbacks of the period. It was natural that he shouldn't have realized that the quarter from which the danger was to come was a Soho coffee-bar where an ex-merchant navy steward called Tommy Hicks had begun to arouse considerable, if as yet local, enthusiasm by imitating Elvis Presley.

December 1966

Section One
British Pop Music

'Hope I die before I grow old'

PETER TOWNSHEND 'My Generation'

Before Tommy Steele

Few people would quarrel with the proposition that British pop music in the true sense dates from the rise of Tommy Steele in the middle 50s. Nevertheless, immediately after the war there were two movements which shared enough in common with pop to justify some consideration here, however brief. They were revivalist jazz and modern jazz, and later there was yet a third, skiffle, which has an even stronger claim in this context.

Revivalist Jazz

It was inevitable that the spontaneous if mysterious enthusiasm which sprang up all over wartime Britain for an almost forgotten music, Negro jazz of the 20s, should lead eventually to an attempt to reconstruct the music and, by the end of the war, there was already one established band, the George Webb Dixielanders. Within a year or two the revivalist jazz movement had spread to every major city in the British Isles, and it was in the jazz clubs of the late 40s that what might be considered the dry-run for a pop explosion first took shape.

Yet I don't think that the revivalist jazz movement qualifies as a pop movement proper. I have written elsewhere* and at length about those days but feel, that to justify my qualifications, I must at least make an inventory of my reasons for excluding it from the pop canon despite the many points of similarity. Revivalist jazz shared with the later pop movements

Owning Up (Weidenfeld and Nicolson 1965, Penguin Books 1970).

25

its spontaneous generation with no initial commercial en-
couragement: the invention of a life-style through which it
expressed not only its own identity but its contempt for out-
siders; its eventual decline due to its success with a wider, less
perceptive public and the resultant lowering of standards and
over-exposure.

Where it differed was in the way it looked back towards an
earlier culture for its inspiration, thus admitting that it believed
in a 'then' which was superior to 'now' – a very anti-pop concept.
What's more both its executants and their public were mostly
into their twenties before the movement was even under way
and, although this was the result of the war, it did tend to add a
certain ballast, a potential respectability. This was further
underlined by the fact that, although enthusiasm for the music
cut right across the social spectrum, it contained a surprisingly
large minority of middle- and upper-class adherents and even
a few elderly and distinguished advocates who had formed
a taste for the music before the war. In consequence, right
from the off, the press treated it as an eccentric rather than a
scandalous manifestation. There was none of that snobbism
disguised as moral concern which was later to be levelled at the
essentially working-class pop movements which replaced it.
This was partially because the sexual emphasis was absent.
Jazz may have begun as brothel-music, may have provided the
background to the prohibition years, but the atmosphere of
the British revivalist clubs, while permissive enough by the
standards of the time, was jolly and extrovert rather than
orgiastic. It's true that a musician of strong sexual appetites
'did all right' and that virgins were thin on the ground, but there
was no moment when the sexual potency of a revivalist jazz
hero made it necessary to isolate him from his over-stimulated
fans.

On balance then I feel that the antiquarian, post-adolescent
nature of the British revivalist jazz movement of the late 40s
destroys its claim to being thought of as a pop movement.

Despite its large public it was never even fully exploited. A
series of over-long, over-packed concerts, the defection of

Humphrey Lyttleton, and the emergence of the 'traditional' purists* were enough to sink it.

*

Modern Jazz

Superficially 'modern jazz', or bebop in this country, bore even less relation to a pop explosion than its revivalist contemporary. It was less compromising, less popular, more esoteric, and it remained so. Yet in some rather central aspects it was closer, at any rate, to pop's more recent developments.

For one thing it was based on a contemporary form and, while romantic enough, had none of the archaic romanticism of the revivalists. Bebop, or bop, or rebop, was the invention of a small group of American Negro musicians based on New York who, during the 40s, deliberately set out to extend the harmonic and rhythmic possibilities of jazz.

Yet this was only partially on aesthetic grounds. It was also an attempt to disassociate themselves from what they felt to be the Uncle Tom image of the older jazz forms. They had no interest in using their music as an in to success in a white world; on the contrary they used it as a wall: its very inaccessibility an expression of their contempt for a society which offered them a living only in exchange for the mugging acknowledgement of racial inferiority. Cool, hip, ironic, they were prepared to go a long way to prove their detachment. Several of the most gifted, including Charlie Parker, the greatest of them all, destroyed themselves with hard drugs.

The early British modernists based their lives and art on the same premises. They too affected dark glasses and the hip stance of their heroes. In contrast to the beer-swilling revivalists, pot and pep-pills were their chosen stimulants and in a few cases, they too went on to hard drugs. Yet being both white and

*The 'traditionalists' claimed that in emulating the jazz-bands of the 20s, the 'revivalists' were already decadent. They maintained that the true grail had never left New Orleans and based their music on that of the few old men still living and working in the Crescent city.

British, they were as far removed from their idols as the revivalist was from his. Their music was better, certainly; most of the early British modernists were professional musicians by training and had heard bop live in New York during their shore leaves while serving in Geraldo's navy,* but the pressure behind it was of necessity less powerful.

This is not to doubt their sincerity. They understood not only the musical complexity of bop but the spirit that created it and, within their emotional means, they tried to play it. Yet they remained what Norman Mailer called 'White Negroes'. They chose to reject society; it didn't automatically reject them. It's this voluntary choice that they share in common with the recent spirit in pop music.

Skiffle

Skiffle was much nearer to a pop movement proper than either revivalist or modern jazz, and although shorter lived than Rock 'n' Roll, it not only predated it by several months, but its leading light, Lonnie Donegan, was for a long time as popular if not more popular than Steele himself.

Like many of the later pop movements, skiffle too was at first unaware of its potential commercial possibilities. Originally the word had been used, during the 20s, to describe a sort of jazz in which some or all the legitimate instruments were replaced by kazoos, washboards or broom-handle bass-fiddles. Later there was, in British skiffle, a resurrection of the music within the traditional meaning of the term, but at first the word was deliberately misapplied to mean a folk-spot within the context of an evening of New Orleans jazz.

Ken Colyer, the traditional band-leader, was the first to institute the 'Skiffle Session' in this sense. Apprehensive that even his loyal public might find a whole evening of ensemble jazz a little hard to take, he broke it up by allowing his banjo-player Lonnie Donegan to change over to guitar and sing a

* Geraldo, a pre-war band-leader, had the contract to supply bands for the transatlantic liners after the war.

28

few folk-blues drawn mostly from the repertoire of the American Negro folk-hero Huddie 'Leadbelly' Ledbetter.

These sessions were so popular that when Chris Barber left Colyer to set up on his own, taking Donegan with him, he kept them in as part of the act.

'Rock Island Line' was originally issued as one of the tracks on a Barber LP but was requested so often on radio programmes that it was eventually reissued as a single and, by May 1956, was Number 1 in the charts.

Donegan received only the Musicians' Union fee for 'Rock Island Line' but its success persuaded him to leave Barber and go single. Skiffle broke away at this point from its anchorage in traditional jazz and set sail on its own. Within a few months it was a national craze. All over the country skiffle groups sprang up, and several performers of varying merit followed Donegan into the big time. The first *British* near-pop movement was under way.

Not British in its source (which was almost entirely American Negro folk music), but as a movement for which there was, at the time, no precedent in the States. Donegan was indeed the first British artist who managed to sell musical coals to a transatlantic Newcastle; by 28 April 'Rock Island Line' was Number 6 in the American charts.

Yet for all its success it must be remembered that skiffle tended to appeal to a relatively restricted audience. It had nothing to say to the Teddy boys. It in no way touched those who were looking for a music rooted in either sex or violence. It seemed, from the off, a bit folksy and tended to attract gentle creatures of vaguely left-wing affiliations. It appealed immediately to very young children, a quality which, in other pop movements, took a certain time. Like revivalist jazz then, although being a vocal music it took less application to appreciate, it was in no way an anti-social movement. There were no skiffle riots.

Why did skiffle have such an impact? There was the 'Anyone Can Do It' side to it; a few chords on a guitar and you were away. There was the charm of the material but, largely, I

believe, it was Donegan himself who was responsible. More difficult is to find a reason. His voice was tinny and harsh, his delivery monotonous, his personality rather prickly. True, he knew how to generate a certain excitement, largely through speeding up his tempos, but this alone is hardly enough to explain his success. The answer I suppose is that he personified, during the years of his success, a certain mood among young people, mostly lower-middle rather than working-class young people, and projected that mood for them. The world he sang of was, in its original, a violent world. Leadbelly, for example, was in prison twice on murder charges and had a near psychopathic personality. But Donegan's version was, like the traditional jazz it sprang from, safely distanced from that world. Its violence and harshness were make-believe, and in retrospect he sounds more like George Formby than Huddie Ledbetter. Indeed, as skiffle faded, it seemed perfectly natural that he should desert the American South as a source of material and record old music-hall numbers like 'My Old Man's A Dustman' or 'Does Your Chewing Gum Lose Its Flavour (on the bedpost overnight)'. Nor was he alone in following this path. Tommy Steele himself was to take it, and it gradually became clear that a large number of the more talented early British pop stars, at first sight totally alien to everything that had gone before, were in fact firmly rooted in an old tradition.

Towards the Male Principle

The ten years after the war were also the golden age for big touring bands on the American model. Yet these in themselves were to have no effect on pop. In fact, as the band-leader Eric Winstone suggested in a recent article, it was perhaps the increasing musical complexity of post-war dance music which helped to ensure the success of the crude amateurism of so much early Rock 'n' Roll. 'Too many round the stand,' he wrote, 'not enough on the floor.'

But in one department the swing bands, in particular Ted

Heath, did point to the way things were going, and this was in the growing public enthusiasm for their vocalists.

Featured dance-band singers were not of course a post-war phenomenon. They go right back to the days of straw-hats, boaters, blazers and megaphones. Nor was a certain amount of adulation unusual. In America Crosby was a national institution by the beginning of the 30s and the bobby-soxers were swooning at the feet of Sinatra before the end of that decade. Over here, too, Al Bowlly and Rudy Vallee were household names, and in my childhood the phrase 'dance-band crooner' was often used by the elderly and censorious as a kind of touchstone to prove that the country was going to the dogs.

Yet, in the immediate post-war period, it was the bands who drew the crowds. While considered necessary, their vocalists were expected to sit on the stand throughout the session and to be prepared to play the maraccas, gourds or claves during the South American brackets; if anything, a girl singer was thought to be rather more essential than a man.

It's difficult to say exactly why this was the case. My feeling is that it took some time to get rid of the emotional pattern of war-time thinking, and that in war time the dream-industry is male-orientated. An idealized wife/girl-friend figure is central and it was no accident that Vera Lynn, the personification of that ideal, should be billed as 'the forces' sweetheart'.

For women, on the other hand, the idealized male during a war is certain to be in some kind of uniform; the antithesis of a dance-band vocalist, and it took the emergence of a new generation to accept the civilian as an effective sex symbol.

This happened in America first; a shorter war and no civilian bombing made the re-adjustment easier; but comparatively early in the 50s the first of these began to come over to Britain for concert tours. They were usually accompanied by the big swing bands, and it may be that the effect of these singers on the audiences suggested to the band-leaders involved that the future lay in men. At all events it was soon the male vocalists who began to attract the adulation, and in particular Dickie Valentine, Ted Heath's principal singer, became popular enough

to justify the formation of a large fan-club which met every year at the Hammersmith Palais in celebration of their plump but personable hero. It's worth remarking, however, that his fans were mostly in their later teens or early twenties. The image of the British pop idol was still comparatively mature, a responsible sweetheart or dashing young husband. There was certainly nothing anti-social about him.

The same was true of the majority of the American stars who toured Britain at the beginning of the 50s. Guy Mitchell, for example, was as wholesome as the jaunty nautically-flavoured ballads which were his stock-in-trade, while Frankie 'Jezebel' Laine and Billy 'Old Black Magic' Daniels sprang directly from the Jewish/Negro tradition of American show-biz expertise, and were furthermore both distinctly middle-aged. There was, however, one visitor who was in a class of his own: Johnnie 'Cry Guy' Ray. Emotional, rather effeminate in appearance, liable to burst into tears, an easy target for the aggressively heterosexual comedians in the dying music-halls, he nevertheless succeeded in provoking a near-orgasmic effect on large audiences of young girls. He was a forerunner of the pop hero proper.

In the cinema too the pop figures were emerging. James Dean and Marlon Brando were perhaps the first heroes with whom the young were able to identify in the immediate rather than the 'when I grow up' sense, and they were soon established as the objects of cult worship.

Dean represented the defeated teenager: sensitive, incoherent, rebellious, moody, grave, the victim of adult misunderstanding. What's more his early death secured him instant and comparatively permanent beatification. I went to see one of his films the other day and a large section of the audience were young enough to have been children when it was first released. Yet the atmosphere was reverent, almost church-like. Death is the one certain way to preserve a pop legend, because age, in itself, is considered a compromise. Buddy Holly is another example. His contemporaries are forgotten and yet, because of his death in a plane crash, Holly is rated by even the youngest pop fans. There are also a whole list of pop numbers of a necrophiliac tinge,

e.g. 'Tell Laura I Love Her' and 'Teen-Angel', all of which push the idea that a sudden and violent death is a pop happening because it prevents its victim from growing older. It's perhaps for this reason that the warnings about the dangers of hard drugs are comparatively ineffectual in the case of those who subscribe wholeheartedly to the pop canon. Temporary exultation is *more* important to them, than a long life tied to the system.

The other film hero was Brando, a different case from Dean in that he represented the pop hero temporarily at any rate in command: a black leather phallus whom it was necessary for society to castrate in its own interests.

Brando didn't die and became plumper and less aggressive, but for a few years at least he was as potent as Dean. It was in Brando that the brutal and destructive side of pop culture in this country has its origins. The Rocker is his child. He was the link between the dangerous motor-biking nomads of America and their British working-class imitators.

Yet the cinema, while sensitive to the hunger of a new generation for their 'own thing' and greedy enough to try and attract them into the theatres, was also under the control of a society determined to preserve its institutions and to satisfy everybody. It was prepared to give screen space to Dean and Brando, but was equally committed to Doris Day. To satisfy the young totally a new outlet was needed. Something which could operate behind the Establishment's back.

*

Rock 'n' Roll didn't create its public. Like a theatre audience, they were already waiting for the curtain to go up and, like a rather old-fashioned theatre audience, they were formally dressed.

While the Fair Isle-jerseyed suburbanites and battle-dressed art students were jiving to Humph down 100 Oxford Street, and the lounge-suited modernists were listening with determined impassivity to the Dankworth 7 down 'Club Eleven', Carnaby Street, the Teddy Boys were evolving their uniform and

establishing their headquarters in the tougher metropolitan areas. They were not criminal in the old sense. They were not out for gain. On the whole, though, they were profoundly anti-social: the dark van of pop culture dedicated to 'the giggle' and 'kicks'.

The sociological reasons for the Teds are speculative. The lack of parental authority during the war? The breakdown of the working-class family as a strong social unit; its standards not necessarily those of the middle classes nor even in some cases impressed by legality, but standards nevertheless? The effect of the bombing? Regret that the war was over too early to allow them to release their aggression under risk? The Teds were a new kind of criminal for whom violence was an end in itself and 'crime' in the traditional sense neither obligatory nor even necessary. They were also a small minority, a fact it would be difficult to realize from the newspaper files of the period which tended, as always, to inflate a phenomenon in such a way as to suggest it was all-pervasive.

Naturally the nihilist Ted spirit, in a diluted form, did affect a great many teenagers, and Ted fashion also, but the hard-core Teds were not only few in number but very much confined to their own 'manors'. Unlike later manifestations of pop aggression – the Mods and Rockers, for example – the Teds, while not against 'borrowing cars', had no regular transport as part of their equipment, and so were unable to sally forth *en masse*. Even the territory disputes with rival gangs were usually pre-arranged, or in direct reprisal for an injury suffered by one of their number.

The way the Ted 'came on' was no more aesthetic in intention than the scarlet throat of a robin or the identifying smell of a dog's arse-hole. It provided, like a dog or robin, a warning, a provocation, a sexual flag, a recognition signal; the interpretation depending entirely on who was exposed to it. A great deal of more recent pop history obeys this principle too. What on the surface may appear to be eccentric individualism is obviously the contrary; conformity within a group.

Yet this is not to suggest that many pop fashions, including

the Teddy Boy fad, are without aesthetic value; it is my belief that art on any level is valid only insofar as it expresses certain interior tensions, that it can never be purely aesthetic without becoming mere decoration. The Teddy Boy and his successors were, in their way, artists. Their bodies were their canvas.*

To return to species, and it is through specifics that it's possible to pin down a certain moment, this was how the Teddy Boy dressed:

Starting from the top:

THEIR HAIR This, by the war-conditioned standards of their fathers, was excessively long. Side whiskers in many cases. A great deal of grease supporting some form of quiff at the front but a certain variation allowable at the back, i.e. the 'Duck's Arse' or D.A. There were other eccentricities: the 'elephant's trunk', a rather obscene sausage-like shape which was allowed to dangle down onto the forehead, or the 'apache', a very radical style in which the whole head was shaved except for a fore-to-aft ridge. But after the arrival of Elvis it was of course his hair-style which became the norm. The general effect, despite the length, was aggressively masculine, a return to the dangerous male dash of the Regency Buck or the Western desperado. The elaborate styling didn't include hygiene as an obligation. The dandruff lay thick on the velvet collars of the early 50s, and indeed the whole Teddy Boy thing was not concerned with grooming for its own sake. The Teds were the ancestors of the Rockers. Despite their shared interest in non-functional clothes they had very little in common with the Mods.

THE CLOTHES The interesting thing about the Teddy Boys' choice of uniform lay in its source. Immediately after the war, suspecting that upper-class young men-about-town might feel the need to express sartorially their dislike of the austerity-minded Socialist government, the smart tailors proposed a style based on the period of their grandfathers: the last golden moment for the British upper classes, the long Edwardian summer.

*Later, during 'Flower Power', body-painting became widespread.

35

There was a certain amount of publicity around this style in the popular press, but the exact moment at which it was taken up by working-class rebels (and of course immediately dropped by upper-class exquisites), is impossible to track down. Equally obscure is the psychological explanation for the adoption of this unlikely uniform. The tight trousers and long jackets with their velvet collars bore no relation to the past of *these* young men. What they added, the boot-lace ties and suède shoes, were entirely unrelated to the original. Yet the whole thing gelled to look undeniably right. The arrival of Rock 'n' Roll was all that was needed. The first real pop movement was ready to explode.

Rock 'n' Roll

Rock, initially at any rate, was a contemporary incitement to mindless fucking and arbitrary vandalism: screw and smash music. To us in the jazz world it seemed a meaningless simplification of the blues with all the poetry removed and the emphasis on white, and by definition, inferior performers. Fats Domino or Little Richard we could, with reservations, accept, even Presley in his earlier records showed some feeling for the blues, but Bill Haley was a source of mystified repulsion. Why should anyone prefer this unsubtle, unswinging, uncoloured music to the real thing?

What we failed to recognize was that the whole point of Rock 'n' Roll depended on its lack of subtlety. It was music to be used rather than listened to: a banner to be waved in the face of 'them' by a group who felt themselves ignored or victimized.

Presley's breakthrough was that he was the first male white singer to propose that fucking was a desirable activity in itself and that, given sufficient sex appeal, it was possible for a man to lay girls without any of the traditional gestures or promises. It's true that his immediate predecessor Johnnie Ray had offered in fairly open terms a musical equivalent to the sex act. 'Oh What A Night It Was' is remarkably specific for its period, but Ray was always a vulnerable figure, suggesting the seduced

rather than the seducer. Presley, on the contrary, came on as though confident in his ability to attract women without appealing in any way to their protective instinct. He was the master of the sexual simile, treating his guitar as both phallus and girl, punctuating his lyrics with the animal grunts and groans of the male approaching an orgasm. He made it quite clear that he felt he was doing any woman he accepted a favour. He dressed to emphasize both his masculinity and basic narcissism, and rumour had it that into his skin-tight jeans was sewn a lead bar in order to suggest a weapon of heroic proportions.

I say the first white singer because this approach, this boasting of sexual prowess, was an old Negro blues tradition and in fact the blues were far more open about it than Presley. Blues lyrics are full of perfectly clear statements on this theme whereas Presley's lyrics were, in themselves, pretty innocuous. It was his treatment which echoes his coloured sources.

What is interesting is that his appeal in the first place was to young males. He said something which had never been admitted so openly in public, at any rate not for a century and a half: that most young men are promiscuously inclined and that a smaller but significant number of girls have strong sexual appetites on their own account.

It's worth noting that the taboo which Presley challenged had, in this country, applied in the main only towards the working or lower-middle classes or, to be more precise, been imposed upon them by their social betters. Even during the Victorian high noon, the upper and upper-middle classes had always allowed themselves considerable sexual licence. Edward VII's mistresses or Lloyd George's goat-like appetites were a comparatively open secret among their equals. Yet it was considered important to conceal this social tolerance from the lower orders, and the greatest crime a member of society could commit was to give away the secret. Wilde and Dilke or, to offer a far more recent example, Stephen Ward were hounded not so much for what they'd done, as for making it public knowledge.

Admittedly during the 20s and 30s the middle classes had

37

pushed their way into the permissive club. Adultery for example was allowable in the theatre as a pretext for comedy rather than melodrama. Huxley's early novels were extraordinarily open in their anatomization of sexual behaviour. Yet it seemed to be necessary to use the comic or satirical approach in order to get away with it. Lawrence, Joyce, and Miller were unacceptable because they were explicit.

The working classes also had recourse to humour as a sexual safety valve. The music-hall comics were often surprisingly bold, the seaside postcards extraordinarily explicit, but sexual licence extended only on the condition that sex was treated as a joke. Otherwise it remained what Lawrence called 'the dirty little secret'.

Rock 'n' Roll, crude and emotionally limited as it was, established an important principle: the right of the under-privileged young to express themselves with a freedom and directness which until then had been considered the prerogative of their elders and betters. Perhaps after all, taking this into account, their choice of uniform was not as haphazard as I suggested. The Edwardian man-about-town was a fair symbol of class privilege.

Aesthetically and morally Rock rates pretty low in my book. Yet its crudity and violence were probably necessary to force the breach. Most revolutions begin by exploiting the mob at its worst. The fights and cinema riots, the gang-bangs and hap-hazard vandalism were produced by a claustrophobic situation. They were the result of a society which still held that the middle classes were entitled not only to impose moral standards on a class whose way of life was totally outside its experience; of an older generation who used the accident of war as their excuse to down the law on every front; of a system of education which denied any creative potential and led to dead-end jobs and obligatory conscription; of a grey colourless shabby world where good boys played ping-pong.

Presley and Haley seemed to speak for them, and out loud on juke boxes or in cinemas. Yet here too there lay a paradox. The adult world allowed them to listen but on condition. No jiving

in the cinemas. No horse-play in the coffee-bars. They took no notice. Accepted the message at its face value and lashed out.

They slashed the cinema seats to ribbons, broke up the youth-clubs, bullied or beat up harmless intruders in their territories, and fucked anything that moved. The hard-core Teds were frightening and horrible, the dinosaurs of pop, but dinosaurs were a necessary step in evolution.

*

Each successive pop music explosion has come roaring out of the clubs in which it was born like an angry young bull. Watching from the other side of the gate, the current Establishment has proclaimed it dangerous, subversive, a menace to youth, and demanded something be done about it. Something is. Commercial exploitation advances towards it holding out a bucketful of recording contracts, television appearances and world-wide fame. Then, once the muzzle is safely buried in the golden mash, the cunning butcher nips deftly along the flank and castrates the animal. After this painless operation, the Establishment realizes it is safe to advance into the field and gingerly pats the now docile creature which can then be safely relied on to grow fatter and stupider until the moment when fashion decides it is ready for the slaughterhouse.

While believing that this metaphor, while elaborate, is basically accurate, I don't mean to suggest that there has ever been a conscious arrangement drawn up between the Establishment and the entrepreneurs of pop. It is simply that their interests happen to coincide.

The Establishment wants order. The entrepreneurs want money, and the way to make the most money out of pop is to preserve at least the semblance of order.

Yet here too the promoters face a difficulty. Any pop movement, at least during its initial and most profitable stages, is attractive precisely because it is believed to propose a revolt against the adult mores and, if it is to be milked, it's necessary to preserve at least the illusion of that revolt.

The trick is to shift the emphasis so that the pop idol,

originally representing a masculine rebel, is transformed into a masturbation fantasy-object for adolescent girls.

The shrieking, squirming audience in the process of self-induced mass-orgasm is, depending on one's viewpoint, unattractive, or disturbing, or sad, but it is controllable. The individual girl mooning over her pop-hero is, for most parents, irritating enough to convince her that she is in revolt, but it is in most cases both temporary and unimportant.

Furthermore this mass-shrieking and solitary mooning are, from the authorities' viewpoint, preferable to the growth of male aggression on whatever level and, on the promotional side, has the commercial advantage of gradually extending its range to include a younger and wider audience before losing its momentum.

Of course not all girl fans are content to leave it on a purely fantasy level. There are some who are prepared to use any means to gain access to their idols and hope that they will prove attractive enough to get laid on however casual a basis. There are others so stimulated that they are prepared to make do with anyone however tentatively connected with the artist or group; a fact that many a middle-aged manager or otherwise insignificant band-boy will be prepared to substantiate. Yet for the majority of fans it remains a fantasy, a dream. However much they scream outside stage-doors or besiege hotels and airports, they need to believe in the non-reality of their idols, and give the impression of being secretly relieved to be held back as this allows them to avoid putting their faith to the test. It may also explain the frequent threats of violence directed against pop wives and girl-friends. Instead of jealousy, the obvious cause, it may well be anger in that, simply by existing, wives and girl-friends draw attention to the human reality of their husbands and lovers.

There have been other explanations for the dangerous aggression which pop fans show towards their idols and of these the most plausible is the betrayal theory. According to this argument the fans are enraged by the fact that the pop stars, whom they have made rich and famous, are deserting them for

the rich life and that, rather than this should happen, they are prepared to tear them to bits.

But while ingenious, I don't feel that this theory fits the facts. The teenage furies didn't make their idols; they accepted them as idols ready-made. If anybody has the right to feel deserted it is the older and earlier enthusiasts in the little cellar clubs. It was *they* who recognized the magic and acknowledged it by enthusiasm on a personal and local level. It was *their* excitement which was instrumental in convincing promoters that there was something worth exploiting. Yet it isn't *they* who scream and weep behind the linked arms of policemen or commissionaires, it's the teeny-boppers.

My feeling then is that the love and fury is not resentment as such, but something much more primitive; a religious impulse; the need to sacrifice the Godhead in order to elevate it above temporal considerations. And just because the overt emphasis is sexual rather than spiritual in no way invalidates this argument. Throughout history religious enthusiasm at this level is frequently indistinguishable from sexual hysteria.

Equally mysterious is the sudden extinction of this dangerous divinity in any one artist or group. Quite suddenly, often in a matter of weeks, the screaming stops, the crowd dissolves, and the artist or artists, often with a certain regret, find it possible to walk unmolested in public places.

This is harder to explain but is most likely the result of the imitative enthusiasm of the fans' little sisters. Once a pop group represents teddy-bears it's hard to continue to think of them as fantasy lovers.

This infantile acceptance is also one of the contributory elements which lead to the decline of each pop movement as a whole, but the other side of the medal, adult acceptance, is equally damaging. Other factors are the emergence of a new pop generation who reject the music favoured by their elder brothers and sisters, and the decrease of enthusiasm among the musicians themselves. But all these are contained within, and explained by, pop's dependence on the mass media. Pop moves from private emotion towards public entertainment, from

41

personal conviction towards empty exhibitionism, from an inner circle speaking a closed language towards a whole generation enthusing with shallow hysteria over a fashion.

This move is naturally regretted by those for whom a particular pop-form has proved a true means of expression and, from the days of revivalist jazz on, they have tried to find a way out of this dilemma.

Some turn their backs on the British derivative and return to the American source on record. Others renounce pop altogether. A few dedicate themselves to guarding the sacred flame, and this was indeed the case among the more convinced enthusiasts of Rock 'n' Roll. Forming themselves into small groups with imposing names like 'The North Finchley Rock and Roll Preservation Society' they disappeared underground, but have lately re-emerged, squeezed into their Teddy Boy suits, to take advantage of a certain nostalgic climate.

Yes these guerrillas are a marginal if touching by-product and, from Rock 'n' Roll on, the progress of every pop explosion may be summed up like this:

A local enthusiasm for some form of music gradually crystallizes around a particular group or artist. At this point an entrepreneur, sometimes a local enthusiast with an eye to the main chance, sometimes an outsider led towards the scene by apparently fortuitous accident, recognizes the commercial potential of the group or artist and signs them up. He pushes on their behalf, talks to anyone who will listen, gets them recorded, feeds the press with stories, dreams up publicity stunts, fans any spark of interest into a flame and, if he is successful, his 'property' becomes first nationally and then internationally famous. In the wake, other groups or artists, many from the same local or musical background, some simply recognizing that a particular sound or image has become commercial, swim along feeding on the vast plankton of popular favour. Then, inevitably, the interest and hysteria die away, and there is a variable time-lag before the same thing happens again.

It is this process which led me to paraphrase the line from Thom Gunn's poem about Presley as the title of the book. 'He

turns revolt into a style' wrote Gunn, and this is what happens in pop; what starts as revolt finishes as style – as mannerism. Later in this section I hope to be able to establish how each pop movement in its turn has more or less conformed to this pattern, but there remains one more generalization to be made first.

This is essential, not only for its own sake, but because it is the one factor which the hostile critics of pop music, either through ignorance or for convenience, have chosen to ignore. It is this:

No matter how clever an agent or manager of the leading group or artist in any given pop explosion, no matter how cunning his manipulation of the organs of publicity or the medium of exposure, no matter how brilliant his sense of timing, his instinct for which offer to accept, which to reject, his hunch as to when his product's 'image' is in need of some modification or intensification, *he cannot succeed without some initial magic inherent in the group or artist in the first place.*

As usual, in order to avoid confusion, this statement needs immediate expansion and modification. The first thing to stress is that it applies only to the *leading* group or groups, artist or artists of any one pop wave. Once the movement is under way any number of imitative followers may succeed in establishing themselves, and even in appearing to challenge for a time the supremacy of the innovators. Another, more central point is suggested by the fact that I have advisedly used the word 'magic' rather than the word 'talent' in my preliminary sentence. And yet, as it happens, although not necessarily immediately obvious and in some cases only potentially, all those who have succeeded in starting and leading the various pop revolutions have had at least a modicum of talent, and some a great deal of talent, but I don't believe it was talent alone which made them succeed.

I have called it 'magic', and yet in this context this word won't do either; it's too vague, too imprecise. There is, however, a more exact word – 'charisma', a form of magic halo emanating from objects, people or places which gives them power over and above their measurable qualities.

I can almost hear a groan from certain quarters at the use of this word. It suffered from appearing indispensable for a whole month and is now *persona non grata*. Yet it is an exact and useful word, and there is no other with precisely the same meaning.

It is the recognition of a charisma which has made the fortune of many managers and some groups and artists, and it is the inability or refusal to recognize the existence of a charisma which has weakened the anti-pop critics' otherwise strong case. It is of course neater and easier to pretend that the whole of pop music is a simple confidence trick: the manipulation of ill-educated children with too much money by unscrupulous middle-aged villains, but it won't fit the book. There is, and has been, unscrupulous and dishonest practice in the pop world especially during its 'frontier days' in the middle 50s, and it is certain that, at the crest of each pop wave, it has been possible to float imitative figures of minimal talent with considerable temporary success. But what has proved beyond even the most determined and knowledgeable entrepreneur is the invention of a group or artist to lead a pop revolution or to hold, for any length of time, the status of a pop hero or heroes.

There is, however, more to be said about the nature and role of the charisma in pop music, and the first point is that it burns most intensely, and is certainly at its purest and most attractive, while still working at club level on a small in-group. After its discovery and exploitation it may *appear* brighter because more and more people are affected by it, and because mass hysteria is self-generating, but this is a delusion. What happens is that the huge crowds tend to applaud, not the figures at the centre of the charisma, but the charisma itself, and it is significant that the age-group to which each successive wave of pop music appeals becomes younger and younger as its popularity spreads.

A further proof that it is the charisma rather than the talent of the artists who possess it which provokes the hysteria is that, on the crest of a pop-wave (and, like a real wave, this is inevitably at the moment before it crashes down to spend its force among the pebbles), it is impossible to hear the music through

the screaming and squeaking of the teeny-boppers. It mustn't be forgotten, however, that this obliteration of the music doesn't mean that the audience is indifferent to it. They have certainly heard and absorbed almost every note before coming to the concert and can in consequence 'hear' mentally and individually exactly what they are preventing each other from hearing aurally. This may be the point to emphasize that it is the *music* which initially ignites a pop revolution, and that the music *in itself* can contain charismatic qualities. Indeed sometimes a record may possess it independently of its performers, and there have been many cases where a disc may become all-pervasive through the non-visual media while the actual appearance and impact of its creators 'means nothing'. It's true that these days, when so much depends on how a sound is doctored in the recording studios, this may be because they are unable to reproduce their record in the flesh, and this problem has become more acute since the TV companies have dispensed with 'miming', but inability to deliver the sound on the record is only one reason for failure. More frequently it is a flaw or fissure between the qualities suggested by voice or music and the actual physical impact of an artist which snuffs out the charisma before it has time to do more than glow potentially.

An important example of the destruction of a powerful charisma by physical presence happened in the case of Bill Haley, one of the two great American heroes of early British pop history. The kiss-curled Haley, a plump figure whose great hit 'Rock Around The Clock' had swept through the ranks of the emerging teenagers in the pre-Steele days, and whose film of the same name became, a little later, almost a form of initiation ceremony, killed his own image dead by crossing the Atlantic and touring the country. Whereas it had been possible to ignore the fact on film, in the flesh it became painfully obvious that this perspiring fat person was quite old. One of 'them' pretending to be one of 'us'. Presley, the other giant, never made the same mistake (or possibly his fee was always too high). By appearing only on film he remained potent. To put on flesh is to risk everything.

It is perhaps useful here to underline the point that one of the basic differences between British and American pop mythology over the last ten years has been the fact that the extreme *youth* of the pop hero seems less central to the American teenage cult. The reasons would need a specialist knowledge of American mores which I cannot pretend to, and the subject is anyway outside the scope of this book, but I would suggest that perhaps it lies in the earlier formation of the teenagers as a separate group within American society. As an adolescent film-goer during the war I remember being amazed by those movies which showed people of my own age apparently loaded with money, and necking with girls at the wheels of their own cars.

It could be said, in objection to this tentative argument, that both the earliest serious examinations of the teenage 'rebel' were American – I refer to the film *Rebel Without A Cause* (1956) and the novel *The Catcher In The Rye* (1954) – but what needs pointing out here is that both the film's teenager, portrayed by James Dean, and the book's Holden Caulfield are middle class, and that the middle-class teenage rebel in this country is a figure of the 60s. Our 50s teenager was basically working or lower middle class, a reminder that our pop revolution has, until comparatively recently, lagged behind America, its source and inspiration. Nevertheless it is evident that the form which each phase of our revolt has taken turned out very differently from its American precursor. It is also obvious that the great breakthrough – an event which can be approximated with the emergence of the Beatles – has reversed the trend not only influencing America's own teenagers, but establishing a dialogue between the two pop cultures which is still open.

To return to the reasons for the extinction of the charisma, as a rule there is no logical explanation. It is simply a case of 'Now you see it. Now you don't'. It is almost as if the temporary possessor of charisma was a pop Cinderella sent to the ball by the capricious Fairy Godmother of pop favour, but at least the original Cinderella knew that it was to be on the last stroke of midnight that her beautiful dress would turn back into rags and her coach revert to a pumpkin drawn by mice. The pop idol

has no such foreknowledge, and the total and inexplicable rejection has, in some cases, led to a complete breakdown of personality. Yet, where talent is present, it has usually proved possible to continue in the less mysterious role of an entertainer.

From Steele to the Trad Boom

'. . . . and the way Tommy Steele was all soft and stupid from the second disc he cut'.

RAY GOSLING *Sum Total*

Tommy Steele's career illustrates the generalizations I've been trying to formulate with almost text-book clarity. He was discovered singing to a small but enthusiastic audience in the cellar club beneath the Two I's, a coffee-bar in Old Compton Street, Soho. He was signed up by two young promoters, Larry Parnes and John Kennedy, who recognized his charisma and believed they could exploit it commercially.

From today's viewpoint it's inevitable that this appears a banal story, the prototype of every pop success including the Beatles'; yet at the time it was far from banal. There were no precedents. Parnes and Kennedy were lone prospectors.

It's true that once the time had come to act they had several things going for them. They moved on the fringe of useful worlds: show biz, popular journalism and the comparatively new field of the P.R.O., but this should not be allowed to negate that flair or instinct which promoted them to make the initial jump into the dark.

Later the Two I's was to become a rather dusty shrine to its claim to be the womb of British Rock 'n' Roll. It is one of pop's characteristics that, once a fad is over, everything connected with it loses all virtue and becomes indescribably tawdry. In the middle 50s, though, it was a Mecca for the still secret world of indigenous Rock. We, in the revivalist jazz world, passed it several times a week, unaware that beneath our feet the fledglings were trying out their wings. Kennedy and Parnes knew this.

47

They circled hawk-like above the Two I's and then swooped down to make their killing.

Again, in retrospect, this may not seem such a remarkable thing to have done. There were plenty of signs available. Presley and Haley had shown that there was a large audience for Rock and yet there was no British hero with whom that audience might identify. Nor did it need an economist to realize that the teenagers were earning a lot of money and had little to spend it on. There was also the renaissance of the gramophone record and the introduction of the coffee-bar juke-box as a free advertising medium. The rapid spread of the coffee-bars themselves was another pointer. Here were the first exclusive teenage meeting-places: a nation-wide network of cells where, above the fierce gurgling and hissing of the Gaggia machine, the secret codes and passwords were formulated. The signs were there all right but Parnes and Kennedy were the first to interpret them correctly.

As a matter of fact even their choice of Steele required considerable imagination on the part of men outside the teenage bracket. He was in those days remarkably unconvincing as a performer. His Presley imitation had as little to do with his hero as has the appearance of a five-year-old girl, smeared with lipstick and wearing her mother's dress and shoes, with her belief that she could be mistaken for Elsie Tanner. But they understood a principle which was as yet unformulated: that given charisma, amateurism is a positive advantage, a means of allowing a teenage audience to identify with a performer. Polish was show biz. They weren't after a show biz audience, not initially at any rate.

So they signed up this ex-cabin boy called Tommy Hicks, and changed his name, and groomed him a little but not too much, and surrounded him by competent musicians (most of them disgruntled jazz modernists who wanted to eat), and they persuaded Decca to record him, and then they really got to work.

*

In pop history, as in every other kind, there is a tendency to oversimplify; to believe that any new development instantly erases all that went before, that the whole landscape is entirely transformed.

Before checking I would have guessed that Steele's first disc, 'Rock With The Cavemen', recorded in 1956, shot rapidly up the charts, reached Number 1 and stayed there. In fact, while doing well, it never made Number 1 at all, and it wasn't until January 1957 that his second recording, 'Singing The Blues', finally got there and even then in a tie with Guy Mitchell.

Nor, as a recording artist, did Steele ever come near to approaching Lonnie Donegan who was almost consistently in the charts right up into the early 60s, while as for supplanting the Americans (another false memory), Presley, Little Richard, Jerry Lee Lewis and the others remained in effective control of this area throughout the whole Rock 'n' Roll period.

Yet this discovery in no way invalidates Steel's triumph as both a live performer and an innovator. Donegan's public might buy more records, but his appearance on stage was received by an audience prepared to applaud hysterically, but to remain respectfully silent while he was actually singing. Steele was the first British performer to receive the true pop accolade; the pubescent shriek.

He was in fact a new animal, the first realized dream of an entire new class, the model of a new world.

*

There are several other useful lessons to be drawn from the Tommy Steele case.

Firstly there is his treatment in the press (the popular press, for in those days the quality papers had either no interest in pop or, more likely, were totally unaware of it).

For once Kennedy and Parnes had succeeded in getting Tommy into the papers they were away; his myth was self-nourishing; it grew from feed-back.

By describing Steele's effect on his early fans with a kind of salacious prurience, the papers ensured that the behaviour they

deplored appeared increasingly attractive to an ever-widening adolescent public. As a result Steele was able to fill larger and larger halls with younger and younger girls already programmed to react hysterically, and, by reporting this, the press ensured the presence of an even less discriminating cross-section determined to cap the Dionysian frenzy of their predecessors.

Yet for reasons I've already formulated, this process had its natural limits. There are, at any given time, only a certain number of girls of the right age. Once Steele had crossed the pre-pubescent line, his reign as a pop idol was already over.

In contrast to this process, another element had come into play: the wish to absorb Steele into the structure of show biz proper; to *use* him to attract audiences into the failing music-halls.

As early as 1956, before he had even made Number 1 in the charts, he was taken away from the Rock circuit, and was topping the bills in the Moss Empire variety theatres. Pantomimes and films followed (the British 'Rock' films are a subject in themselves, a crucial stage in the 'castrating' process of the middle and late 50s). All these factors contributed to Tommy's wider acceptance and the consequent alienation of his first public, the teenage rebels.

Parnes and Kennedy were not alone in miscalculating the potentiality of pop. In fact, considering that they had no precedent to work from, they made remarkably few mistakes. Furthermore the belief that the only path for a pop artist lay in the direction of general acceptance was to persist well into the 60s. The cliché 'I want to be an all-round entertainer' may have become a joke, but it remained the only answer that most pop artists came up with when questioned as to their ambitions. For a long time pop seemed no more than a back entrance into show biz.

So of course it was, and come to that still is. For singers like Sandy Shaw, Lulu and in particular Cilla Black, pop is the most convenient route into show business proper now that the music-halls have gone; but what has changed in the last few years is that there is now a choice. Whereas before there were only two alternatives: show business or obscurity, there is now a

third. Given sufficient determination and talent of the right kind it's possible to develop within pop.

In the middle 50s, however, nobody imagined such a possibility. Come to that not many people over the age of sixteen or so thought of pop as anything more than a profitable gimmick or an unpleasant epidemic. No one saw that it was in fact the key to understanding a new social phenomenon, the teenage revolution. Well almost nobody. The first adult to recognize the significance of pop and to make an attempt to formulate his conclusions was not only outside the pop world but well outside the teenage age-bracket too. He was the novelist and critic, Colin MacInnes.

MacInnes's book *Absolute Beginners* (1959) remains the most accurate and sensitive exploration of this then-virgin territory, but more immediately I am concerned with a short essay he contributed to the magazine *Encounter* in December 1957. His subject was Tommy Steele and in under 2,000 words he not only succeeded in analysing his hero's appeal and impact, but showed a penetrating understanding of what pop was about.

For what MacInnes realized was that pop was not simply an empty pseudo-American sub-music but that it was also the banner of a new class. Not that he overestimated its aesthetic value; on the contrary, he mildly regretted its empty mid-Atlantic idiom and compared it unfavourably with the songs of the Edwardian music-hall; but he recognized its potential and even tipped Lionel Bart, who wrote several of Steele's early hits, as the first British pop writer with a British accent.

MacInnes did make one error. He went to hear Steele in concert and, watching the rapture of a small child and the approval of its mother, concluded that Tommy appealed equally to teenagers, adults and toddlers alike whereas, by that time, he had already lost his pop charisma. Yet this was a very minor misunderstanding, and MacInnes was to go on, in the face of much initial disapproval, to pioneer the exploration of this new continent. It was an astonishing feat of empathy.

One final point – MacInnes's reference to the old music-hall is

interesting because it was in just this direction that Steele and several other early pop stars were to move. Later Tommy actually recorded Harry Champion's 'What a Mouth'. Others who have followed his example are Marty Wilde and Joe Brown, and the influence of the music-hall on British pop music has been surprisingly strong. The Kinks are a case in point; many of Ray Davis's compositions pay overt homage and so do the Beatles on occasion; but I shall leave any speculation as to why this should be so until later in the section.

To finish with Steele, his early records, which the hard-core Rock 'n' Roll fans rightly suspected of having little to do with the fiercely subversive music of the American originals, illustrate a useful point. Playing them today they sound tuneful, archaic and very British indeed. His image too is that of a sweet rather gormless lad. I recently discovered on a junk-barrow a couple of framed collages of Tommy, smiling toothily or playing his guitar. These date from the height of his teenage pop-idol period. They look, like most old pop phenomena, the essence of a rather charmingly dated innocence. Come to that even Elvis sounds pretty harmless now. Only the coloured artists, Little Richard and the rest, retain something of their fire.

Steele's financial triumph had not only a widespread effect at the time but established the pattern for the second stage in all subsequent pop explosions: the pursuit of others cast in the same mould.

Promoters and would-be promoters deserted what until then had been their usual hunting-grounds, the music-halls and the talent contests, and invaded the coffee-bars, fountain pens at the ready, looking for embryonic rock stars.

For their own part, the singers themselves who, up until then had performed for love of the music and if they were lucky a little small change, recognized their monetary potential, and, even some parents, who had thought of their children's obsession with Rock as at most a waste of time, realized there might be profit in it and, despite no previous experience, assumed a transparent air of spurious business acumen.

It was as if Parnes and Kennedy had found gold and now the

rush was on. Like most gold-rushes it was an unattractive spectacle.

Parnes and Kennedy themselves were in the happy position of being able to pick and choose. After their success with Steele nobody was going to turn *them* down. What's more, unlike many of those who were trying to emulate them, they did at least know what they were looking for, and most of the young men they signed up had, for a span at any rate, considerable success.

Having discovered an effective formula they naturally made no attempt to alter it, and their disciples were equally faithful to their principles. For example they'd laid down a system of naming their discoveries which was as rigid as that adopted by Mr Bumble in *Oliver Twist*, a homely Christian name coupled to an abstract surname suggestive of a force of nature or, to be more exact, descriptive of their properties' sexual potential. Among Tommy *Steele*'s successors were Marty *Wilde,* Johnnie *Gentle,* Tommy *Quickly,* Billy *Fury,* Rory *Storm* and Johnnie *Eager.* It was a rather ludicrous idea, but given that both promoters knew that the audience they were after was made up of pubescent girls, it was by no means stupid. Screaming at a concert or lying on their beds listening to records while staring at a wall covered with photographs of their heroes, they no doubt thought 'he'd do it gently, or quickly or furiously or eagerly'.*

Yet strangely enough Steele's most successful challenger had no evocative name to help fix his image. He was called Terry Dene: a moody-looking young man with a rather plump face and hooded eyes. Dene was the first conspicuous victim of pop music. He was crushed between two forces: an over-rapid exposure to adulation on the one hand, and an attempt on the part of the establishment to use him for its own ends on the other.

In Dene's case the latter was demonstrated at its most extreme and absurd. When the time came for his call-up they made a big deal of it, hoping thereby to convince his increasingly resentful

* Re-reading this I suspect that although my analysis of the promoters' reason for choosing such names is probably accurate, both they and I were giving in to a male fantasy in believing it to work in the way I suggested.

June 1970

generation that the Army was not so square after all. Within a few days he had a nervous breakdown and they were forced to release him. This led to a great middle-class, middle-aged outcry which can't have made it any easier for him, but at least on this occasion the authorities failed.

Anyone less obtuse than the army could have guessed this would have happened with Dene's previous unstable history. Unable to cope with the pressures of civilian life it was dotty to imagine he could take the army in his stride.

Yet on the face of it the Military had a case – the Presley case. Presley was doing his service as though it were an extension of show biz. Furthermore the U.S. authorities were handling it remarkably cleverly in that they succeeded in stressing simultaneously both his ordinariness and his glamour. He had been photographed joining his regiment in Germany as if he were its commander-in-chief rather than a private soldier; but in the months that followed they had stressed his lack of privilege, his ordinary 'buddies', his humble duties. Like British Royalty he was seen to be both God-like and commonplace at the same time.

Where our authorities went wrong was in failing to recognize the difference between the way the American and British working class feel about their army in peacetime. For Americans the army is still a citizens' army, but for the average British conscript it is an upper-class army whose function is to defend 'their' interests. Even if Dene had taken to military life like a duck to water it would have done the army no good. For his fans he would have seemed either a mug or a stooge. It is, on the other hand, true that it might have made pop more acceptable to the middle and upper classes. They have always tried to treat pop artists as private soldiers. Later, with the Beatles, they were to face a successful mutiny.

Dene's case was an extreme one, however. Slowly pop itself was putting its house in acceptable order; losing its dangerous anti-social flavour; gaining a boy-next-door image. Naturally this didn't happen all at once, but the signs were there.

In 1958 the emergence of the Everly Brothers in America seemed to be indicative of the way that pop was moving from

grunting, sexually powered protest towards middle-class boy-next-door acceptability. Their very name sounds like a politer version of 'Elvis', and their appearance too was a tidied-up, gelded caricature of the early Presley. Their material was well sung and ingenious but inoffensive. They swung rather than rocked.

In Britain too the same thing was happening. Steele had begun to leave the Rock behind and there was an increasing amount of schmaltz in the charts; but the most significant indication of the swing towards acceptability was the rise of Cliff Richard.

Richard is a key figure in relation to the castration of the first British pop explosion. Steele may have abandoned pop for show biz, but Richard dragged pop *into* show biz. He is still around, too, an enigma in many ways and apparently ageless. He alone among his contemporaries is still able to touch the very young. Only last year I heard them shrieking at a charity concert at the Festival Hall. There is an omnipotence about him and, at the same time, something a bit creepy.

He began as an Elvis imitator and a flash one at that. He played the guitar, wore a quiff *and* sideboards and moved in the then fashionable pelvic masturbational manner. As a Rock singer he had instant success. His 'Move It', a fairly conventional piece of sexual metaphor, did well in the charts as early as October 1958. As was customary he was instantly booked into variety and pulled them in all over the country. 'Handsome little brute,' said a middle-aged homosexual friend of mine after watching him appear at a provincial concert. There was nothing then to suggest he was destined to alter the whole pop image.

His Mephistopheles was a TV director called Jack Good, of whom more later. Good was an important figure in early British pop mythology because he was determined to turn it into acceptable family entertainment. It was he who, holding out the carrot of an appearance on *Oh Boy!*, insisted on shaving off Cliff's sideboards, thinning his quiff and taking away his guitar. It worked. Cliff was soon less of a threat than a promise. His

erotic twitching turned into a bent-kneed shuffle, not so much a sexual courtship dance as a suggestion that he'd wet himself; and his material became soppier and soppier.

By August 1959 he'd made Number 1 with Lionel Bart's 'Living Doll', a song as pretty and as harmless as a stick of candy floss. Later he was to stand up and be counted as one of Billy Graham's most effective side-kicks. He was show biz's favourite convert, just a shade magisterial but untouched by any breath of scandal.

Following in Richard's foosteps came another hammerer of nails into Rock's coffin – Adam Faith.

Faith, small in stature but with a remarkably large head (in the physical sense, for there has always been something attractively modest and puzzled about his persona), exemplified something less abstract than Richard: the decent, slightly wild, lower-middle-class adolescent who, with puberty behind him, would no doubt turn up trumps.

The choice of Faith's *nom-de-chanson* was in itself significant. In place of sexual promise – a religious amalgam: the first man, fallen but convinced of his redemption.

His material too soon shifted from Rock, an idiom in which he displayed even less aptitude than Richard, to an almost self-mocking melancholic if gently up-beat type of number describing the ups and downs of suburban coffee-bar-orientated calf-love. There was a certain rather touching truth in Faith's material and even more perhaps in the way he delivered it. His pronunciation of 'baby' as 'baybay' (in fact plagiarized from Buddy Holly), was his early trade-mark and widely ridiculed. Yet there was something attractive about him, something demanding respect. He appeared for example on John Freeman's *Face to Face,* a notoriously probing TV interview show of the period and emerged unscathed. He was also the first teenage idol to admit to pre-marital sexual experience, a banal enough confession you'd have thought, but it had an extraordinarily violent effect on those who preferred to believe that nobody ever fucked anybody until after they were married. Today the reaction appears almost incomprehensible; but it was the Ward

Trial and a spiritual age away. It helped, however, to endear Faith to the newly emerging liberal establishment who, until that time, had ignored pop completely. It also may have forced him into a pi-permissive role which was not entirely natural to him. He became the same teenager, the interpreter, the ombudsman. Yet Faith opened up an entirely new possibility within pop, the idea that it represented more than noise or mindless sexual provocation. Musically he may have been among those who helped to kill the rock, but personally he was an innovator. The first to admit that his ambitions went further than a home for mum and acceptance as an all-round entertainer.

*

On the evidence of the charts there was very little happening between 1957 and 1961. Rock 'n' Roll, the first true pop explosion, had turned to prettiness and favour. Not only had the pop public become younger and younger but its artists too. In 1958 Laurie London had made the charts while still a sub-teenager and his hit ' He's Got the Whole World In His Hand', a sickly spiritual, was said to have been composed while he was at school. Infantism rampant.

Aesthetically British Rock had little to its credit: a few sub-blues; imitations of American white imitations of the late Negro urban originals. In fact a better case could be made out in favour of the non-Rock pop songs which at least have acquired a certain period charm. Yet British Rock did point to certain possibilities and its failure at least provided a useful lesson for those who came after.

The Rock 'n' Roll movement in pop history was killed by over-exposure in the press, by a mixture of bullying and flattering, by the crushing embrace of show biz. Its original supporters turned away early. Some married and started families, the dusty 78s in the attic or under the stairs all that was left to remind them of that heady moment. The dark fringe, the anti-social, swarmed in on Notting Hill to mix it during the race riots of 1958. Then they crawled back under their stones,

ignored where possible by the society which had malformed them and didn't want to know.

The first pop explosion was not without its constructive critics even at the time. Peter Sellers, on one of his satirical LPS, included a brilliant track in which a lady journalist interviews a young pop idol under the eye of his owner, a ferocious whip-cracking colonel. A longer attack was the successful musical *Expresso Bongo,* a sharp look at the rise and fall of a pop idol during the coffee-bar era. In the subsequent film the lad was played by Cliff Richard and he of course never fell. Still many did and, after being disgracefully exploited by the less reputable entrepreneurs, were turned off to fend for themselves.

During the Rock era, we in the traditional jazz world weathered the financial drought as well as we were able. We were amused by certain aspects of what we felt to be a totally absurd phenomenon: by Screaming Lord Sutch, the Arthur Brown of his day, who used Rock in the service of necrophilia and Hammer-film sadism, by an eighteen-year-old member of the House of Lords who had a group of his own and was billed as 'The Rock and Roll Earl', by Wee Willie Harris and his dyed pink hair. But what never occurred to us was that the next pop explosion, the bridge between Rock 'n' Roll and what was to become known as the Liverpool Sound was to be traditional jazz.

The Trad Boom

Just as a giraffe's neck or anteater's tongue give a clearer idea of the evolutionary process than less exaggerated examples of Darwinian natural selection, so the unlikeliness of the trad boom, its *untypical* features, are particularly useful in demonstrating certain aspects of pop. For the trad boom was both unexpected and untypical; its heroes were far older than the norm and had been around much longer; the emphasis was instrumental rather than vocal; the sexual aspect was almost non-existent. Yet in the way in which it was sold, over-exposed

and abandoned, trad presents a classic case and, in the way in which it contained the seeds of a later movement – British Rhythm and Blues – it demonstrated how, below pop music, lies a common substratum from which the apparently unconnected peaks rear up.

Without Chris Barber it is doubtful if the British trad boom could have taken place; he was the great popularizer, the Sir Kenneth Clark of the traditional idiom. It's true that Ken Colyer's convinced disciples had little time for him. From their viewpoint he had betrayed not only the music, but its message, for Ken had equated traditional jazz with left-wing protest and it was to the sound of a New Orleans marching band that the Ban-the-Bomb columns kept their spirits up on the road from Aldermaston.

During the middle and later 50s Barber had been engaged in polishing away the rough sound of New Orleans traditional jazz, the form of music which had largely replaced the revivalism of the first half of the decade. His didactic, somewhat pedantic presentation flattered a growing audience; he spawned imitators in almost every major town in the country, and it was they who filled the mushrooming jazz clubs and played host to an increasing number of pro and semi-pro London-based bands. Yet off his own bat, I don't think that Barber would have led to a trad boom on the scale it took. He ploughed and fertilized the ground and harvested much of the temporary advantage; he suffered too from its decline; but he lacked both the panache and the common touch needed to transform what was still a committed minority interest into a nation-wide fad. The man who achieved that was the flamboyant Mr Acker Bilk.

Superficially Acker may seem to have been a totally manufactured phenomenon; a golem put together by a Frankensteinian publicist called Peter Leslie. It was Leslie who, faced with promoting a rather rough if dedicated band in the Colyer spirit, imposed the obligatory 'Mr' on all billings, dressed the product in a striped Edwardian waistcoat and bowler hat, and couched its publicity in elephantine pastiche of Victorian advertising prose, larded with unbearable puns. To this already confused

picture, he in no way discouraged Acker from projecting and indeed exaggerating his own West Country origins. In effect then the public was asked to accept a cider-drinking, belching, West Country contemporary dressed as an Edwardian music-hall 'Lion Comique', and playing the music of an oppressed racial minority as it had evolved in an American city some fifty years before. More surprisingly they did accept it. Acker was soon a national idol.

He was of course more than the sum of these unlikely append-ages, he possessed the necessary charisma, a great deal of warmth and the ability to produce a simple recognizable sound; but what remains interesting is to try and decide just what this middle-aged clarinettist stood for in the minds of the British public at the beginning of the 60s. My own feeling is that he may have represented some kind of chauvinistic revolt against American domination; that the mixture of Edwardian working-class dandy and rural bucolic came to stand for a pre-atomic innocence when we were on top. Although Bilk himself was carefully represented as a-political, it was his bowler which the less thoughtful and more emotional fringe of the C.N.D. move-ment adopted as their symbol, and it was the simple music he purveyed which drew them together at such tribal rites as the later Beaulieu Festivals to rave and riot. Yet simultaneously, for the middle-aged he seemed a reassuring figure, and for the very young, a jolly uncle. From the many-layered amalgam built up by Peter Leslie all could draw what they needed.

In Bilk's wake others prospered. A few went so far as to imitate his stake in fancy dress, but most were content to aim at reproducing the trad sound, an increasingly dispirited formula, which finished up by boring everybody including its exponents.

Much of this over-exposure must be laid at the feet of the B.B.C. It was they, more than anyone else, who were responsible for over-plugging the trad sound so that, not only was a trad-band obligatory on such general pop-mélanges as *Saturday Club,* but *Jazz Club* itself, until that time a serious programme covering the entire spectrum of the music, was ordered to limit itself exclusively to trad.

The reasons for this imposed monopoly are obscure. Was it the unworrying simplicity, the nostalgic archaism of the music, which reassured those in authority? Was it the social ease of the practitioners; for the young lions of the other pop movements tended to treat even beneficent authority with marked disdain? It's difficult to reach a conclusion but what remains certain is that, even for those to whom the revival of early jazz had been a sacred cause for over a decade, the grinding out of the same old tunes in the same old way soon became a monumental drag.

It's worth emphasizing perhaps that, even at the height of the trad boom, the records which made the charts lay for the most part *outside* the idiom. The first success, Barber's 'Petite Fleur' (April 1959) was a sentimental composition of Sidney Bechet's cloyingly interpreted by Barber's clarinettist, Monty Sunshine; Bilk's greatest hit was the syrupy 'Stranger on the Shore', originally the theme for a children's TV serial; while Kenny Ball, although his chart-busters were superficially 'hotter' in style, chose to record such non-jazz material as 'Midnight in Moscow' or 'The March of the Siamese Children' in a manner which the hard-core jazz fans were to christen 'traddy-pop'.

Despite the LPs, which were usually less commercial and aimed at retaining the loyalty of those who had made the whole boom possible, this mixture of compromise and monotony was eventually bound to alienate even the most dedicated trad-fans and with no confidence at the centre the whole thing slumped.

There are two other points to raise. Firstly that, while 'the trad sound' was the heart of the boom, many non-trad bands were responsible for the wide public it drew on. In particular the Temperance Seven are important here. Skilful and solemn, they exploited a weakness for nostalgic camp by reconstructing the banal charm of the *white* dance music of the 20s and early 30s within an Edwardian visual framework. In this they represented a constant thread in pop music; the yearning for a simpler earlier time masked by irony; the musical equivalent of the rash of Union Jacks with which 'Swinging London' was to conceal its uncertainty.

The other point worth stressing is that within trad itself and at the height of the boom there were many who rebelled against its increasing conformity, notably Chris Barber himself.

Chris moved away from the sound for which he was largely responsible long before it reached its height. His wife, Ottilie Patterson, who during the early 50s had sung in a comparatively convincing approximation to the style of Bessie Smith, took to plugging both Gospel music and urban Rhythm and Blues. Barber was also responsible for introducing many of the originators of both these idioms to the British public and indeed of encouraging the embryonic talents of the emerging British R and B movements. Yet when the slump came his name was too much associated with trad to allow him a free pardon, and the only band-leaders to emerge comparatively unscathed were those who had most resolutely refused to cash in: that is, on the one hand, Ken Colyer, the great incorruptible of New Orleans jazz, and on the other Alex Welsh whose dixieland-flavoured band had never totally convinced the diehard traddies, and who in consequence lay outside the direct path of the backlash.

With The Beatles

'Those who flock round the Beatles, who scream themselves into hysteria, whose vacant faces flicker over the T.V. screen, are the least fortunate of their generation, the dull, the idle, the failures. . . .'

PAUL JOHNSON *New Statesman* March 1964

In 1961 I decided that it might be possible to withdraw from jazz-singing as a full-time occupation and try to make a living from writing. I had 'Flook' as a basis, and had been encouraged by a request to write an article for *Queen* magazine, so it wasn't as bold a move as all that; besides, as the trad boom was at its height, I could not only fall back on a certain amount of singing but was in some demand as a B.B.C. compère.

This well-hedged gamble paid off. I was lucky enough to be asked to write reviews and articles for quite a wide variety of

journals, but one thing worried me and that was the way it appeared to be taken as read that I was something of an expert on pop music, a subject which up until then I had deliberately and scornfully ignored. At the outset of a new career I knew better than to own up to this deficiency and, in order to satisfy my patrons, I began listening to pop. Rather to my surprise I found it more interesting than I'd imagined.

In fairness there were perhaps other reasons beyond financial survival contributing to this change of heart. For one thing the trad boom had temporarily exhausted my love for early jazz, and on top of this was the fact that my own livelihood was no longer in direct competition with the practitioners of pop. I had, as it were, left the water-hole for the hide in the tree. Yet I have the feeling that perhaps after all the main cause was less opportunist.

Just before I left the jazz world, I'd met my wife. She was, at that time, something of a pop-buff and, as a result, I found myself listening to and eventually enjoying quite a lot of pop music in a mild way. What's more, despite the jazz executant's built-in rejection of dancing, I even learnt to dance the twist.

Outside of trad, for the boom lasted well into 1963, the twist was the only real innovation until the Beatles emerged from the Cavern. It was in no sense a pop movement as such, but the latest craze from America, one of a long line of dances, usually of Negro origin, dating back to the Cakewalk in the early 1900s. In the spring of 1962 Karl Miller, then Literary Editor of the *New Statesman,* asked me to write a piece on how people were dancing in London, for the twist, coinciding as it did with the arrival of the discothèque, those wombs of 'Swinging London', had sparked off a considerable terpsichorian revival. I reprint it here because I think it caught something of the pop atmosphere of that time. It was called 'Late Perpendicular'.

I have spent a certain amount of time lately watching people in London dance in the various new ways. I report what went on in three very different places where my fellow-countrymen and women had come together to give what Shaw called 'a perpendicular expression of a horizontal desire'.

The Saddle Room, Hamilton Place, W.1

One of the several theories as to the origin of the Twist is that Harlem homosexuals, incensed at being forbidden by law to dance together in public, invented a routine of high erotic content in which there was no actual physical contact. This may or may not be true, but it is amusing as one watches the ladies and gentlemen twisting at the Saddle Room, to believe that it is. It is also quite difficult. The Saddle Room is not the first, but it is certainly the most fashionable, discothèque in London. Outside the door is a fiacre with a liveried driver. This can be hired by arrangement to drive one home. Inside the door is a notice saying that, for the moment, the membership list is closed, which in the club business is surely the real cachet of success. One of the reasons for this is that, for the West End of London, the cost is extremely reasonable. The décor is harness and hunting pictures and horse-box panelling. It's so English it couldn't look more French. The music all comes from a very loud hi-fi gramophone. The clientèle are those people from SW1 and 3 who feel uncomfortable at The Establishment, people connected with the rag trade, and, most noticeably, a great many fashion models. It is very crowded, everyone a little irritable.

Most of the dancers on the floor are really quite embarrassing to watch. They are also for the most part too old. The Twist is above all a dance for the very young. Danced by the young it is certainly immensely erotic, but danced, and danced badly, by the middle-aged it becomes obscene. As though to point up the difference, the night I was there, in contrast to all the flabby jowls and bottoms wobbling about on the dance-floor, there was a young model girl dancing superbly with her equally accomplished partner between the tables by the entrance. She wore a cow-girl skirt, high boots and a white shirt under a little black waistcoat.

The highlight of the evening for me, however, was provided by two ladies from the country wearing those dispirited floral cocktail dresses which nowadays signify 'a night out'. They stood for a moment contemplating for the first time a floor of people in full twist. Then one of them said in a hurt voice, 'And I've only just learnt to cha-cha!'

An All-Night Rave at the Alexandra Palace

An all-night 'trad' ball held in the echoing and chilly infinity of the great hall of the Alexandra Palace. Band followed band from 9.30 P.M. until 7.30 A.M. the next morning. The audience were dressed

almost without exception in 'rave gear'. As the essence of 'rave gear' is a stylized shabbiness, the general effect was of a crowd scene from a biblical epic. To describe an individual couple, the boy was wearing a top hat with 'Acker' painted on it, a shift made out of a sugar sack with a C.N.D. symbol painted on the back, jeans, and no shoes. The girl, a bowler hat with a C.N.D. symbol on it, a man's shirt worn outside her black woollen tights. 'Trad' dancing in the contemporary sense is deliberately anti-dancing. When I first went to jazz clubs, there were usually one or two very graceful and clever couples. But today the accepted method of dancing to trad music is to jump heavily from foot to foot like a performing bear, preferably *out of time* to the beat. I have no explanation to offer for this unattractive fad, unless it is to underline that they have no connection with the lovers of pop music, all of whom dance rather well in a somewhat mechanical way. Trad musicians have christened these self-made elephants 'Leapniks'.

A Lunch-Hour Record Session at the Lyceum Ballroom in the Strand

To come out of the cold, wet, mid-day Strand into the warmly lit ballroom of the Lyceum Palais is a curious, rather dream-like experience. The Lyceum was originally a theatre, and Mecca Dance Halls Ltd have left most of its Edwardian-baroque opulence untouched. Above, all is crimson and gold, cherubs and swags of fruit. On the band-stand a sharp young man in horn-rimmed spectacles fades the records in and out on the two turntables of the enormous record-player. On the floor over a thousand teenagers jive and twist several times a week from twelve till two. It costs them a shilling a time. Sandwiches, cakes, soft drinks are provided.

As in all teenage rituals the atmosphere is solemn and dedicated. Most of the dancers silently mouth the words of each pop song from its opening bars on. The standard of dancing is high. Unlike the clientèle of the Saddle Room, they only twist to twist records, and can all twist properly. A great many of the girls dance together throughout the whole session, and refuse to be split up. The reason for this is that they have worked out elaborate routines and don't want to waste them. All the dancers without exception wear the fashionable cut-off expression. Their clothes, less extreme than they would be at an evening session, are a compromise between their own ideas and what their employers will stand for. The average age I should guess to be

just under seventeen. I did see one man in his early forties, but his
bald head and spectacles seemed somehow in rather dubious taste.
One corner of the floor was occupied entirely by children none of
whom looked much over twelve. I was assured, though, that they
were all over sixteen, the legal age of admittance. At two o'clock the
bright lights went on overhead, and by five past the place was empty.
'We never have any trouble,' I was told. 'They've all got to get back
to work, you see.'

It's a rather touching proof of how quickly a pop phase
withers and dies to listen today to one of the twist numbers of
the early 60s: Chubby Checker's 'Let's Twist Again', for
example. It suggests another age, the age of Macmillan affluence,
and for some reason it was the last dance which the middle-aged
felt obliged to learn.

Outside the twist and trad there was almost nothing
happening on the eighth of the pop-iceberg above water.
Presley went softer and softer, Faith and Richard more and
more boy-next-door-like. There were some fine ballads among
the slush: Matt Monroe's 'Softly as I leave you' was remarkable
not only for its fine tune and first-class execution but for the
realism of its words, a new departure in this line of country.
There were some good carriage-trade recordings too: Nat King
Cole's 'Let There Be Love', for example, but it might have been
written for a Cole Porter musical in the 30s. There was Helen
Shapiro, a good deed in a naughty world. Yet in an article I
wrote about pop music for *New Society* in October 1962 there
was only one strain I discovered that seemed to me encouraging.
Of Mike Sarnes' 'Will I What', I optimistically suggested it to
be:

. . . an example of a trend which I applaud wholeheartedly; the use of
a real situation firmly placed in contemporary Britain. Sarne, imi-
tating a modern London boy (no boiled beef and carrots for him),
tries to chat up a little doll. At first she'll have nothing to do with him,
but finally says O.K. and then suggests he comes home and meets her
Mum and Dad. He immediately mumbles excuses and makes a hasty
departure. It's beautifully done. Comic and affectionate. There have
been quite a few records in this category which have made it. Anthony

Newley was, I believe, the first to exploit modern cockney – that flat, slightly Americanized, accent with its understated *in* humour and criminal-derived vocabulary. Bernard Cribbins also has captured perfectly on two records* the feel of the new working-class with its non-forelock tugging approach to the bourgeoisie and determination not to be kicked about. These records, on a modest scale, are the equivalent of the New Wave in the British Cinema. Their success is heartening . . .

and so, in the surrounding apathetic gloom it seemed, but it was not for real. Newley and Cribbins were both actors acting out the new proletarian revolution, Sarne an intellectual. The real pop revolution was elsewhere. In Liverpool, my native city, Brian Epstein was already managing the Beatles. Within a year they were to become the most famous people in Britain.

*

I should have guessed too. The Mick Mulligan band, with which I sang, played the Cavern through the second half of the 50s and towards the end of the decade, just as the trad boom was getting under way, we noticed that the management was no longer hiring a local jazz band to play during our interval. Instead we returned from the pub to find the small stage cluttered with amplification, in place of a three-piece front line playing the reassuring if stereotyped Negro dance-music of the 1920s, there were these young men with electric guitars playing and shouting the modern Negro urban blues at what seemed to us a quite unnecessary volume. The Liverpool groups, the Beatles in all probability among them, were beginning to emerge.

We were puzzled but unworried and shortly afterwards moved to another Liverpool club with a straight trad policy and forgot all about it.

If by this point anyone should find it odd that this unrecognized intimation of what was to come should take place at the *beginning* of the trad boom, I have clearly failed in making it

*'Hole in the Road' and 'Right, said Fred'.

clear that each of the true pop explosions has its origins in the clubs and usually, to start with at any rate, in the clubs of a comparatively small area. During the next year or two 'beat' remained a purely Liverpool phenomenon although, as the now prosperous trad bands were able to refuse the ill-paid long hours demanded by the German clubs in Hamburg and elsewhere, the beat groups moved in there too. There is a famous photograph of the Beatles in Hamburg in 1961. They look aggressive, scruffy and totally uncompromising.

Although it was my wife who turned me on to pop, by 1963 my own interest had begun to overtake hers, and it was in fact me who first registered that a record called 'Love Me Do' was both catchy and enjoyable. By the time 'Please, Please me' had got into the charts we knew a bit about the Beatles because the musical press had begun to make noises but, as far as I was concerned, they were just a new group, if a rather superior one. I certainly never associated them with the interval relief down the Cavern four years before, nor had I realized that they'd become a Liverpool cult.

Even so, when I was asked in the spring of that year to be one of the compères on the B.B.C. Jazz 'n' Pop Festival at the Albert Hall, I was pleased to see they were on the bill. (Incidentally, the title of the concert was, in itself, significant of the way things were going. For the previous two years it had been a straight jazz festival.) By now the Beatle legend was beginning to grow. There were references, usually patronizing, in the ordinary press. It was becoming clear they were something rather special.

I happened to arrive as they were rehearsing or, to be more accurate, fooling about. The producer, Terry Henebery, was *not* pleased. 'A couple of records in the charts,' he muttered to me, 'and they think they can do exactly what they like.' They seemed amiable enough, though, in the communal dressing-room.

There was a photograph of them in the programme, in neat suits and ties and what now looks like rather short hair. It was a very poor photograph in the show-biz tradition. They were all

grinning and Ringo, who had by this time, and in the face of strong Liverpool feeling, replaced Pete Best, is showing some hairy leg between his trousers and Chelsea boot. I got them to sign it for my son.

What I hadn't been prepared for was their reception. It was my chore to announce them, and the moment I went on I was met by a solid wall of screams. In the end I just gestured into the stairwell, mouthed 'The Beatles' and walked off. The screams lasted right through their act. Beatlemania had arrived.

After the concert the fans gathered outside the stage-door yelling for George Harrison. 'We want George!' they shrieked. This was already an indication of something unique about the Beatles; the way that at one time or another all of them in turn have seemed to be singled out for popular favour. Theirs is the only group of which this has been true. In the Rolling Stones, for example, it's Mick Jagger and, less forcibly, Brian Jones,* who count but in the Beatles not only have they *all* their own devotees, but the emphasis has frequently shifted from one to another, and each of them has a separate function.

The replacement of Pete Best by Ringo is usually taken to have been on musical grounds alone, but I wonder. Ringo is not the world's most inventive drummer, but he *is* lovably plain, a bit 'thick' as a public persona, and decidedly ordinary in his tastes. He acts as a bridge, a reassuring proof that the Beatles bear some relation to normal people. The Beatles' intuition had told them that despite the angry crowds milling around outside the Cavern, they needed Ringo.

Throughout the rest of 1963 Beatlemania grew and grew. The papers fed it and it fed the papers. It wasn't, of course, the first post-war outbreak of mass hysteria, but it was on a completely different scale and on several levels. The teenage reaction was perhaps largely sexual, but the music, in itself, was fresh and interesting and very few people could remain indifferent or antagonistic.

What's more, the advent of 'pop art' and its theoretical justifications had broken down a great deal of prejudice. The

* Written before his death in 1969.

Beatles were analysed at every level, and the reactions were usually favourable.

Yet the emphasis was in the main traditional. Their music had become all-pervasive. Their personalities made good copy; in particular Maureen Cleave wrote a very perceptive four-part analysis in the *Evening Standard;* their first two L Ps were to be seen lying about in quite smart drawing-rooms, but it was as scream-stimulators that most people still thought of them.

At about the same time as the Albert Hall concert I was asked by *Town* magazine to revisit Liverpool, my native city, and write a piece about it. Most of the article was about the local painters but naturally I went to the Cavern and asked about the Beatles. This is the relevant paragraph:

Did the groups which had made it still come back? Oh, yes, the Beatles were there next week. They knew it was the kids at the Cavern that had made them. Besides, they were still based on Liverpool. Of course, they hurry away a bit quicker than they used to but you couldn't blame them. Now they were famous some of the girls might try to get their ties off them or something like that.

Was there a lot of squealing when a group like The Beatles was on? Yes, all the way through. It annoys some of the older fans like ... I mean some of the kids that went for them when they were still unknown.

I wrote this in the spring of 1963 but it didn't come out until the following December and by that time it made nonsense. There was no longer any question of the Beatles appearing in a club or, indeed, anywhere in direct contact with their public. They had become a four-headed Orpheus. They would have been torn to pieces by the teenage Furies.

There are some other points to note. The confirmation of my generalized statement about the alienation of the serious fans, for instance. There is also the reference to the other groups. The Beatles, although admittedly pre-eminent, were still thought of as a part of 'the Liverpool Sound'.

Whether the Liverpool sound existed is another matter. It is a fact, though, that following the success of the Beatles, it was to Liverpool that the industry turned in the hope of striking oil

twice; for a time at least the Liverpool groups could do no wrong.

The city itself, then suffering from a severe depression, became temporarily fashionable. As for the Cavern, it was holy ground and held for a year or two the position in hip mythology which was later to be occupied by Carnaby Street.

Liverpool, a fiercely patriotic city, worshipped the Beatles, especially as for a long time they continued to live there. In those days the only thing the Beatles thought about after a job away from their own city was getting back to the 'Pool.

By November 1963 the volume of publicity devoted to the Beatles was becoming a considerable drag, and when the *Observer* asked me to write a long piece about pop music I suggested I play them down. I was overruled though, and went along to talk to them and Epstein during a TV rehearsal. They were friendly but exhausted and one of them, I forget which but I believe it was Paul, told me that they'd become musicians so as to be free from being pushed around, and here they were pushed around all over the place and cooped up like prisoners into the bargain.

I didn't quote this, but I did imply that I didn't think the Liverpool sound had very much longer to run. I based my supposition on the fact that the Beatle fans seemed to be becoming younger and younger, a phenomenon which I remembered as having preceded the decline of Tommy Steele as a pop idol . . . 'Perhaps because of the general trend towards earlier puberty,' I wrote, 'the average age of the fanatic Beatle fan today is about twelve.'

A bit later I felt I'd been over-conservative. In 1964 my step-daughter Candy, at three, fell in love with the Beatles in a way that was painful to witness. Every time she heard 'the Beakles' on record or saw them on television, she would become rigid as though hypnotized. We could hear her having imaginary conversations with them all over the house too. Paul was her particular obsession and sometimes she threatened to 'wee all over him'.

That Christmas we took her to see the Beatles in a stage show

which was running in Hammersmith. Behind us sat two girls. We heard them discussing whether to scream at some of the supporting acts or save it for the Beatles. They decided to save it and then, when the Beatles did come on, they quite calculatedly covered their ears and let rip.

Candy didn't though. She leant forward in her seat and watched them expressionlessly while they were on. Then, as soon as the curtain fell, she burst into tears. She made us buy her a huge photograph of them which was for sale in the street. She made us pin it on the wall at the end of the bed and would sit up smiling like a child in *The Turn of the Screw*, staring at it for hours at a time.

Yet despite Candy, or rather because of her, I was more and more convinced that Beatlemania was entering its final, if most hectic, phase.

There were several signs. For one thing, the hard-core pop fans were beginning to enthuse over Rhythm and Blues and in particular the Rolling Stones, a group who looked as non-compromising as the Beatles in their Hamburg days and gave no indication that they were prepared to shift an inch. Further-more, the Beatles had begun to receive those accolades which, in the pop world, had usually turned out to be the kiss of death: the Royal Command Performance, the flattery of politicians of both parties, the cooing approbation of elderly actresses.

Nor did their triumph in America – 'Ringo for President' read the placards of the teeny-boppers – do anything to make me change my mind. Nor did their triumphant return; the whole of London Airport a-throb with pubescent enthusiasm. What had died was the feeling that the Beatles represented any longer a symbol of teenage revolt. I was certain that once their sexual charisma had burnt itself out, they would join, as the other talented products of pop had joined before them, the ranks of traditional show business.

What I hadn't allowed for was their own determination to do nothing of the sort. I should have taken the hint from an evening I spent in the company of John Lennon on the day his book *In His Own Write* was published. During the course of the

party I suggested that despite his fame and money he was surely prepared to own up that not only did he owe a considerable debt to such Negro blues singers as Muddy Waters, but that objectively they were greater artists. He turned on me with sublime arrogance. He'd admit no such thing. Not only was he richer but better too. More original and better. We almost came to rather drunken blows.

Yet despite Lennon's confidence the early months of 1964 offered no convincing omens that the established pop pattern was about to break down. I'd heard of course that the Beatles were making a film but this was in itself no revolutionary departure. Steele too had made films and they had, if anything, accelerated his propulsion into the mum and kids belt. What I hadn't catered for was Alun Owen's script.

Until *A Hard Day's Night,* films about pop stars showed their early struggles, the big break and the happiness which success alone can bring. Owen's film did nothing of the sort. It showed the Beatles as the prisoners of their situation: on the run from fans, short of sleep and used by everybody. Instead of losing them ground it re-established their position. They were victims not victors. They were as trapped as any working-class boy or girl in a dead-end job. Despite being ousted from their position as the Number One Group in the *Melody Maker* poll by the Rolling Stones, the end of the year saw them back in power.

The première of *A Hard Day's Night* was held in Liverpool. It looked as if nothing had changed that night. The Beatles appeared after the film on the balcony of the Town Hall. They were cheered by 50,000 people, but they didn't wait for the reception. They flew straight back to London.

Their doing so is a key to their long survival. They had, from the off, a formidable talent, perhaps genius; but very early on they recognized that in order to be free to exploit it, they would have to spend a great deal of their time in weaving and dodging. They knew that, in the pop world, the moment of total universal hysteria is the harbinger of complete rejection. Unwilling to accept the retreat into conventional show biz, the traditional get-out, they invented their own escape route. What Brian

Epstein called 'their marvellous instinct' has allowed them to recognize the precise second before the band-wagon they were riding plunged into the abyss. Like the heroes of a weekly cliff-hanger, they knew just when to jump and were thus able to reappear in time for the next thrilling instalment.

In turning their backs on Liverpool with the cheers of 50,000 people ringing in their ears, they demonstrated this principle at its most brutal. By refusing to tour at a time when they could command any fee Epstein chose to ask, they proved that they were prepared to push their belief to the limit.

The 'lovable mop-heads' became the arrogant leaders of the popocracy. They, in their turn, were absent at the funeral of Swinging London, emerging shortly afterwards as grannie-spectacled, hirsute, drag-orientated weirdies just in time for flower power.

And that I suppose to have been the Beatles' strength. By continuously throwing the pack off the scent they have won time to develop. They have been loved, and have deliberately courted rejection. They seemed immune and have succeeded in pro-voking the authorities to harry them. They embraced philan-thropy but abruptly dropped it in favour of ruthless business manoeuvring. They were inseparable, but are now most often apart. Yet none of this would matter except in so far as it has helped them preserve and develop their talent. While themselves admitting to being interested only in what they are up to at any given time, they have succeeded in producing a body of work which has illuminated a whole landscape and enlarged the horizons of a whole generation. The comparisons with Mozart and Schubert seem to me irrelevant; the Beatles' aim is different; 'art' is a concept which, as Beatles, they reject. They remain pop artists, but there is nothing to say that pop may not, in retro-spect, turn out to have been art after all.

*

I don't intend to try and offer a close textual analysis of their musical development. Yet I feel it's obligatory to chart their

progress in general terms, for not only have they extended the potentials of pop music out of all recognition but in doing so they have changed from the 'happy little rockers' of 1963 into the complicated neurotics of today. They have paid a considerable price in pursuit of the holy grail of pop – 'Doing your own thing' – and their only reward, which no doubt they reject, is to have created something which I suspect to be of permanent value.

The Beatles' point of departure was the more sophisticated fringe of post-war urban Negro blues and their earliest LPs contained their version of several songs originally recorded by American coloured artists. It was indeed 'Twist and Shout' which produced the strongest orgasmic effect on their audiences in their charismatic days; but while fresh and charming, their version of these songs in no way rivalled the adult attack and conviction of their idols. The first compositions of Lennon and McCartney were a different matter. Not that they seemed particularly original. It's true they fulfilled one of the essential conditions of a successful pop single: to sound like every pop song and yet somehow lodge in the mind like a burr. Yet, while both in imagery and musical idiom the early songs seemed to break no new ground it soon became clear that they were both superior to and different from the run-of-the-mill pop tunes of their period. If you try and recollect the other numbers in the hit parade at the same time as 'Love Me Do' or 'I Want To Hold Your Hand' there is confirmation of this assumption. What's more the words, while seemingly mere cliché, proved extraordinarily accurate in reflecting the language and attitude of a whole generation of teenagers. These songs were not *about* Liverpool; that area was to be explored later when the Beatles had left – emotion recollected in turmoil; but they trapped what it felt like to be a rebellious suburban Liverpudlian for whom beat music offered an escape. They were tough *and* tender. You could sense behind the words and music, the emergence of a new spirit: post-war, clever, nonconformist, and above all cool.

*

But who were the Dakotas, the Dennisons, the Foremost? They were all Liverpool groups who emerged in the Beatles' wake, shook their heads, played their guitars half-way down their thighs, and provoked the shrieks of the pre-pubescent and adolescent class of '63.

I don't think I'd have remembered who they all were if I hadn't interviewed them all for an unpublished article. They were all appearing on a bill featuring Billy J. Kramer at Dartford in Kent, and I asked them where they stayed on tour.

'We stay in four-star hotels,' the Dakotas told me, 'and the only reason we stay in four-star hotels is because there aren't any five-star hotels.'

The leader of the Dennisons was sadder. When I asked him what he hoped for in life he said 'To be someone', and so for a time he was. So for a time they all were. The Saint Remo Four, the Swinging Blue Jeans, anybody with the right adenoidal accent and louche looks.

Some have hung on. Kramer himself, one of Epstein's second line, remains a name, and Billy Fury who, as his name implies, was much earlier on the scene, is a regular contender as a ballad singer.

As for Cilla Black, another of Epstein's protégées, she has become the Gracie Fields of our day, the Queen of the Common Touch, the Toast of the Golden Mile, and yet she too came out of the Liverpool boom, had been a cloak-room girl at the Cavern. She even wore black leather at one time.

Epstein himself tried to stop the boom from getting out of hand. He signed up only those in whom, usually correctly, he suspected some staying power, and he tried to avoid over-exposure and too much close identification under a Liverpool label.

If he failed it was because others were less scrupulous. As he told me, at the height of 'Pool mania, agents were getting off the train at Lime Street Station and signing up each other; while, at the Cavern, it was difficult for a press photographer to get a shot which didn't include another photographer on the

other side of the room. By 1964 the Liverpool cult was over, its lesser heroes either part of show biz or forgotten. The aficionados had turned towards R and B. Black leather and scouse accents were chucked into the pop attic.

Yet the Beatles had escaped; they'd broken the pattern.

They had neither gone down with the Liverpool ship nor taken to the show-biz life-boat. They'd become part of 'Swinging London', a catch at trendy parties, defending themselves through irony from such hazards as the Royal Command Performance and the courting of politicians. Their nerve and timing kept them out of trouble.

In 1965 they were awarded M.B.E.s, a reward based partially on the amount they'd earned in dollars, partially on the Labour Party's mistaken belief that to flatter the Beatles was to win over a future electorate. Not that Wilson was alone in this misunderstanding; the Tories too made pro-Beatle noises and aroused the justified if ill-directed scorn of Paul Johnson in the *New Statesman* for doing so; yet it was the Socialists who really made asses of themselves. Wilson himself went so far as to travel up to Liverpool to be present at the opening of a rebuilt and tarted-up Cavern, failing to recognize that, not only was the Cavern scene over but that it was *because* it was scruffy, smelly and disreputable that it had loomed large in young Liverpool's legend.

As for the M.B.E.s the only result was to infuriate those to whom the right to put letters after their name and shake hands with the Queen meant something.

The Beatles now claim to have accepted their M.B.E.s only to annoy such people but, even if they believe it themselves, I take it with a pinch of salt. Up until 1966 they were still touring, still a group and, whatever the Beatles themselves may have felt about those bits of ribbon, I'm convinced that Epstein, in many ways a very conventional man, thought of them as an honour and a confirmation.

Musically, too, things developed logically. 'Can't Buy Me Love' marked in my view the end of their early period. Issued as a single in March 1964 it was also part of the score of *A Hard*

Day's Night, that watershed which marked their defection to London.

Inevitably they lost their naïvety. Throughout 1965 I found their single releases less and less interesting while at the same time more contrived, more knowing. Influenced perhaps by the success of their new rivals, the Rolling Stones, they sacrificed audibility in favour of volume and a rather synthetic excitement. For me, 'Paperback Writer' was a poor thing, a falling off.

At the same time, and somewhat confusingly, their LPs were becoming more rather than less convincing. Up until then, the British pop LP had been of little interest, a string of single hits with a few 'standards' added for good measure. The Beatles set about altering that. They not only composed and performed more experimental pieces on their long-playing records but also, whether consciously or not, they gave the impression of working towards the creation of an internal unity or at any rate a musical and emotional balance. They had gradually dropped their early habit of performing other people's songs. *Rubber Soul,* issued at the end of 1965, was entirely Beatle music, mostly Lennon and McCartney with two tracks by Harrison. While 'the happy little rockers' were perhaps losing their grip on their single releases, the Beatles, as mature and conscious artists, were maturing on LP.

This split between what was considered commercial and experimental material was in fact unnecessary. McCartney's over-sweet 'Michelle', for instance, was put out as singles by several other artists and went zooming up the charts. Yet admirable as most of the material on *Rubber Soul* was, it was no break-through. The impression I got from this LP was that Lennon and McCartney were gradually moving into that exclusive class: the aristocracy of popular song, and that they would have to be rated, as both composers and lyricists, alongside Cole Porter or Gershwin. In confirmation of this their music was everywhere. It tempted the quality jazz singers and not, you felt, simply on commercial grounds. And it wasn't only jazz singers; they changed the guard to oompa'd versions of *A*

Hard Day's Night; others arranged Beatle compositions in imitation of Bach. Yet it was also a fact that, despite a limited technique and no particular vocal brilliance, Beatle songs sounded better performed by Beatles.

My personal feeling that they were tending to under-estimate the singles market was confirmed in August 1966 when two tracks from their new and brilliantly original LP, *Revolver*, were issued as a 45 release. Not only did it make Number 1, but one side at least broke right through the conventions of the very best traditions of popular song, let alone pop. It was with a sense of delighted awe that that summer in Wales I heard, for the first time, 'Eleanor Rigby'. It seemed to me that pop had come of age.

*

At the time this song appeared to me as a miracle: an immaculate conception brought forth from the womb of Our Lady of Pop, but this view was naïve, based on a knowledge of pop limited by what you could hear on the Light Programme. The Beatles were at the heart of pop, hungry for change, and of an eclectic temperament. I now suspect it was the influence of Bob Dylan which secured their release from the prison of commercial pop.

This is not to diminish the use to which they put their freedom. Unlike Donovan, whose early songs were pure Dylan pastiche, the Beatles simply followed his example in trusting their own memories and feelings as the source for their music. It was, however, their *own* past they turned to. As James Joyce reconstructed the Dublin he had fled from, so the Beatles rebuilt the Liverpool of their own anonymous childhoods. I can vouch for the imaginative truth of 'Eleanor Rigby': the big soot-black sandstone Catholic churches with the trams rattling past, the redbrick terrace houses with lace curtains and holy-stoned steps, the parchment-faced old spinsters who kept a canary, did a bit of dress-making, or had been 'in service'—all the lonely people.

On the written page, 'Eleanor Rigby' is good minor poetry, but then it's not meant to be read but listened to and, as a song,

I believe it to be great poetry – concentrated, a whole world in 3½ minutes:

> *Eleanor Rigby, waits at the window*
> *Wearing a face that she keeps in a jar by the door . . .*

*

'Yellow Submarine', the other side of the single and one of the tracks from *Revolver,* seemed in contrast over-simple, wilfully banal; yet as time passed I felt that here too they'd pulled off something extraordinary – an instant nursery rhyme, as un-selfconscious as a children's street song, but true to their own experience, to their own childhood. For the Beatles have seldom betrayed their own memory bank. It's not American comic book heroes who climb aboard the Yellow Submarine but Desperate Dan or Lord Snooty and his pals. The departure for 'the Sea of Dreams' is from the Liverpool pierhead.

In the year which followed they released only one single: 'Penny Lane' backed by 'Strawberry Fields Forever', both 'Liverpool' songs. The former was a funny and touching trans-formation of what is, in reality, a dull suburban shopping centre. It's peopled by surrealist personages and full of concealed dirty jokes; the girls working in a fish-and-chip shop in Penny Lane were it seems pestered by requests for 'finger pie' over the next few months; but as a whole the effect of the song is melancholy in the way an absurd dream is melancholy. The fireman, the banker, the barber, the pretty nurse 'selling poppies on a tray', act out their little drama under 'the blue suburban skies'. It struck an extraordinary balance between the absurd and the touching. It was full of affection; a quality of which the Beatles have always given evidence and rare in pop music.

And 'Strawberry Fields' – the name of a large Victorian-Gothic mansion, now a remand home for girls – was an almost abstract song, and more anguished than anything the Beatles had ever done before. I didn't understand it at the time. I thought it was very beautiful, extraordinarily beautiful, but it made me feel like Alice looking through the little door in the

wainscot at the garden beyond. In the event I was right to feel like Alice. There was indeed a little cake on the glass top table, or to be more exact a sugar lump impregnated with LSD.

*

If peripheral to what is going on one is liable to stumble across clues which make no sense until later and so it was with LSD.

Just about the time 'Strawberry Fields' was released my wife and I went to dinner with a friend of ours whose whole life is dedicated to sensation.

The actual dinner party was staid enough although the conversation tended to roam over some pretty recherché sexual territory involving rubber, sado-masochism and baths full of machine oil, but while we were sipping our brandy – 'and there's no need to meet anymore. I can tell him what I want him to do over the telephone' – the door bell rang. In came a Comus-like rout of exotic creatures, the first time I'd laid eyes on the beautiful people as it happens, although I'd known several of them in the days when they'd worn ordinary if fashionable suits and floral ties. There was a girl in the shortest mini I'd ever seen, who lit up a joint and blew the smoke into our mouths. There were other girls hung with as-then esoteric beads and bells, and there were several young men in Kaftans or matador pants and floral shirts or shepherds' smocks, and they all giggled a great deal, or went suddenly totally silent, or touched each other in a curiously non-sexual way, and there was Dylan whining away on the hi-fi.

Wandering into the bedroom I discovered our host in conversation with one of these bizarre figures and I heard him ask him if he'd brought the LSD and I thought what an old-fashioned expression for money.

A week or two later there were long articles about what a dangerous drug it was in a magazine called *London Life,* so I realized that it was *that* sort of LSD but I still didn't connect the Beatles' break through with it, not until *Sergeant Pepper* really, and by that time it was clear that the whole pop world was behaving oddly, deserting their usual imagery, dressing like mad

prophets, and talking about love and vibrations and flying saucers; in fact it seemed to me (and still seems to me), that they'd lost their marbles.

Rhythm and Blues

Before considering the effect of *Sergeant Pepper* on British pop music (and its influence was for a time more or less disastrous), it's necessary to go back to the beginning of the 60s and look at the roots and progress of British Rhythm and Blues in general and the Rolling Stones in particular.

The first point to establish is, that although R and B may have followed and supplanted the Liverpool Sound as a pop explosion, as an underground movement it was more or less a contemporary. It was a geographical rather than a temporal difference which separated them. While the Liverpool Sound was hatching down the Cavern and trying its wings in Hamburg, R and B was establishing its public in Soho, along the Thames Valley, and in certain provincial outposts such as Newcastle-on-Tyne.

Nor, come to that, were the musical sources of the two movements all that different. Both derived from the Negro blues, agreed in rejecting the jazz-inflected woman-blues singers of the 20s as a mark of their detestation of everything that trad had held dear. Both admired the post-war blues, the heavily amplified near-Rock 'n' Rollers like Chuck Berry. Yet there were differences, and these sprang mostly from the fact that the Liverpool groups were entirely separate from trad, whereas London-based R and B had seceded from it, bringing over something of the historical pedantry and delight in schisms which had distinguished the early days of revivalism.

There were in fact three schools of R and B. The Ken Colyer of the movement was Cyril Davis, a harmonica-player and singer, a country-blues purist and a considerable influence. He died young and became something of a legend. Alexis Korner, on the other hand, while extremely knowledgeable about the

whole field of blues history, favoured the post-war blues as a performer. His group, Blues Incorporated, attracted a fiercely partisan public among the generation which turned its back on trad. Ironically Korner was very much under the aegis of Chris Barber in his role as entrepreneur. It was in a club called the Marquee in Wardour Street, Soho, that British R and B established itself at a time when, in the wider field of pop, the Beatles were carrying all before them.

To recap, the groups at the Marquee varied between the back-porch rural blues and the post-war electronic urban blues with a certain amount of overlapping and, eventually, a kind of fusion: mouth-harps *and* amplified guitars. On the other side of the road, however, was a club called the Flamingo, and it was here that the third school of R and B evolved: the 'soul' blues, Ray Charles-orientated, and much more to the taste of London's growing coloured population. Georgie Fame was king here. He used organ and saxes, modern jazz musicians; the Flamingo had been a modern jazz club, just as the Marquee had been a traditional jazz club, and, like children who reject their parents and yet betray their origins in everything they do and say, the Marquee blues and the Flamingo 'soul' reflected this.

Later a marriage was to be arranged, but in the fairly early 60s it was the Marquee which became the goal of the blues purists, the 100 Oxford Street of R and B. Like the revivalists before them the young hopefuls learned their job in the outer suburbs, in pubs mostly, sometimes even the same pubs where we'd started out in the early 50s. Among the other groups so occupied were five young men called the Rolling Stones.

*

'What a drag it is getting old'
MICK JAGGER and KEITH RICHARDS 'Mother's Little Helper'

Like the revivalists before them, the Stones and their peers felt themselves part of a crusade. They were going to preach the blues and they were going to live the blues too.

But what were the blues about or, to be more precise (for in

83

their long history the blues had been many things), what were the blues about that the Stones admired: the post-war urban blues of Muddy Waters, Bo Diddley, Chuck Berry?

They were about hatred really, but there was no overt protest in them. They were about racial aggression expressed in sexual terms. They were ironic too in the way they exploited the white myth of Negro sexual superiority.

Sex had always been an important theme in the blues but in the pre-war blues, whether rural or jazz-orientated, it had been treated within the context of the ghetto. The boasting blues for example were aimed *at* other Negroes and what's more the boasting blues were only one facet. Sex in the old blues had been treated in many ways: humorously, tenderly, erotically, desperately. Bessie Smith, for example, had anatomized sexual love in every aspect. But the post-war blues were different. They were shouted *out* into the white world. Grind, shake, rock, ride all night long!

And the British drop-outs heard this and wanted to join in. Sex was still a weapon, still a way to appal the suburbs from which they sprang. Of course Jagger and the rest of the Stones had the disadvantage of being white, but they could grow their hair, cultivate a funky grubbiness, swear, behave with a consistent lack of couth, and Jagger had his big red lips going for him too. He could get by as a bogyman for the nine-till-five dads with teenage daughters.

Without Jagger, without the Stones, it's possible that Rhythm and Blues might have remained a minority interest, a rather pedantic British homage to a certain aspect of the music; but Jagger was there, shaking away in Richmond. He was the charismatic Moses needed to lead R and B out of the clubs and into the promised land.

The queues grew longer outside the Railway Hotel. It was only a matter of time before the right entrepreneur walked in and recognized his chance. On Sunday, 28 April 1963, following a tip from the Beatles, two gentlemen visited the premises. They were Eric Easton, a traditional pop-cum-show-biz agent and his protégé, prototype of a new breed, Andrew Loog Oldham.

Easton had reservations but, with the success of the Beatles in mind, saw possibilities. Oldham had no reservations. Here were his ready-made homunculi. He looked at Jagger as Sylvester looks at Tweetie Pie.

*

The entrepreneurs of pop are significant in themselves. They seem, almost as much as does the music or its performers, to encapsulate the flavour of each era. Thus in the mid-50s they tended to cynicism, to an almost open contempt for 'the product', towards sharp or dubious practice. Epstein was a totally new phenomenon. He was *for* the Beatles, some frustrated urge for self-expression – he had after all tried to be an actor at one period – found fulfilment *through* them. Yet at the same time he wanted them to be loved and accepted. He pushed them towards this acceptance, offered them success in return for a degree of conformity.

Oldham, the next step in the evolution of the British pop-manager, totally rejected Epstein's paternalism.

His own hatred of conformity seized on the Stones' grubbiness, their language, their assumed oafish and anti-social stance and, far from trying in any way to persuade them to cool it, he encouraged them to behave even worse.

On commercial grounds his instinct was sound. Its fruits are still with us; the Stones have never had to move far in order to retain the respect of the young rebels. They represent basically what they always have: an easy way to enrage parents, a rallying cry for all those who hate the even-landscape they are expected to enter via university or an apprenticeship. Yet nor did Oldham attempt to promote them or encourage them to come on as rebellious intellectuals. There has been none of the didactic aura of the Beatles about the Stones' public persona. Indeed one of the more provoking things about them is that they and he in no way attempted to disguise that they were after money! Anarcho-idealists are acceptable villains. Even if they made money by chance they can be dismissed, but the real gall in the Oldham approach was that he openly and brutally stressed his

commercial ambitions. Money, claimed the bourgeoisie, was won by conformity of dress, respect to elders, an accumulation of confidence-inspiring property, arse-crawling, apple-polishing and, once at the top, ruthlessness. Oldham's thesis stood this approach on its head. The Stones (and he) would make money through outrage. They would flaunt their contempt, their sexuality, their inability to suffer fools gladly without any concession either in public or private. Even when they accepted a traditional show-biz chore: *Sunday Night at the London Palladium,* for example, or (in the Beatles' footsteps) took over the whole *Juke Box Jury* panel, they wouldn't give an inch. It was a tradition at the end of the Palladium show for every act to take their place on a revolving platform and wave at the real and televisual audience. The Stones refused and aroused the ire of the whole schmaltzy trad-minded show-biz establishment. *Everybody* waved at the end. It didn't matter how big you were, you got on that revolving platform and waved. The Stones were unrepentant. They'd done what they'd been paid for – their act, and the whole show-biz establishment could get stuffed. On *Juke Box Jury* they behaved no better. Despite all David Jacobs's efforts to squeeze an opinion out of them they just grunted, yawned, scratched themselves or remained silent. *Juke Box Jury,* in a sense always a pop anachronism, was admitted to be a powerful influence on the market. Everyone who went on it (especially those connected with the pop-music world, and who were in consequence liable to benefit directly) did their best to be witty or at any rate keen, especially as Mr Jacobs was skilled in administering an avuncular rap across the knuckles to anyone who traversed what he felt to be the line of 'good taste'. The Stones defeated him. They behaved like a rather badly trained chimpanzees' tea-party. As a result the switchboard was jammed with angry phone calls, and the papers full of outraged letters, and Oldham was as pleased as Punch. Whatever happened to the Stones – they were fined for pissing against the wall of a garage, they were constantly being thrown out of hotels – was good news to Andrew Loog Oldham because he knew that the more they were hated by people over thirty the

more they would be loved by every resentful teenager who had to be in by ten and was sent up from the table to scrub his nails.

But it wasn't only the kids who went for the Stones. 'Swinging London', still unchristened but all the more potent for that, elected them co-rulers with the Beatles. The Stones were welcome in milieux where the hard-working disapproving fathers would have given their eye-teeth to shake certain socially exalted hands. They were announced as bait by ambitious hostesses, courted by the bored scions of ancient houses. As I hope to show in a later chapter, 'Swinging London' was a caricature of traditional capitalism. Success and money was the key; only the trappings were different. The suburban nine-to-fivers might remain appalled by the pop ethos, but once they'd realized there was real money involved, the rich men were prepared to overlook the longest hair, the grubbiest T-shirts.

Oldham himself was not a total original. In America Phil Spector had shown the way to teenage power via outrage. Oldham copied Spector's use of make-up, his overt neurosis, his unpleasant public manner. Yet Oldham contributed several original elements too. His public-school background gave him that authority which is its only justification. His accent might be classless cockney, his clothes Beardsleyesque fantasy, but he knew how to make head waiters crawl and commissionaires climb down. He taught the Stones the trick. They came on like princes.

Oldham had also absorbed from Spector the importance of recording, of creating 'a sound' in the studio artificially. Under George Martin, the Beatles too were moving towards the use of tricks and artifice in achieving their musical aims, but Oldham, through his own glamour, raised the P.R.O. into a position equal, not only to the pop musicians he was recording, but to the whole swinging route: photographers, rag-trade designers, fashion models, film actors, the lot. He was calculatedly vicious and nasty, but pretty as a stoat. He had enormous talent totally dedicated to whim and money. He was destined later, and inevitably, to play St Peter to Jagger's anti-Christ.

*

The Stones as social catalysts, martyrs and (of late) as paid-up members of the permissive establishment, will reappear in a chapter dealing with pop as a social force. Here and now, though, it's time to try and place them as musicians and this is more difficult. Somehow, even at its best, their music seems secondary to their legend; and yet at its best it's been as seminal as the Beatles.

To start with they were almost grotesquely derivative: blues shouters from the Thames Valley cotton fields; and Jagger's early success was based almost entirely on his sexual charisma.

I write 'Jagger's charisma' rather than 'the Stones' charisma' because without Jagger I don't believe the Stones would have ever meant much. Brian Jones was certainly pretty, Keith Richard sinister, Watts Aztec, Wyman a hole in the air, but Jagger was always the point of the Stones; the others existed only in relation to him like planets round a star.

But charisma however powerful is not enough. If the Stones had continued to rely on no more than Jagger's lips and hips they'd have soon gone the way of all teenage flesh. There came a moment when it was essential that they found their own voice, when they translated the outrage of their appearance and social behaviour into music. They did it too. Jagger and Richard did it. Between 1963–6 they wrote a series of songs which faithfully reflected the teenage revolt against adult mores and, importantly, the *male* teenage revolt for, as I suggested earlier, the female influence on pop is towards reform and eventually conformism. They scream but in the end hope to tame. The Stones recognized this. Their music remained anti-feminine. There was none of McCartney's tender regard for girls. None of Dylan's regretful acknowledgement of his failure to accept the chains which tempted him. 'Look at that stoopid girl,' sang Mick Jagger.

Sex aside, their songs attacked every 'decent' standard, even (or perhaps especially) those of the liberal intellectuals who wanted to understand. There is no doubt that they were helped by the hard-core pop fans' suspicions that the Beatles were pre-

paring to abdicate, to accept the embrace of the grey world. Their American success too was partially based on the Beatles' U.S. breakthrough and the American need for accelerated sensation. Yet their importance was not in any way dependent on what the Beatles had achieved. It lay in their abrasive sour honesty. Their refusal to cover up. Their open acknowledgement that they were determined to live for kicks.

This is of course very much the message of the urban Negro blues, the source from which the Stones drew their original strength and from which, musically at any rate, they never moved far. What they achieved though was to relate this tradition to life in Britain in the first half of the 60s: life as it could be lived by determined teenagers with a certain amount of money and no sentiment. Where they were remarkable is that they never suggested that their determination to live like this led to happiness or fulfilment. 'I can't get no satisfaction' is, after all, a defeatist view of obsessive promiscuity. There is a great deal of hate in the Stones' best records. Jagger was pop's Byronic hero, its Rimbaud, its Maldoror.

Where they differed from the blues singers was above all in the way they were able, through education, to look outside their own world, to attack as well as defend. They might pretend to be morons, oafs, but this, in Jagger's case at any rate, was a mask. To give a concrete example, at the very moment when the press was obsessed with the teenage appetite for pep-pills as an aid to sleepless week-end raving, the Stones, on an LP track called 'Mother's Little Helper', pinpointed with cruel accuracy that millions of housewives were gobbling down those same pills on doctors' prescriptions just to keep going. Right through the Swinging London period the Stones flayed the square world, provoked it, mocked it. They were to reap their bitter reward later, but their noisy, frequently inaudible, basic records remain worth listening to. The Beatles during that period were developing their own talent, adjusting themselves to their new roles. The Stones, on the other hand, spoke for a generation or at least for that part of it which was fighting for its right to live as it chose.

What spoiled the Stones? *Sergeant Pepper,* or at any rate what Sergeant Pepper stood for; but as to how and why, that comes later.

*

The Stones were the heart of R and B, the group which led it out of the clubs and into the public arena, but they were not of course alone. Swimming in their wake were other groups, some good, some almost incredibly bad. There were the Animals, who were among the best and came down from Newcastle; Manfred Mann, a rather earnest South African whose group was called 'Manfred Mann', as twee an idea as ever came out of pop; there were the Yardbirds, the Moody Blues, the Pretty Things, Long John Baldry, Georgie Fame, Zoot Money, and all of them offering one form or another of the country or urban blues. Most of the music was as imitative as trad had been imitative or British Rock 'n' Roll imitative, but the music was not really the point. 'Swinging London' was the point, for it was about this time that Swinging London had become a formal concept.

In pop's earlier years the rewards offered by success were adult rewards: cars, houses, public recognition, girls, a villa abroad, but now pop had succeeded in creating its own shangrila, its own aristocracy. What mattered was to know where to go, what to wear and drink, who to lay. What counted was to be accepted by the right people, welcomed by name, rated by what came to be called the 'in' set.

This set up its own problems because, due to the musical importance of what the Beatles and the Stones were up to, the groups began to worry about pop on an aesthetic basis. In the early days this hadn't entered into it. You played what you wanted when you were still playing for kicks. When you'd made it you compromised, you went for the money.

The situation was further complicated because, due to the ascension of the Beatles and the Stones and their coronation as the Emperors of Swinging London, the pop structure has become almost feudal. The edicts filtered down from above, from the Ad-Lib through *Ready, Steady, Go* and *Rave* to the teeny-

boppers in the outer darkness; and yet, as soon as these edicts were obeyed, this group rated, that artist high in the charts, the popocracy felt obliged to reject, to condemn. How else to prove their leadership, their right to rule? Instinctively this may have always been the way pop worked, but the difference now was that it had become far faster, more conscious, and above all hierarchic.

Some pop artists refused to play this game; they went all out for the teeny-boppers, even their mums and dads, and to hell with the cognoscenti. Others avoided the issue by proving so esoteric that they remained the property of the 'in' set, compensated by their respect for material loss. Mostly though they tried to have it both ways, and mostly they lost out. An anxious double-standard gripped the pop world.

Through 1964 and 65 it became increasingly difficult to decide exactly what pop was. Was it the sound most rated by the 'in' set? Or the records at the top of the charts? Was it the groups most screamed at by the teeny-boppers? In my view it was none of these things or, to be more precise, it was not an aural measure at all, but a temporal one. Pop had become a moment, the moment when a sound, a group or an artist was poised between the appreciation of a coterie and wide acceptance; the equivalent of the moment in the City when it becomes known that a private company is going public.

To define this moment more exactly it was somewhere between the time when the queues were growing longer outside the Marquee or the Flamingo, the first recording beginning to climb the charts and the time when several appearances on *Ready, Steady, Go,* an American tour, and a more commercial follow-up disc or discs had propelled the group or artist into the kiddy-pop belt.

Nevertheless this definition was only applicable to run-of-the mill pop, to its daily sliced-bread. Its aristocracy remained above the question, arbiters rather than participants. There were some, too, whose stance was original enough to preserve themselves outside the ebb and flow of fashion. The Kinks were the most admirable example. They stood aside watching, with

sardonic amusement, the pop world chasing its own tail, and they turned out some of the most quirky intelligent grown-up and totally personal records in the history of British pop. Their trouble (or perhaps their strength would be more accurate) was their non-conformism, their refusal to join the club. They were and are hugely underrated in consequence.

Back at the Ad-Lib (or the Cromwellian, or the Scotch of St James, or Sybilla's, or the Speakeasy or wherever the Pop Caravan had decided to pitch its tents that month), the fashions ebbed and flowed. Straight R and B didn't last long. 'Soul' supplanted it, but the trouble with soul was that whereas it seemed to come naturally to American Negroes, it was very difficult to make it sound convincing if you were white and British. Georgie Fame got close to it for a time but, faced with popularity, withdrew into a rather pretentious jazz-inflected shell and pleased nobody. There were a certain number of coloured Americans around who should have been all right, but there weren't any James Browns among them. Stolid, conscientious and by pop standards rather old, they were respected as soul brothers but failed to excite their audiences into any significant frenzy. 'Soul' in British pop was a non-starter.

To an outsider another confusing thing about 'in' taste was its occasional unpredictability. In general there was a logical progression six months ahead of comparatively informed outside opinion but there were some artists who were accepted despite the fact that their work lay right outside the current fashion.

Take the American import, P. J. Proby, for example. He was admittedly a fine singer, but then he specialized in rock and ballads, both held more or less in contempt. Furthermore he was the last great King of the Damp Crutch, and this at the very time when both the Beatles and Stones were turning against live appearances and working towards a form of hermetic pop. Yet Proby was admired, for his hair in its ribboned bow, his velvet suits, his splitting trousers, his clashes with authority, his bloody-mindedness. It was I suppose his too muchness they went for. He was a supreme exponent of what was to become

92

known later as 'doing your own thing'. Even his downfall had a certain panache.

Dusty Springfield got by too. Among the girls she got nearest to a coloured sound and her neurosis, camp make-up, and out-spokenness helped her to preserve her legend. Most girls in pop went show-biz as soon as they got the chance, and were prepared to come down strong against permissive behaviour as part of the deal. Dusty went show biz all right but in an older tradition. Tantrums, breakdowns, the lot. She was the Judy Garland of the 'in' set.

Sandy Shaw was a more marginal case. She looked mar-vellous, she didn't turn pi, but she did sing increasingly dreadful songs.

Tom Jones though was respected as a kind of latter-day Elvis and he later preserved that respect by coming on like a vulgar caricature of a show-biz success. What's more he appealed not so much to the teeny-boppers as to young housewives, a more loyal, less fickle class and sufficiently far removed from the pop world as to cause it little embarrassment.

The Walker Brothers, especially Scott, sang ballads but *looked* so beautiful, and were furthermore American, a growing advantage.

Finally there was Donovan, at first despised as a plagiarist of Dylan, but slowly recognized as the Fairy Prince of pop. Dreamy, poetic, innocent and, once he'd found his feet, original, he was the forerunner of the Flower Children, the precursor of Love. It is, I suppose, possible that subconsciously the pop world recognized this; after all, it lived on flair and instinct.

Yet all those listed above have one quality in common; they lay outside the pop mainstream, and that was perhaps why they were able to remain *persona grata*. Inside it was becoming in-creasingly difficult. Certainly sincerity was not enough. Man-fred Mann was a very serious musician, but he couldn't stop his popularity escalating. His singer, Paul Jones, was willing to stick his neck out, to commit himself to every liberal cause, the Adam Faith of his day, but the little girls went on screaming. Both were soon rich but out.

Yet it was possible to produce hit records and remain 'in', socially at any rate. Eric Burdon of the Animals did it because he seemed so desperate, so sincere, so drunk, so willing to shoot his mouth off, so excessive. In the pop world of the middle 60s nothing succeeded like excess.

*

The hippy joints were the stage on which the cast of Swinging London assembled nightly. I wrote a piece about them in the autumn of 1965. In it I tried to pin down the ambiance of that heady moment.

The block on expense-account entertaining has crippled the old-style night clubs, and in many cases not before time. The Stygian gloom concealed considerable squalor. The food was disgusting. The hostesses equivocal teases. The floor-shows stereotyped. The bands bored and indifferent. The bills enormous yet haphazard, relative to how rich and drunk the customer appeared to be. The whole atmosphere permeated with cynicism, a confirmation of the belief that it is sinful to want to stay up later than eleven o'clock.

The new-style clubs of the middle 60s are very different. They are not on the whole particularly cheap, but you know in advance what you can expect to pay. They are clean, and their décor, while often in joke bad taste, is intended to be seen. They, and their members, occupy in the gossip columns the gap left by the disintegration of the Chelsea Set, and they have their place in the dossiers of the sniffers-out of Beatlemania.

Indeed the most famous of them, the Ad Lib, has entered the language as an adjective of denigration. It would seem to mean fashionable but trivial, glossy, transitory, graphics masquerading as art. I have heard it applied for example to the films of Dick Lester and the Robertson–Russell–Snowdon *Private View*.

Yet as far as I know nobody has yet had a proper look at the clubs as actual places full of real people. Nobody has tried to see how they came about and what they are for. Like so many current phenomena they have been forced into a role. In the age of the instant they have become instant symbols. What follows is an attempt to be objective.

The new-style clubs, the hippy joints to use current jargon, derive from the invention of the discothèque at the turn of the 60s. As the

name suggests this originated in France, and arose out of the craze
for dancing set in motion by the Twist. The traditional night-club
bands of the period were unable to simulate the volume and attack
of the records (this has since been rectified by the coming of the elec-
tronic groups), and the use of amplified discs or tapes provided a
solution. From the Midi, during the Bardot–Sagan moment, the
discothèques spread all over Europe. French students and the Au Pair
girls carried the virus, and many of the first British discothèques were
aimed at their patronage, but these were unambitious financially, a
musical extension of the coffee-bars. Soon several shrewd and
sophisticated entrepreneurs had realized the larger possibilities. One
of the first and certainly the most successful was Madame Cordet, the
owner of the Saddle Room. There were always a great many fashion
models there, but this was before the emergence of the 'in-crowd',
and the rest of the cast – the photographers, the pop stars, the actors
of working-class origin – didn't figure. Predominantly the members
were those people from s.w.1 and 3 who didn't feel at home at the
Establishment, and a high proportion were middle-aged. They all
twisted enthusiastically enough, but it was a rather distressing sight.
The emphasis on youth, the whole point of the hippy joints, was still
to come. What young men there were, guards officers or in Lloyd's or
possibly in advertising, preserved the smart upper-class image. The
hippy joints, despite a fair proportion of Hoorays, are virtually class-
less. Success in a given field is the criterion and, in the case of girls,
physical beauty. The Saddle Room still exists, and indeed its member-
ship list is temporarily closed, the sure sign of success in the club
world, yet its moment of glory seems irrevocably linked to the voice
of Chubby Checker and the pre-Profumo age. Nobody smart boasts
of being a member any more.

Annabel's

Nobody boasts of being a member of Annabel's either, but this is
because alone among the new clubs it preserves a distinctly upper-
class ambiance. This might seem to disqualify it from the list, but it
reflects the top band of the spectrum of what is considered desirable
in 1965, the world of the Glossies, the quality ads, the private yacht
and the house in the Bahamas, and this gives it more in common with
its humbler stablemates than any earlier attempt to personify the good
life.

The club has its premises in the basement of a William Kent house

in Berkeley Square. There is a long corridor, with smaller rooms off it, which give the impression of a very small country house gone over by a fashionable interior decorator. The main room, however, the night-club proper with its bar, dining alcoves and dance floor, is as dark as a bank vault, its columns sheathed in highly burnished metal, a waiter's face suddenly illuminated in the light of flaming brandy. Annabel's is a club restaurant with rather hip Muzak. Then, as the elderly rich go home to bed, the *jeunesse dorée* arrive, the volume of the records doubles, and the place becomes a night club.

I spoke to its owner Mark Birley in his elegant offices in the mews behind the club. It's been open two and a half years but took a year and a half to build. From the first it was intended as a discothèque ('based on *Le Cinquante-Huit*,' says Mr Birley whose conversation is full of smart 'in' references he mistakenly believes common knowledge). He'd originally thought in terms of very simple food and a military bowling alley. (For guards' officers? No, no, there wasn't any room for a full-length one.) However, the price of gutting and rebuilding the basement had forced him to aim at something more ambitious. He'd been lucky enough to get Louis, 'You know, the Manager of the Mirabelle', and 550 people, 'all chums of mine', put up five guineas each, 'jolly brave of them as the club wasn't even open'. There were 2,500 members now. He thought the success of the club was because it was 'unstuffy, unpompous'. The food was absolutely central, in fact they were enlarging the kitchens, and it was, he agreed 'not cheap', but there was a mixture of ages in the club, 'the older and richer dining. The younger and poorer drinking.' It was a good line of retreat after dinner, and there was no fuss and bother. I asked him if there were any clothes regulations. 'Dark suits, don't you think?' he said. Some evenings were more swinging than others. It probably depended on the number of pretty girls, didn't it? Of course the lighting was very flattering. Yes, the music was very loud once the club became a night club. In fact there was once a power cut. It was very disturbing. The silence.

I asked if the club hadn't a lot in common with the Glossies, and at first he was inclined to disagree. 'They're tremendously phoney, don't you think?'; but later he said there might be something in it. Despite Mr Birley's implied suggestion that the members are simply nice people, a smart club depends on attracting very smart regulars. The night I was there, for example, Paul Getty sat emanating melancholy from a table, and Lucian Freud stood projecting mystery at the bar. Yet *who* is considered smart varies according to the milieu. I had

heard from another incredulous club-owner that the Beatles had once been refused entry at Annabel's 'just because they wasn't members'. I asked Birley if they did in fact come there. 'I think two of them are members,' he said, 'but I'm not sure which two. Is it George and Paul? I've seen them all here eating. The other two as guests I suppose.' I have a suspicion that he was pretending to be more vague than he was. So astute a man must be well aware who is, and who is not, a member of his club. What is true though is that the Beatles are not in any way important to the success of Annabel's, whereas on the next rung down the hippy ladder they and the Stones are, as Mr Birley said of his food, 'Absolutely central'.

The Ad-Lib

The Ad-Lib opened in February 1964 on the Soho penthouse premises of an unsuccessful night club called Wips. Nick Luard of the Establishment and the late Lord Willoughby had founded Wips and aimed it at the jet set. It was very expensive, projected a mild flavour of perversity, fur walls and carnivorous fish, and meant nothing. It was bought by Bob and Alf Barnett who already owned several trad night clubs, and they put in John Kennedy, who had been Tommy Steele's first manager, to run it for them. He too suspected that the time for the discothèque had arrived. He installed amplification, cut down the tables to knee-height, replaced the chairs by stools and banquettes, got rid of the fish. Above all he hung large mirrors everywhere. 'A club needs movement,' is how he puts it, but I feel he realized, whether consciously or not, that the whole hippy world is obsessively narcissistic. They don't dance for each other's benefit but for their own. Kennedy told me he never got over his amazement at the indifference of the men. 'The girls at the Ad-Lib,' he said, 'they're such little dollies, but where do they come from? You don't see them anywhere else. And they dance so sexily, but for all the reaction they get they might as well not be there. Now when I was that age, they'd have driven me mad!' Being extremely bright he has drawn profit out of these observations. The club discourages older members because of their tendency to leer. It bars girls on their own and, although less rigidly, boys too. The physical set-up helps avoid arguments. The only way up to the club is in a small lift which is less conducive to aggression than being able to blunder in out of the street. The club itself has a low ceiling with inset coloured lights. Its great asset is a huge window looking down on London. For the pop stars, fashion

photographers and young actors this must suggest a conquered world. The music is very loud: a constant feud with a nearby Catholic priest is the club's one headache; the clothes reflect Carnaby Street at its most extreme; the dancing is really breathtaking in its expertise. It's not very expensive, you can eat steak or chicken in a basket for about a pound, and drinks, after twenty-five shillings for the first one which includes cover, are about ten shillings a miniature with ice and coke thrown in. The mid-Atlantic bias of the pop world is carried over into its drinking habits. It is, however, extremely difficult to become a member nowadays without some special distinction. Admittedly the eminence involved is unlikely to carry much weight in the Corridors of Power, but this club is the celebration of a certain breakthrough. It is dedicated to the triumph of style. It may be chic, non-committed and a-moral, but it's also cool, tolerant and physically beautiful. It's essentially to do with being young, and those who attack it are in many cases motivated by envy at the sight of young people, many of them of working-class origin, with the means and poise to enjoy themselves. These critics remind me of women who oppose painless childbirth because *they* suffered. There's a lot of snobbery involved, and the idea that this club and what it represents is somehow undermining serious art is to turn the whole thing upside down. It's not the young who are to blame, but those older people, whether artists or not, who ape them.

The Ad-Lib was lucky in that it opened just after the beat groups had begun to make it, and provided an atmosphere in which they felt at ease. John Lennon was the first Beatle to go there. Then Ringo came and, to quote Kennedy, 'made it his home'. Within seven weeks the club had it made.

The Scotch of St James's

It was only to be expected that with the success of the Ad-Lib, other club-owners should attempt to cash in. Some enjoyed a temporary success, others vanished without trace, but the Scotch of St James's is currently a serious challenger and seems to have staying power. It is owned by a Mr Brown and a Mr Bloom, and has as its host an enthusiastic overstrung young man called Rod Harrod who is also a pop journalist. The club is on ground and basement levels in a large yard off St James's. On the ground floor is a bar and restaurant, below a dance floor surrounded by tables. It uses records and live groups, and there are 'impromptu performances by famous clientèle'. The

décor is Scottish Baronial. This is neither as eccentric nor as uncommon as you might think. The original French discothèques shared the general Gallic belief in the chic of Scottish tartan, and the Saddle Room, for example, faithfully stuck it all over the walls. Mr Brown, who is also 'an expert interior decorator', has carried it even further. There are sporrans, swords and antlers in abundance, and a coach on one side of the bandstand. 'It's beautifully designed,' he says, 'very effeminate.' Rod Harrod elaborated. When the club opened, he told me, there was a very smart tartan with a white stripe in it facing the staircase. What did I think the effect of that was? I said I didn't know. 'Well,' he said, 'you felt *you* had to look smart. You straightened your tie. You didn't relax. So what did Mr Brown do. He put a battered old moose-head facing the staircase. You came down. You smiled. You were in the right mood.' Mr Brown is also convinced that his club's situation has made a lot of difference. 'Hidden away in the smartest area,' he said, 'so the groups can come here incognito. Nobody bothers them.' Rod Harrod is very insistent on this point. He just says 'Good evening' to the groups, and leaves them alone. It was reported in the newspapers recently that he threw somebody out for asking for George Harrison's autograph. 'I don't deny it,' he said, 'and I'd do it again.' He told me that a party of millionaires came down recently and wanted to sit at the table reserved for the Stones. Mick and Chrissie Shrimpton were there by themselves. There was plenty of room, but he wouldn't let the millionaires join them, and they went away offended. He'd turned away perhaps £50 worth of business, but he knew he was right. 'Yes,' added Mr Brown, 'this is more than a club to the pop world, it's a home.' He would keep his customers. They were young and swinging. So was he. They'd grow older, maturer, so would he. I noticed that the table reserved for the top groups was on a little platform slightly above the level of the rest of the floor. It was also corralled off. The top groups were not to be bothered perhaps, but very sensibly their presence was not allowed to pass unnoticed. No amount of tartan makes a place successful. Like great fish the top groups glide from club to club, and those whose pleasure is to follow in their wake swim with them. The entertainment, drinks and food not so different, yet somehow they must be persuaded to stay. The Scotch of St James's has struck a clever balance between privacy and adulation on their behalf. It's a trick every fashionable restaurant head-waiter has practised for decades.

Mr Brown acknowledges Rod Harrod's importance to his success. The club started with a completely different policy. It was intended to

be something like Annie's Room or the Cool Elephant, aimed at the older set, with a jazz policy. It meant practically nothing. Then Harrod, who had been attached to a club called the Cromwellian, quarrelled with them and offered his services to Brown. As a musical journalist he had some influence on the groups. He brought the Animals with him. 'They were loyal to me,' he told me. 'They came here every night. They spread the word around, and suddenly it was all happening. The Beatles don't pay of course, and neither do the Stones, but everybody else does except the Animals. Other groups at their level, Manfred Mann, all of them, they all pay, but not the Animals. They were loyal.'

As I was leaving, Harrod was on the phone. He replaced the receiver and turned to me in a state of great excitement. 'That,' he said breathlessly, 'was Kensington Palace. Princess Margaret and Lord Snowdon will be arriving in five minutes!' I wonder if they shared a table with Mick Jagger and Chrissie Shrimpton.

The Cromwellian

I don't know the details of Roy Harrod's quarrel with the Cromwellian, but there is no doubt that it is 'out'. I went there six months ago and it was full of well-known faces. On my recent two visits I recognized nobody. Bart Kimber, the general manager, says he is delighted. 'It's back to sanity and smartness' is the way he puts it. He hated the place full of paint-stained jeans and last century T-shirts. 'We get three distinct crowds,' he told me, 'downstairs the younger set. We offer them name-groups, and records introduced by disc-jockeys from the pirate radio stations. In the ground floor bar, there's a higher age-group, drinkers you see. While upstairs there's gambling. Would you care to look around?'

The club is in a large house in the Cromwell Road. It too is decorated in the baronial style except here there are suits of armour and old master reproductions in heavy gold frames. The basement has murals of nymphs seducing puritans, and is very noisy. The atmosphere of the whole complex is relaxed and pleasant. 'Nobody rushes' is how Mr Kimber puts it. The prices seem very reasonable. 'Here,' he says, 'the artists are not being fleeced, but they're just too high for the kids.' Quite a lot of pop performers still come; Georgie Fame, the Zombies, the New Faces, Jonathan King were all there on one night he told me, and Dusty likes it. What about the top groups, I asked. 'We have them here occasionally,' he said, 'and we're pleased

100

to see them, but we're not desperate.' The club was full and spending so I am inclined to believe him. I asked him who his clientèle was. 'A lot of continental people, film extras, hairdressers, P.R.O.S, advertising people, no boxers. They cause bother, but quite a few wrestlers.' In fact the club is owned by five wrestlers so of course it's natural that they have never had any trouble. 'Look,' said Mr Kimber, 'of course we're successful. Parking's easy out here, and you can get stoned out of your eyeballs for £2. We don't want to be in.'

I've suggested that, among the 'in' set at any rate, it was becoming more and more difficult to be taken seriously as a British pop artist, a fact which, given the success of the British groups in America after the Beatles, may seem strange. My explanation is based on the 'in' set's need to stay ahead, an increasingly difficult task now that the gap between initial discovery and nation-wide if rather transitory fame was becoming almost instantaneous. In consequence they tended to rely more and more on rather esoteric American LPs and their possession became the outward and visible sign of pop sophistication. With the exception of Beatle and Stone records, by early 1966 it was considered hopelessly square to listen to British pop records. The sounds were later Dylan, the Beachboys, the Mamas and the Poppas, and above all what one French critic has brilliantly described as 'cocktail soul', the pretty, empty, mechanically sexy coloured girl singers put out under the Tamla Motown label. Yet because the pop world made records it was only a question of time before these too influenced the local product, and, in certain cases, even the originals seeped through the layers of pop appreciation to make the charts.

Still at least there was a time lag and, given that the teeny-boppers needed the physical presence of those they took to their hearts, the Atlantic helped to preserve the Americans as cult heroes. It was possible to dig* the same sounds for several months on occasion without feeling hopelessly compromised. A further help was that in those days the difference in price

*Throughout this book I've tried to use the appropriate slang of the period under discussion. 'Dig', for example, is now totally archaic.

between the 45 r.p.m. single and the LP (especially the imported LP) successfully held the shrieking hordes at bay.

All this illustrates the dilemma of the pop world in those trendy swinging days. Their problem was how to stay in the news without their lead over those who sought to emulate them. This has always been a problem for those who can't believe they exist without reading about themselves every day in the papers, but the difference was that, unlike 'the fashionable intelligentsia', 'the bright young people', 'the Chelsea Set' etc., the pop musicians were without inherited wealth and had to earn the money to live the 'in' life. That meant producing records which would sell (or at any rate succeed in filling concert-halls) and this so easily meant falling into the teeny-bopper trap. The Beatles and the Stones had shown it could be done, but it needed a great deal of talent to pull it off and not only talent, careful handling too.

Unable to resist the bonanza, group after group went out into the commercial limbo, artist after artist joined Cliff and the Bachelors in the well-cushioned darkness. Pop had begun to have two meanings: What the kids liked (the kind of music which was to become known as kiddipop), and *real* pop although here in many cases, given time, real pop turned into kiddipop too.

A further and final element of confusion was the result of certain groups or artists setting out quite deliberately to isolate what they felt to be the reason for certain 'in' trends reaching the charts and reproducing such trends out of context. The Troggs, for example, a West Country group, took Jagger's tormented sensuality and cleaned it up. They cleaned up too with records like 'Wild Thing', a kind of fish-finger version of 'Satisfaction' which might have been marketed under the slogan 'You get nothing but the sex'. It may seem odd to suggest that a group who calculatedly set out to sell sex to little girls can be accused of 'cleaning up' their source material, but Jagger's songs sprang from his whole being. What was disturbing about them was his honesty; he didn't mind seeming a sod. The Troggs' version was admittedly aimed to provide a musical

aphrodisiac, sex as grunt and friction, but it left its post-orgasmic audience with no hang-ups. Jagger related sex to life.

The protest bit produced an even more absurd expurgated edition. Dylan, its prototype, even in his most overt early songs, suggested a complicated universe where cause and effect, greed and exploitation, revolution and reaction are part of our fibre, not just nasty bogymen who can be exorcised with a guitar and a lyric. At most, he hoped to make us think, perhaps to act.

Commercial protest was a grotesque travesty of Dylan's cry for sanity and self-scrutiny. The most extreme example was a song called 'Eve of Destruction', the lyric of which acted as a hold-all for every protest flashpoint from the Bomb to the Negro ghettoes. It was growled out by one Barry Mcguire, ex-member of the New Christie Brothers Minstrels, and seemed to me a totally disgusting piece of opportunist cynicism.

From then on every underground movement came to be covered commercially in this way. It was no longer just a case of someone 'going commercial'. Others were standing by to do it for them. You had to dig pretty deep to stay underground.

It was about that moment that the *Observer* asked me if I was prepared to write an occasional column on pop and I said yes.

As a result the phone began ringing. P.R.O.s and managers mostly, yet, despite the hyperboles, it was through them that I found myself in touch with a surprising amount of young talent.

There may have been an explanation for this – perhaps only those entrepreneurs interested in avant-garde pop felt it worthwhile to bother with a posh paper – but whatever the reason the next eighteen months led to meetings with Donovan, Mark Bolan and, most significantly in relation to what was happening at that period, the Who and the Move, both at the beginning of their careers.

It was typical of what was changing in pop that, apart from their drummer, all the Who were ex-grammar school and that their leading spirit, Peter Townshend, had been an art student and a singularly communicative one at that:

We deliberately put ourselves on a knife-edge [he told me], . . . we concentrate on 'the concepts of dynamics' and the use of crescendo. We aim to be as far away as possible. Remote. Even so you can't go *too* far and make a valid record. It's a question of doing it inch by inch. We're very loud, we use massive amplifiers, beyond all reason. You've got to be drastic and violent to reach the audience now. They've been getting too much *given* to them.

It was all a long way from the clumsy, ventriloquial mumbling of the early British Rock 'n' Roll idols.

Lambert and Stamp, the Who's managers, had been pushing them as playing 'Real pop-art music' and I asked Townshend if this wasn't a simple gimmick.

. . . a bit of a gimmick, but we felt it was necessary to bring colour to their image, to stop us looking too sinister, too drab and over-intense. Actually though there was something in it, because pop art borrowed from real pop and we're taking it back again. Our music was cybernetic. It had the autodestructive bit . . .

There it was then. By the middle 60s pop had become very conscious of its aims, and was attracting those who would almost certainly have been drawn towards jazz, probably modern jazz. I found Townshend compelling and touching in both his cynicism and self-awareness, but couldn't help wondering if pop music which, with all its faults, had started as a spontaneous and committed movement, could survive such candour.

*

Pop had always been loud but now, following the Who's lead, it became as Townshend said 'beyond all reason', a total assault on the nervous system. Yet despite inventive lyrics ('My Generation' is a key record in the development of British pop), the Who were not great musical innovators. They were in fact in some ways reactionary, and looked back to the origins of rock for most of their inspiration. But, for all that, they were extremely important in their *conscious* exploration of the potentials of pop as an art form. They succeeded, temporarily at any

rate, in making the Beatles sound precious and the Stones old hat.

*

The Move were different. They had none of the Who's intellectual coherence. They were Brum golem; the willing creatures of the youngest member of that bizarre club, the creative pop managers.

From the cynical manipulators of the middle-50s, through the gentlemanly establishment-minded Epstein, the ferociously anti-social Oldham, the McLuhanite team, Lambert and Stamp, we reach Secunda, a hustling motor-mechanic of pop, tuning-up a group for the grand-pop-prix.

Secunda can stand as the most perfect specimen of all those ex-public-school layabouts who'd been sitting on their arses up and down the King's Road for almost a decade wondering what to do with the only talent most of them had – an instinct for style.

Some had become criminals, some hustled on the fringes of the art world, some went into advertising, some married heiresses. For those who'd hung on, pop was the answer; a simple world without precedents or an established hierarchy, prepared to accept any fantasy as a potential and profitable reality.

'Imagewise,' said Secunda of the Move, as they sat in a long rather sullen row on my sofa, 'I didn't think 1966, I thought 1967, and the 30s are going to be the next big thing.' (He was right there.)

I suggested that their name, the Move, was more related to the 1966 fad for short abstract names like the Who or the Action.

'The best of every period,' said Mr Secunda blandly.

Secunda restyled the Move over and over again in the years that followed. He was outrageous, openly devious, and nothing gave him greater pleasure than explaining exactly what strokes he was pulling to take in – me for instance. I found this endearing which is no doubt exactly why he did it.

Flower Power and After

All you need is love, love . . .
Love is all you need
THE BEATLES

Flower Power was the next manifestation. The act it designated
– the handing of posies to policemen and other unfriendly
spectators – formed only a single moment in the history of a
long movement: the International Underground.

It became public property that particular season because it
fulfilled several necessary conditions.

Firstly, both phrase and action neatly if inadequately en-
capsulated a complicated, many-layered phenomenon, and this
is always essential if the popular press and other media are to
become enthusiastic.

Next, there was the fact that the Beatles had become Under-
ground converts, and the Beatles are and were news in
themselves. Finally there was the fact that Flower Power was
understood to combine 'Love' (always a suspect word along
the murkier gutters of Fleet Street), long hair and drugs. It had,
as they say, everything.

Yet this in no way explains what Flower Power contributed to
British pop music and the answer to this is, in my view,
remarkably little.

The music became folkier, softer, prettier and, for the first
time since the middle 50s, totally untouched by the influence of
the Negro blues and their derivatives. This might, at first sight,
appear to be an advantage. After all the British pop world was
in the main white and it's theoretically obvious that it would be
more convincing if it were to draw on white musical sources,
but it became apparent that its previous empathy with coloured
attitudes had given it what guts and backbone it had. In that
summer of 1967 it turned into a prettily-tinted jelly-fish.

It may seem a contradiction but another side-effect of Flower
Power on British pop was to destroy its local character. Its
Negro-orientated stage was, for the most part, so unconvincing

as Negro music that something original had managed to come through. I'd been puzzling why this should have been so when I came on a passage in a collection of jazz articles by the American Negro writer, LeRoi Jones.

Does anybody really think it's weird that all these English 'pop' groups are making large doses of loot? It's pretty simple actually. They take the style (energy construct, general form, etc.) of black blues, country or city, and combine it with the visual image of white American non-conformity, i.e., the beatnik, and score very heavily. Plus the fact that these English boys are literally 'hippier' than their white counterparts in the U.S., hippier because as it is readily seen, they have actually made a contemporary form . . .

This was written in 1966 and it was true. It was to become true again, but during the reign of Flower Power it was not true. For that summer San Francisco became the capital of British pop, and British pop became in consequence provincial.

Furthermore the instant assimilation process took place even more promptly than usual; a circumstance made all the easier by the transatlantic time-lag. An American song, 'San Francisco', a hit for a sub-folk singer called Scott McKenzie, was immediately followed up by a number called 'Let's All Go To San Francisco' sung by an instant Flower Power British group called the Flower Pot Men (Oh the coyness of that 'pot' especially taken in conjunction with the fact that the B.B.C. put out a popular toddlers' puppet-show featuring 'Bill' and 'Ben' 'the Flower Pot Men'. Tee, Hee!).

All this ran true to form; the castration-through-trivialization-syndrome in action. Flower Power, for all its failings, aimed at something revolutionary and sympathetic: the establishment of an anti-materialist, anti-political set of values. There is no doubt either that its practitioners were prepared to put themselves at risk both physically and mentally in pursuit of 'perception' through the use of hallucinatory drugs. Yet, superficially at any rate, within a month or two all had become meaningless. Songs like 'San Francisco' and its derivatives bore as little relation to the dangerous ecstasy of Haight-Ashbury as

that commercial blues of the 30s, 'Farewell To Storyville', bore
to the violent squalor of the pre-1917 New Orleans Red Light
District it purported to celebrate. The only difference was that
Storyville had been closed twenty years before they wrote its
requiem, whereas Haight Ashbury, albeit in the throes of
Carnaby Street commercialization, was still extant.

As an indication of how fast this happened, I was in Wales
that summer and went to the village fête. There was a fancy-
dress competition, and the six-to-eight 'funniest pair' section
was won by two children from Birmingham dressed in wigs,
beads, and flowing robes. The local non-conformist minister
announced the result through the crackling microphone, a
strong wind blowing his words around the stall-lined field.

'First prize,' he said, reading out what the children repre-
sented from the cards hung round their necks, 'Two Hippies:
"Gone To Pot" and "Keep Your LSD In The Bank"!' and this
within four months of the first rustlings of Flower Power on the
British pop scene.

<center>*</center>

Flower Power as such was crippled from the off, a national joke,
but the serious end of pop had learnt cunning. They left the
flowers to kiddipop, and concentrated on other, more provoca-
tive underground facets – on love especially. I think it's im-
portant to stress here that 'love' in the sense it was used by the
pop-orientated underground is, together with its accompanying
impedimenta: the brilliant clothes, long hair and 'gentle' faces,
an extremely aggressive weapon. I read of a man who, if he
wished to keep a railway compartment to himself, would
beckon anyone he saw with a crook'd finger and a loving smile
knowing that the effect would be to make them hurry past. So it
was with 'love', with pop-hippiness in general. It was used
perhaps unconsciously, to alienate and to provoke.

Within the pop-world itself, however, it was still necessary to
preserve the hieratic structure and the way the élite managed to
maintain its position now was by establishing and publicizing
whether or not it had gone through 'the LSD experience'.

The kiddipop fringe was free to use the trappings: the light-shows, the strobes, the nudging references to drugs, the record-covers crawling with day-glo elves and attenuated pre-Raphaelite girls, but the real crunch was 'yes' or 'no'.

It may seem strange that, given this to be the case, everyone didn't take acid. It was not at that time illegal, after all; anyone could get hold of it, swallow it and publicize the fact afterwards, but comparatively few did. Why? In America an enormous number of people took it, but here it was different. Perhaps it was because it was said to change you totally, and it could be seen to do so. A tough hard-drinking 'loner' like Eric Burdon of the Animals had taken it to reappear dressed like a Bible illustration, smiling with beatitude-like enthusiasm and preaching love, love, love.

The Beatles, too, Lennon especially, the hard-man, sprouted hair and grannie-specs and beamed and beamed. Acid changed you, and there is a conservative streak in the British, even among the rebellious young, which made them hesitate.

Pot of course was different. Pot had been around for years. The British modern jazz men had smoked it in imitation of their doomed heroes from the middle-40s on. The pop world, too, had smoked it from the off, and there had been the odd prose-cution followed by an occasional savage sentence; but once the liberal establishment became alarmed, once the middle-aged middle classes took it up, fines became the norm, and all the authorities asked was discretion.

Pills? Everybody took pills, including cabinet ministers – but acid was something else. It sorted out the men from the boys. The bored young aristo-layabouts took it, the popocracy took it, but the run-of-the-mill pop world, however hung with bells and beads, however ambitious to suggest they'd been through it – left it alone.

So what distinguished plastic flower power from the hard-core pop-hippies was 'the experience'. The only trouble was that, even within the inner circle, the effect, the aesthetic effect of acid, was so uneven.

Burdon, for instance, a bearable shouter within the blues

idiom, was only able to produce what seemed to me pseudo-mystic rubbish, patently sincere but as empty as the mumbling of a drunk who thinks he's stumbled upon the secret of the universe.

The Stones too went soft. The point of the Stones was the way they continuously gathered up their strength to spit in the face of society. 'Love' for them seemed like a form of abdication. *Their Satanic Majesties Request* . . ., for all its pretty 3D cover, is a mess.

Donovan, on the other hand, came into his own. I don't know if he ever took acid. Later, following a pot charge, he became publicly anti-drugs ('uncool' said *IT*), but it was during this period that he produced some of his most mysterious and poetic records. Helped undeniably by Mickie Most's promiscuous expertise in the recording studios, his universe glowed like the first morning of the world. Objects appeared and disappeared. Metamorphosis became a commonplace.

His influence, on the other hand, was a disaster. A nursery surrealism spread like a rash through pop music, and in its route came a raggle-taggle of limp mystic theories: Arthurian legends tied in with flying saucers, Christopher Robin turned-on Winnie the Pooh, even Black Magic was encouraged to run through its nasty little repertoire.

It was all very 'nineties', very Beardsley – Yellow Book only, as somebody pointed out, in this precocious century we even had our decadence thirty years earlier.

The point about acid, about any drug used as a key to creativity, is that while it makes its communicants feel they have the world in a jug, what they're able to 'bring back home' depends on what sort of mind they have in the first place, and this applied in America too.

*

So did nothing come out of that public summer or the secret year which preceded it? Very little, and yet what did has stood up very well.

As a one-shot wonder I rate the Procul Harum's 'Whiter Shade of Pale' highly. A very beautiful record with all the

dangerous and seductive charm of Baudelaire's 'Artificial Paradises' – in pop music only Dylan's 'Mr Tambourine Man' offers the same dreamy intensity, the same hallucinatory evocation of the drugged state and its justification in the face of all reason.

As a mythological creature Arthur Brown had something of the same magic. I didn't rate him much musically – his hit 'God of Fire' was melodramatic kitsch – but as a performer he alone, among the psychedelic barkers, managed to suggest something of the splendours and miseries involved in taking acid. Once it was over, though, his powers faded. He was left with his tatty theatrical props like a discredited medium. In a recent *Melody Maker* there was an interview with one of his group who had just left him. 'He just went on doing the same thing,' said the musician. 'It got to be a drag.' So it did, but for a short time Arthur Brown suspended disbelief.

A long-term gain from this largely negative period was the way it stung the authorities to overplay their hand. They came out against the whole pop culture, a move dictated in the first place by the spread of pot-smoking, but showing itself finally as a hatred of the non-conformist young as such.

The searching of teenagers without warrants on the grounds that they looked as if they *might* carry pot, the deliberate hounding-down of the Stones and the Beatles, succeeded in hardening pop in its determination to preserve its own identity. What's more, this creation of martyrs was carried through in so ham-handed a way that it became obvious that the authorities had allowed their aggressive feelings to override their alleged purpose: the discouragement of soft drugs. This in its turn alarmed the liberal establishment. Even *The Times* weighed in on behalf of Mick Jagger, pot-smoking became almost respectable, and comparatively mild fines the customary punishment for the detection of its use.

Yet finally the justification for the whole, largely absurd bead-hung period lies in one artifact, the L P *Sergeant Pepper's Lonely Hearts Club Band,* the Beatles' near flawless *chef-d'oeuvre.* For me this is the conclusive proof that pop can be

111

both art *and* pop, immediate *and* timeless. I don't know if such a balance can ever be struck again. It was perhaps pop music's classic moment.

Pepper

. . . to turn you on
'A Day In The Life'

What were the '4000 holes in Blackburn, Lancashire'?
The police probes in the search for victims in the Moors murder case.
Who 'blew his mind out in a car'?
Tara Browne, killed in a car-accident in Chelsea. He didn't actually blow his brains out though.

etc., etc.

Sergeant Pepper is on one level ideal thesis and examination material. It's full of esoteric references, irony, red herrings, deliberate mystification, musical influences, the lot. I've no intention here of writing such a thesis. All I hope to do is to suggest some aspects of this multi-layered and prodigious work.

The Beatles, in their later work anyway, are not automatists. They work at what they're doing, very much conscious artists. This applies particularly to *Sergeant Pepper*. As Hunter Davies makes clear in his patently factual and anti-critical book,* it was sweat all the way with either no improvisation, or at any rate very little.

In this the Beatles (and for 'Beatles' in this context read for the most part Lennon/McCartney) relate more to traditional art than to jazz and its derivatives. Their opting out of touring was in itself an affirmation of their determination to prove their self-sufficiency as artists. To paraphrase Cézanne, they hoped to make pop 'solid like the art in museums'.

Yet they are also masters of a peculiarly modern technique – the collage. There were already indications of this on earlier LPs and singles, 'Yellow Submarine' for example, but in

*The Beatles.

112

Sergeant Pepper they carried it that much further. It's a patch-work quilt of extra-musical effects: barking dogs, cock-crows, a hunt in full cry, canned applause, and of musical influences: Indian music, military bands, George Formby backings, multi-tracking, electronic crescendo. Like all true collagists, the Beatles were not intimidated by the old taunt that they 'can't do it themselves'. They realize this to be irrelevant, and have always done so. They relied, as usual, on George Martin to carry out their musical ideas, and on the engineers to mix and balance their less conventional wheezes. What mattered to them was the end-product – the complete L P.

But *Sergeant Pepper* is more than either the work they put into it or the ingenuity of its effects. Determinedly matter-of-fact as the Beatles may be in their approach to creativity, they possess the ability to pin down a moment in dazzling con-temporary imagery.

They've always been able to do this (their early songs have already begun to work in that vivid Proustian way which, in pop music, is what divides the transitory from the evergreen), but *Sergeant Pepper* was made at a particularly crucial moment in their lives.

They'd broken with pop in the public sense. They'd been through L S D. They'd been forced to try and cope with a flood of impressions which would have drowned most people. They were prisoners of a fame which carried with it neither power nor responsibility in the conventional sense. They were in fact at a juncture where, to quote Hunter Davies in one of the few committed statements in his thick book, 'Materially and emotionally they were a hundred years old, but intellectually they were still in many ways adolescents'. It was from here they produced *Sergeant Pepper*. Like Auden's writer they ran 'howling to their art'. The result provides not only a self-portrait but a microcosm of a period which could produce and sustain a phenomenon like the Beatles.

At the time a great deal of critical energy went into speculat-ing on just how much of *Sergeant Pepper* was directly concerned with drugs. Did 'Lucy in the Sky with Diamonds' refer to L S D

or was it, as Lennon maintained, simply the title of a picture his little son had brought home from school? This was largely a waste of time, but I suppose inevitable. The Beatles themselves had openly come out in favour of LSD and are furthermore born teases, enjoying above all things placing banana-skins in the right places to bring about the discomfiture of the more solemn critics. Hermetic references apart, there are plenty of open references to drugs in *Sergeant Pepper* and whatever the origin of Lucy's title (and there is no proof by the way that both explanations may not be equally 'true'), the imagery of that song is decidedly psychedelic and rather tiresome with it. Like a lot of simulated 'trips', it's a bit cloying and one of the least successful tracks on the whole LP in my view.

But 'Lucy' apart there are plenty of other references to 'turning on' and 'getting high' while the cover, by pop artists Peter Blake and Jan Howarth, includes among its 'rendezvous of friends' a substantial number of those who relied on chemical crutches in pursuit of their vision: Aldous Huxley, Poe, Burroughs, Lennie Bruce, etc.

It's scarcely odd after all that *Sergeant Pepper* should have a lot to do with drugs. The Beatles had tried LSD, and the thing about acid is that it convinces most people who have taken it that they *are* changed by the experience. Yet what's interesting about the LP as a whole is that, with the exception of 'Lucy', they should have presented drug culture in so desperate a light. The B.B.C. banned 'A Day In The Life' on the grounds that it might encourage drug-taking. It seemed to me a most eloquent argument against that very course. It shows the mind at the end of its tether – there is none of the weary ecstasy of 'Mr Tambourine Man' – just pain and disgust. It's a terrifying track.

Listening again to *Sergeant Pepper* now that its electrifying novelty has worn off, what strikes me as so interesting is that it is finally a celebration of the past with its certainties and simplicities.

Sergeant Pepper himself began to play 'twenty years ago today'. 'When I'm 64' is in the style of the interwar music-halls.

Mr Kite and his bizarre fairground friends are taken literally from an old circus bill (cf. Hunter Davies). Even the girl who is leaving home, a very successful ballad in the tradition of 'Eleanor Rigby', leaves from a two-up, two-down terrace house.

Alone in pop, with the possible exception of the Kinks, the Beatles are at their happiest when celebrating the past. They display little enthusiasm for the way we live now.

Meditation – Revolution (1967-9)

That autumn Flower Power predictably withered and died. The press, having turned it into a bore, decided it was a bore and dropped it. The Beatles had already turned their backs on drugs and were trying meditation under the giggling Maharishi. Harrison had pushed them in this direction and, as was usually the case when he was at the helm of the yellow submarine, there was something rather pretentious and absurd about it. I never cared for all that sitar much either.

Well that passed off, as they say in Liverpool, and for a time it looked as though nobody had any idea what to do next. Then a tremor ran through pop. They seemed to decide it had been whimsical and pretty for too long. The blues were back. There was even a short burst of Rock 'n' Roll, and everything became tougher again – tougher and better.

For a start the Stones shook themselves. Jagger had even gone to Bangor on the Maharishi's train but that predictably hadn't taken. 'Jumping Jack Flash', their next single, was a reaffirmation of what the Stones were about, while their LP *Beggars' Banquet,* although still a shade too pretentiously diabolic for my taste, was at least tough and hard-driving.

The Beatles too wrote some excellent songs for their rather poor TV film *The Magical Mystery Tour,* and a very good single, 'Lady Madonna'. Pop was back on keel.

Yet the Flower-Power summer had ·helped establish two definite and permanent changes in the structure of the pop world.

On the one hand it had severed the links between pop in the kiddy-mum-and-dad-Eurovision-song-contest-sense and hard pop. On the other, it had made it clear that hard pop was anti-establishment. There was no danger after that summer of pop becoming officially acceptable. It was tolerated but only just, its heroes were harassed at regular intervals and that, from the teenage viewpoint, was enough to endorse its continuity

The closing-down of the pirate-radio ships, the foundation in compensation of the direly emasculated Radio 1 in their place strengthened its resolution not to compromise. Whatever explanation the government might give for this move, from the pop fans' viewpoint it looked like discrimination and that's what counted.

Furthermore, although the flowers had died, they had thrust down permanent roots. The Underground was no longer the property of a tiny minority. It had thousands of adherents and sympathizers, its own slang, its own meeting-places, its own heroes and, more relevant here, its own groups.

On the extreme avant-garde fringe were groups like the Pink Floyd and the Soft Machine – too experimental for the vague affiliation of Underground-minded teenagers, and tending to appear in the main at prestigious if ill-rewarded venues like the Institute of Contemporary Arts, or as respectfully received supporting acts at the larger underground happenings.

At the centre though were what might be described as the Rabble-Rousers of Quality: in particular the Cream and Jimmi Hendrix. They were eclectic, drawing equally on the folk/rock period of Dylan and the dirty old blues although amplified up to eardrum-bursting proportions.

The Cream (or 'Cream' as they were to become known to the enormous cognoscenti) were very good and serious and disbanded when they felt they'd nothing more to say.

Hendrix was much more of an old-style rocker. He sold sex outrageously and made Jagger look like Shirley Temple in comparison.

He was by origin an American Negro, but not one of your old-style show-biz American Negroes, not even one of your

Rock 'n' Roll-type American Negroes. He was Underground, hip, 'beautiful'; his blackness helped him to look just that much more provocative and extraordinary. He wore his hair *à la* Harpo Marx, a style which became for a time almost obligatory in the Underground and eventually made the glossy fashion-mags. He showed a lot of very flat stomach. He simulated orgasm, reviving the orgiastic screaming, only by now the screaming had become much more knowledgeable. He admitted to using his act to pull birds. Musically, however, within his idiom, he played marvellously, with enormous guts and conviction.

But I could never see the point of the other great underground rave of the period – Brian Auger and the Trinity with Julie Driscoll ('Jools' to the vast army of the initiated). She looked fey and sexy in the proscribed outer-space manner and swore a great deal if the dots in the interviews she gave were anything to go by, but she sang in such a cool little voice that I suspected it was to hide a total lack of any feeling at all. Her 'image' was chic, it would be stupid to deny that, but what else had she to offer? I'm inclined to think of her as the Underground's answer to Lulu, except that Lulu, 'Boom-bang-a-bang' apart, can sing with rather more fire.

There were other tendencies sheltering under the Underground's umbrella. The folk-poetic strain held its own, headed by the Incredible String Band. Pop music and pop poetry, a long engagement, was finally consummated, first by the beat poet Pete Brown, an old-time advocate of jazz and poetry who now moved popwards and assembled his 'battered ornaments', later by the painter-poet Adrian Henri whose group, the Liverpool Scene, is currently a solid success.

That 'Liverpool' is no longer a dirty word has been proved by the continued acceptance of the Scaffold, a Merseyside satirico-pop group including another Liverpool 8 poet, Roger McGough, which swings between catchy little top twenty singles and verbal and visual sniping at the establishment.

Yet despite the Scaffold, the Underground's principal humorous platoon is without doubt the Bonzo Dog Band

117

(originally the Bonzo Dog Doo Dah Band), an organization founded in the cod-20s tradition of the Temperance Seven, but moving recently towards a more contemporary form of piss-take.*

Nevertheless, these are deviations. Mainstream underground music is for the most part the tough prolonged blues-inflected style with its roots in the British blues revival on the one hand and American acid/rock on the other. It's been comparatively static now for the last eighteen months – only the heroes change. Here, as always, the old dilemma remains; to succeed you need a powerful individual image (gimmick is the less friendly word for it), and inevitably, with the passing of time, that image seems dated, ossified, out. In consequence the heroes come and go. Currently (August 1969) they include Jethro Tull, the Family and this month's big deal, King Crimson; but in six months?

As a general forecast it looks as though pop is determined to move towards aesthetic (if not social) respectability.

Recently the feelers have gone out between the more experimental fringe of pop and the 'new thing' jazz groups. For the first time, since Rock 'n' Roll, the horns are back, saxes mostly but playing not in the honking clichés of the Haley era, playing in fact what amounts to jazz. Words, too, in the past the major concern of pop, are losing their importance. LP tracks grow longer and longer.

'The Old Guard', on the other hand – the Stones, Beatles, even the Who – would seem to have settled for a conscious archaism. One of the Beatles' last LPs, the austerely named *The Beatles* (packaged with all the austerity of Berg or Bartok), presented a witty and affectionate potted history of pop, or at any rate those aspects of pop which influenced them. Their recent single, 'The Ballad of John and Yoko', for all its bizarre verbal content is early Beatles in treatment. The Stones' new single, 'Honky Tonk Woman', was also a reversion to their origins. It's noisy, frantic and nostalgic. Back to the Cavern! Back to the Railway Hotel, Richmond!

This is not, it's true, a wholly British phenomenon. In

* And now disbanded.

118

America Dylan has turned his back on his disturbing introvert middle period. His last two LPs have both courted a new simplicity only lightly tinged with irony. *Nashville Skyline,* his latest album, is almost simple-minded in its determination to avoid self-doubt.

The Who, a generation younger than either Stones or Beatles, present a rather different case. They recently produced a double-album opera; that, of course, is in line with pop's new-found belief in its cultural role. It's called *Tommy* and, though highly praised, I must admit to finding it pretentious in content and not worth a single chorus of 'M Generation' in emotional or sociological insight. Yet musically *Tommy* is a straight throwback to rock. It's as though the heroes of pop's golden age had turned back towards the old certainties. It's as though they were beginning to feel that pop – as pop – had begun to lose its way.

*

I return briefly to the spring and summer of 1968, the time of the great 'demos', of the 'battle of Grosvenor Square' and the art school revolts.

This was surely the moment when you might have expected pop to provide the anthems, the marches, the songs for the barricades. In fact it did nothing of the sort. The only direct reference to the student revolution came from the Beatles and they poured cold water. Pop, anti-authoritarian when its own interests are threatened, played no part in the events of those months.

In America this was not the case and it's comparatively easy to see why. The Vietnam war directly affects the pop audience. They may have to go. As a result the acid/rock groups were active at the great marches. There is a definite political, or to be more exact anti-political, flavour to the American Underground. In particular the Mothers of Invention, led by the lavatory-squatting, highly intelligent Frank Zappa, has successfully used the pop idiom to probe America's sickness. Here, though, only the right to smoke pot has stung the pop world into protest,

only the sentences against the Stones got them out into the streets.

I think this is partially related to the comparatively permissive attitude of the authorities. There is no systematic persecution or automatic brutality. It's spasmodic, arbitrary. All in all (and the situation could well deteriorate) there is a considerable degree of personal freedom in Britain: an assertion to which the number of American expatriates on the London Underground scene bears testimony. Pop acts out revolt rather than provokes it. It's almost a substitute for revolution in the social sense and is anyway geared, even these days, to the capitalist system. Its only revolutionary value is in its insistence on personal freedom. This is certainly important, but the right to smoke pot or strip naked in public are not going to affect the structure of society. This is not to deny the pop world a political bias. It is almost totally anarchist because, alone among the schools of political thought, anarchism defends total freedom. But pop anarchism is of a limited order in that while perfectly prepared to call the police 'pigs' (or whatever the fashionable epithet may be), it is nevertheless totally unprepared to lift a finger to change the power structure which controls those police.

There are politically activist pop fans and even pop artists, but they are few in number and in effect political activists who like or play pop; the two terms are by no means interchangeable.

Asked what he thought about the battle of Grosvenor Square Mick Jagger said that 'the violence gave me a buzz', which was not in the end what it was for. The Beatles got it right as usual. Their song 'Revolution' was attacked as reactionary but as they pointed out:

> And there you go carrying pictures of Chairman Mao
> It won't help you to make it with anyone anyhow

which was basically what most people in the pop world feel but were unwilling to admit to feeling.

At all events the political upheaval of 1968 proved that pop music, in the revolutionary sense, was a non-starter, a fake

revolt with no programme much beyond the legalization of pot; yet in its insistence on its right to live by its own standards it has shown considerable tenacity, and a refusal to be pushed. It is after all a young people's music and has managed to preserve its identity in the face of every pressure, and good on it.

*

And that takes us more or less up to date, and whatever happens between now and publication I'm not going to do any radical rewriting to this section. This may be a difficult temptation to resist. One of the odd things about pop music, about pop culture in general, is that any radical development seems to alter the emphasis of everything that went before it. Perhaps I'll add a final note at the end of the book but very likely that too will be out of date.

To sum up my present conclusions about pop music, I must admit to finding the music less fascinating than I did a year or two back. This is not because it's worse – in many respects it's much better – but because it's all so much more conscious. British pop music is teetering on the edge of becoming art.

In this it's following in the footsteps of jazz; that too began as a popular, rather disreputable music, advanced to a point where it was able to give birth to and support its great creative geniuses, and then gradually moved away from its origins, its mass (if defined) audience, to become a minority interest. Pop seems to be *en route* to the same destination.

At first glance this argument may appear nonsense. The audience for pop today is enormous. The free open-air concerts this summer were attended by thousands of young people. The sale of 'serious' pop LPs has risen higher than the sale of kiddi-pop singles. Here, though, it's essential to stress that not only were most of the crowd at Hyde Park or Parliament Hill Fields younger than they would have been a year ago (that's after all a traditional pop pattern), they're also drawn from an increasingly restricted social background.

Despite his carefully grubby and poverty-stricken appearance, his classless cockney slur, and painfully restricted vocabulary,

the average young pop fan today is drawn in the main from a middle-class or suburban background and is educationally usually in one of the higher streams.

Although he would deny it indignantly now, I suspect he'll move on to become the university graduate of the 70s, the liberal professional *paterfamilias* of the 80s. Pop is, for the moment, the music of his symbolic revolt; it's noisy, aggressive, and provides the occasions for mass tribal rallies. It also includes enough cultural references, enough affinities with poetry and the visual arts, to flatter his appetite for cultural respectability, and yet is still attacked sufficiently to allow him to feel engaged in battle on its behalf.

But the danger signs are there: regular pop columns in the serious press for a start and the rest, arts council grants and all, will follow soon enough.

I'm not knocking this as such; for one thing I believe it inevitable, and for another there's no reason to weep sentimental tears when a popular form develops into something more esoteric and possibly more profound. All I am saying is that it looks as though pop music in its original sense, will cease to exist. They'll probably go on calling it 'pop' though. They did with jazz.

An interesting side-effect of the intellectualizing of pop and its middle-class take-over is the resentment it has provoked among the working-class young. At the open-air concerts gangs of C-stream fifteen-year-old drop-outs stalked aggressively around the fringe of the enormous hairy crowds. They were surgically clean, wore their hair cropped, brown boots, and jeans at half-mast with braces. They were looking for 'bother' and seemed to sense that pop, once a music cutting across class barriers, was now the property of an intelligentsia (however embryonic), a potential 'them'.

While understanding their feelings, I couldn't but resent their mindless violence. Irritating, deliberately irritating as the young pop fans may be, they're also gentle and, despite the fashionable look of vacant exhaustion, enthusiastic.

British pop music has lasted now for about twelve years and

is, I suspect, reaching the end of its cycle. The structure is changing. Despite a few token appearances on an enormous scale, the big groups spend most of their time in the States, where, after all, the money is. (Anti-social content is never allowed to stand in the way there when there's a dollar to be made.)

The clubs here can only afford groups who haven't yet made it or will never make it. We act as a potting-shed for America.

Pop in this country evolved from its primitive beginnings (1956–7), through its classic period (1963–6) towards its noisy and brilliant decadence (1969–?). Both live and on record it provided a series of insights which a more self-conscious form could never have achieved. It lit up the contemporary landscape as if by a series of magnesium flares. It's shown the possibility of the evolution of a new kind of culture, neither 'popular' nor mandarin. Yet despite attracting an enormous amount of talent, it's produced very few artists of genius in the traditional sense, far less than jazz music for example.

Even in America where the whole pop category is less precise (is Aretha Franklin a pop singer, for example? Is Negro 'Soul' pop?) I'd rate only Dylan for certain and take a raincheck on Frank Zappa. Here too I'd be equally ungenerous. The Kinks (Ray Davis) and the Who (Peter Townshend) I think of as borderline cases. I'd pass Jagger, not so much as an artist but as a total pop personality. (Like Wilde he's put his talent into his work, his genius into his life.) But in my book the only totally convincing geniuses in British pop music to date have been the Beatles. Scarcely a shatteringly original view, I admit, but I'm sure it's true. Their work alone occupied 'that gap between art and life' which is the most convincing definition of pop culture, while at the same time fixing its moment for the future. There will no doubt be many pop 'revivals' on period camp grounds, but I don't think the Beatles will need that excuse. They have transcended their time, or at any rate I believe so.

There is a school of thought (Nik Cohn is a subscriber to it*) which, although admitting the Beatles' brilliance, believe them

* *Pop From The Beginning.*

to have helped destroy pop music through their intelligence. This may be true, although it would apply equally to Dylan, but I don't think it matters. Nostalgically we may regret the simple cocksure days of Rock (the Beatles would seem to regret them as much as anyone), but there has never been a way of preventing an art form from developing. The compensation for the loss of innocence, of simplicity, of unselfconscious energy, is the classic moment. In pop this has belonged to the Beatles. It's there on record. You can play it any time.

August 1969

Section Two
Visual Pop

**'But I want to go to the pictures.
Look at the pictures on the wall'**
from 'Sister Anna', anon.

Imagery

In writing about non-moving visual pop – that is pictures, prints, posters, sculpture, record sleeves, book-covers, the decoration of objects connected with pop culture and fashion – there is at this point in time some difficulty in deciding what is and what is not pop.

Up until a year or two ago it was comparatively easy. Pop in the static visual sense had three separate meanings. Firstly intellectual pop: that is, works of art created quite consciously in homage to pop culture. Secondly sophisticated artifacts created to sell the produce they either advertised or decorated to the pop public. Thirdly visual decoration or visual selection which either the pop public or a section of it decided to be relevant to its life-style. To give three concrete examples: (1) can be represented by Richard Hamilton's collage *Just What Is It That Makes Today's Homes So Different, So Appealing,* (2) by a juke box of the early 60s, and (3) by a rocker's brass-studded leather jacket.

The confusion has arisen because the more sophisticated fringe of the pop world itself has latched on to pop culture as a dual-concept and aim, aided and abetted by pop intellectuals, to live pop while at the same time observing it. And as a further extension of this tendency, the commercial end of pop have themselves recognized the easy charm and availability of much intellectual pop and are tending more and more to use it as a source of mass-produced pop imagery.

To give concrete examples again, in the first instance I can cite the record sleeve designed by Mr and Mrs Peter Blake for

Sergeant Pepper or the Mick Jagger poster designed by Richard Hamilton, and in the second a recent, widely distributed poster for soup which conscientiously copies Andy Warhol's Campbell Soup tins.

This last demonstrates very precisely the ambivalence of visual pop in the late 60s. In the first place Warhol, around 1962, took a deliberately banal commercial object, a soup tin, and, ironically but successfully, elevated it into an art object. Seven years later an advertising agency persuades a soup manufacturer to accept an imitation Warhol as a genuine poster.

Another example, also involving Warhol, is to be found on a recent cut-price LP of George Formby reissues.* This framed a central photograph of Mr Formby with twenty cigarette-card sized identical close-ups of his face reduced to basic tones and then overpainted in two arbitrary colours apiece (yellow face – orange background, green face – blue background, for example), in direct imitation of Warhol's multiple images of Marilyn Monroe.

But there is another ironic dimension in cases of this sort. It springs from the fact that 'high' pop is only interested in depicting the objects which obsess it at one remove; that is in imitation of the way they have already been formalized in 'low' pop.

Warhol for instance painted, not realistic soup tins, but soup tins as they were represented in the more banal advertisements of his time. Yet even while he was painting these pictures, the language of advertising itself was changing. Under the influence of the young photographers working for the glossy magazines, commercial posters had begun to exploit soft focus photography and later to absorb the more superficial aspects of psychedelia or whatever else was lying about. Finally, inevitably, given the new eclecticism, they cottoned on to Warhol and his imitators. A 'pop' soup tin was back on the hoardings, but in a new ironic context.

'High' pop (by which I mean pop which exists for its own sake rather than to sell something else), began by imitating low

* *The Inimitable George Formby* (Music for Pleasure).

pop and later, as we've seen, low pop returned the compliment. Yet they have not become interchangeable. Initially it's true that, even for those on the side of the avant-garde, pop painting appeared as mechanical and as insensitive as its models. But a real artist, however determined he may be to hide any signs of personal intervention, however hooked on the idea of anti-art, tends to give himself away in the end. In the seventeen years since the formation of the Independent Group it's become evident that what at first appeared to be a closely-knit group was in fact a loose alliance of individual talents, and the same is true of the two later generations of pop painters. Paolozzi and Hamilton, Blake, Tilson and Kitaj. Hockney and Caulfield may have shared certain preoccupations in common but it is where they differed which interests us now.

This kind of obligatory reassessment is not unique to pop art. It has applied to all modern movements. André Breton quotes a letter from Paul Valéry which demonstrates the same process in operation. After visiting a cubist exhibition Valéry wrote plaintively, 'How is one to distinguish Cubist A from Cubist B or Cubist C?'

The answer, as applicable to pop as it had been to cubism, surrealism, abstract expressionism or any other moment of group activity, is 'Give it time'.

For pop art too time has already done its work. No one in any way informed is likely to equate Hamilton's cool if affectionate intelligence with Blake's warm academic sentimentality, or to confuse the thinking behind Kitaj's hermetic anarchism with Hockney's celebration of American West Coast bathing-pool culture. It's clear now that Caulfield use of 30s kitsch as a quarry for the building materials of a new formalism has little in common with Allan Jones's nagging obsessions with 40s leg and shoe fetishism. Yet in the early days of pop it was quite easy if you weren't at the centre to confuse 'Pop artist A with Pop artist B or C'. I can remember thinking of the proto-type pop painting as something close to the hard mechanistic imagery of Peter Phillips: a hand-painted collage of pin tables, pin-ups, car engines, highlights on plastic curves and art-deco

129

stencils. This for me *was* pop whereas now it's exactly this tendency which I feel has dated most.

It's not my intention anyway to analyse British pop painting here except insofar as it has affected the main body of pop culture and, in the early stages at any rate, that influence was non-existent.

The early British Rock 'n' Rollers were certainly unaware of an equivalent 'egg-head' culture based on Dover Street, but although the I.C.A.'s theologians were conscious of the emergence of Tommy Steele and Company they were far too busy genuflecting in front of American culture to pay them any attention.

Throughout the late 50s both high and low pop faced the American altar. Their temple was the supermarket, their old testament the Golden Age of Hollywood, their saviour Elvis Presley, their sacraments the hamburger and the coke. They prayed side by side, each in their own fashion.

Yet even the triumph of the Beatles made little difference to the established High Pop Church. For one thing by this time most of its hierarchy had turned from specifically contemporary subjects towards what had always lain behind their thinking anyway: an obsession with the meaning of the language of painting. Visiting dignitaries like Jim Dine or Claes Oldenburg might celebrate a pop mass for London but the older generation of British pop painters made no move. Only Peter Blake turned heretic, and he had always been a little suspect theologically – something of an outsider.

It's true that back in the 50s Richard Hamilton had painted a single picture with a British theme: an angry protest against Gaitskell's defence of a British nuclear policy; but typically it was an American pulp magazine, *Famous Monsters of Filmland,* which provided the basis for this satirical metamorphosis. Besides, for a long time this remained a single departure from the main body of his work: a moral rather than a formal state-ment. It was not until the arrest of Jagger and the art dealer Robert Frazer on drug charges in 1967 that Hamilton felt the need of treating a specifically local subject again, and here too it

was moral and personal indignation which provided the impetus.

British pop painting was already set in its ways long before the emergence of an equivalent general pop culture. Its exponents were not prepared to abdicate in order to serve in the pop ranks, and rightly so. On the other hand their influence was important because, as pop developed, it began to draw on a new and comparatively informed generation, and the recruiting centres were in the main exactly those institutions where the effect of high pop was most seminal – the art schools.

*

Recently they've clamped down on entry into the art schools. They've made it obligatory to have a set number of 'O'-levels except in the case of what they call 'exceptional talent'. In the 50s and early 60s no such conditions existed. The art schools were the refuge of the bright but unacademic, the talented, the non-conformist, the lazy, the inventive and the indecisive: all those who didn't know what they wanted but knew it wasn't a nine-till-five job.

The art schools were the first to appreciate and employ the various pop movements: revivalist jazz, beat, R and B, Underground rock. Not only that, they were also the womb of a great deal of pop talent: Lyttleton and Fawkes in revivalist jazz days, Lennon, Townshend and Ray Davis in pop proper. They provided an atmosphere committed for the most part to no immediate practical end. They were the incubators of total pop. They extended its range into extra-musical fields. Without them, I suspect, the history of British pop in the 60s would have been very different.

For a time pop culture, as it gradually came to be understood in the art schools of the early and middle 60s, suggested no specific graphic style of its own. Pop art itself had become a style all right but only one of several available to those who hoped to 'make it' as artists in the traditional sense. Furthermore, with the importance given to 'originality' by the increasingly show-biz minded gallery world, pop art as such

131

began to look old hat within a remarkably short time and a rapid turnover of other styles – op, hard-edge, neo-dada, minimal and so on – replaced it for a season or so each. Not that this wasn't in itself a very pop manifestation; the same was happening in pop music, and a further parallel between the two forms was the way that in each case the originators of a stylistic move were able, despite fluctuating reputations, to develop and prosper without feeling obliged to discard their own invention. It was their imitators and the art students themselves who felt obliged to leap desperately from one stylistic band-waggon to the next.

Yet what I suppose I must call traditional pop art was not thrown away *in toto*. It was recognized as a useful vocabulary for certain marginal art forms: book and magazine illustration, film and theatre décor, typography and, as I've already explained, the posters and advertisements from which a great deal of it derived in the first place.

Even waxworks went pop. Madame Tussauds, that most traditional of London's entertainments, offered a pop art treatment of certain contemporary figures under the modish title of 'Heroes Live', and at this moment its poster on the underground stations still shows a Lichtenstein-like treatment of the waxwork version of a famous nineteenth-century picture, *When did you last see your Father?*: an idea even more ironic than Lichtenstein's own dead-pan pictures of pictures in that it incorporates yet another link in the chain.

The expression 'pop art' or 'pop' implying 'derived from pop art' became increasingly slapped on to all kinds of things. There were pop colours, for example, usually clear primaries or what would have been thought of as unfortunate or vulgar juxtapositions. Pop fashions also, the meaning here signifying anything either shiny or transparent and inevitably made from synthetic materials without any attempt to conceal the fact.

The word 'pop' was interchangeable with the word 'camp' in relation to an irreverent revival of certain humble or popular objects from the past: brightly coloured enamel mugs, Victorian

chamber pots and so on. With the rise of Carnaby Street and a shortage of originals, these were manufactured again at first in direct imitation, but later subtly caricatured in order to exaggerate the nostalgic and self-confident simplicity of the genuine articles.

It was this period which saw the resurrection of the Union Jack as a potent symbol. This may have partially owed something to Jasper Johns's reliance on the American flag as subject matter, but it was in a totally different spirit from that artist's plastic researches. From shopping bags and china mugs it soon graduated to bikinis and knickers. Americans, for whom the flag in their century of Imperialism has a great deal more significance, were amazed by our casual acceptance of our flag as a giggle. They might burn their flag in protest but they'd never wear it to cover their genitalia.

Yet the first real indication of the direction from which a true pop style would evolve was in the fashion for old posters to be used as décor. This was not in itself a new idea of course. In the late 30s the 'art' posters of the London Underground had been popular as works of art. In the 50s, with the growth of foreign holidays, the bull-fighting posters frequently illuminated by lamps made from empty chianti bottles had hung in increasingly less trendy homes as an outward sign of non-insularity. Some posters, especially those of late nineteenth-century France, had achieved the status of works of art on grounds of rarity as well as aesthetic merit. The difference now though was that it was posters 'in bad taste' which were sought after, and soon after they were joined by blow-ups of film folk heroes, huge photostats of Laurel and Hardy, Theda Bara or Shirley Temple. It was in the area of the poster that the future lay.

To return to the art schools, the dilemma in the creation of a true pop style, a graphic equivalent to pop music, lay in the uniqueness of the art object. Whereas a record was sold cheaply in great quantities, a work of art, even a lithograph or etching, was expensive. It was partially for this reason no doubt that so many pop-minded students dropped out into pop music or preferred to move into a mass-produced area like fashion or design.

There were perhaps other less ethical reasons too: the cult of instant success or bust, the belief that if you didn't make it straight from art school to a fashionable gallery you might as well give up certainly influenced a lot of promising students; but on the credit side it was understood that in honesty the creation of objects for the pleasure of the informed few was the direct antithesis of the pop belief in art for everybody. Posters were the obvious solution, and yet it was not until late 1966 that this began to surface and the reason yet again was presumably due to the spread of hallucinatory drugs and the resulting increase of visual sensibility throughout the pop world and its followers: a group which in the main had up until then ignored the pleasures of the eye in favour of the ear.

All accounts of hallucinatory drugs speak of the significant increase in visual perception and, in many cases, of the interchangeability of colours and sounds. It's true that the number of people who actually took LSD was small, but they were at the centre of pop and, even leaving aside the astonishing increase of visual imagery in the lyrics of that period, they spoke quite openly of the new importance of shapes and colours in their lives and of the need to extend pop to include all the senses. To this end light shows and happenings became an almost inevitable accompaniment to the music, and it was in this favourable climate that the Underground poster artists set up shop.

In December 1967, in an *Observer Colour Supplement* devoted to the Underground, I tried to anatomize this development. This is what I wrote.

Sometime in the early summer of 1966 I went along to the Victoria and Albert Museum to look at the Beardsley exhibition and was rather surprised to find it packed with people. I was puzzled, not only by the size of the public, but because I found them impossible to place. Many were clearly art students, some were beats, others could have been pop musicians; most of them were very young, but almost all of them gave the impression of belonging to a secret society which had not yet declared its aims or intentions. I believe now, although I was not to realize it for several months, that I had stumbled for the first time into the presence of the emerging Underground.

That this confrontation should have taken place at an art exhibition is, again in retrospect, significant. The Underground is the first of the pop explosions to have evolved a specifically *graphic* means of expression, and Beardsley, while not as it turned out the most important element, was one of the earliest formative influences in this openly eclectic process.

I use the word 'graphic' advisedly. Every British pop movement, from Rock 'n' Roll on, produced its own visual style, Until the Underground, this had affected only the clothes, hair styles, facial expressions, or the choice of this scooter or that transistor. Naturally this visual selection reflected an attitude while, at the same time, declaring allegiance to the movement it externalized, but the Underground consciously set out to evolve a graphic imagery which would provide a parallel to its musical, literary and philosophical aspects.

Inside the pop world, even as early as 1965, there were several pointers to the way things were moving which I – by both age and inclination a friendly outsider – had taken in only to misinterpret. Yet, however unperceptive, my misunderstanding was at least explicable. Ever since the early days of Presley, the intellectual 'pop' movement, which was largely graphic in its means of expression, had paid frequent pictorial homage to the heroes of pop music, and it was for this reason that, when pop-record sleeves in particular had begun to show signs of visual sophistication, I imagined that this was merely because the record companies had decided to put the enthusiasm of pop painters and designers to commercial use.

Nor was I entirely mistaken. The coming together of the two edges of the pop spectrum was initially a slow process, but what I hadn't realized was that it was a case of mutual attraction and not simply an unacknowledged intellectual offering laid at the shrine of pop music.

The sleeve of *Sergeant Pepper,* the Beatles' recent LP, could stand as the fruit of this cross-pollination. It has become not so much a sleeve as an art object with its card of cut-outs and double-spread photograph of the Beatles in nineteenth-century military uniforms (John Lennon wears a daisy in his epaulette). What is more, the front of the sleeve is almost a microcosm of the Underground world.

This collage–photograph was 'staged' by the pop artists Peter Blake and his wife Jan Howarth, and acts as a sign that the liaison between the two wings of pop is complete. Yet Blake remains an established painter who has become accepted by the objects of his admiration. He is not a product of the Underground but an ally. The real graphic

135

artists are completely of it, and dedicated entirely to the concept of total involvement. Their medium is the poster.

'Hapshash and the Coloured Coat' is the curious trade name of two young men called Nigel Waymouth and Michael English. They are musicians in the avant-garde pop idiom, but also, and it is this aspect which is relevant here, poster designers. They are cool, polite and very beautiful to look at with Harpo hair styles, unironed marbled shirts, tight trousers, loose belts and two-tone Cuban boots. I talked to them in their house in Notting Hill and within a few sentences felt, as is usual when in conversation with the Underground, that I had tumbled into a world where time operates at a different speed.

English, who has been at Ealing Art School, met Waymouth when the latter was painting the shop-front of the Chelsea boutique, Grannie Takes a Trip, in December 1966, and by March 1967 they had decided to join forces and design posters. But what were these posters for? Superficially the answer was to advertise the activities of UFO, which stands, among other things, for 'Unlimited Freak Out', and which was the first spontaneous and successful attempt to produce a total environment involving music, light and people.

What interested 'Hapshash' was *using* this environment as a launching pad. Unlike conventional poster designers they weren't concerned with imposing their image on a product out of the environment. It must be emphasized here that the aim of UFO was mind expansion and hallucination at the service of the destruction of the non-hip and the substitution of 'love', in the special, rather nebulous meaning that the word holds for the Underground.

Waymouth and English set out to discover a visual equivalent, but their method of doing so showed them to be very much the children of the technological society. Their street posters revived the use of Day-glo, an invention which had had a short burst of commercial life in the mid-1950s, and which they hoped would 'blow the public's mind'. But, inside the club, a chance revelation of the effect of the all-pervasive ultra-violet light on certain colours interested them in how they might exploit this accident. Yet why display posters *inside* the place they are intended to advertise?

The answer is that the Underground poster is not so much a means of broadcasting information as a way of advertising a trip to an artificial paradise. The very lettering used (a rubbery synthesis of early Disney and Mabel Lucie Attwell carried to the edge of illegibility) reinforces this argument, and suggests that, even in the streets, the aim of the Underground artists is to turn on the world.

However, this a-commercial approach to the poster should not be taken to indicate a belief in improvisation and shoddiness in the technical sense. On the contrary, the Hapshash posters are of a standard which makes most contemporary commercial advertising look both uninventive and sloppy. Yet when it comes to imagery there is no attempt to conceal a magpie approach to any artist past or present who seems to strike the right psychedelic note. As a result the Hapshash posters are almost a collage of other men's hard-won visions: Mucha, Ernst, Magritte, Bosch, William Blake, comic books, engravings of Red Indians, Disney, Dulac, ancient illustrations of treatises on alchemy; everything is boiled down to make a visionary and hallucinatory bouillabaisse.

Nor are more contemporary sources despised. Pop and comic books have played their part, and the modern commercial designer Alan Aldridge,* himself a brilliant pasticheur of the 30s, is heavily drawn on. (It may be of interest here to point out that it was Aldridge who first conceived the idea of painting designs on a girl to advertise Penguin Books. It's an omnivorous eater, the Underground.)

Yet this open eclecticism has surely a built-in flaw, and that is the drying up of a supply of new spices to add to the pot. What amazed us in the spring of 1967 is already beginning to do no more than charm, and what charms must eventually pall. Furthermore, as the influence of Hapshash spreads into commercial advertising, the inevitable law of pop culture has begun to operate: that which spreads becomes thinner.

The other principal designer of Underground posters is the Australian artist Martin Sharp. His future in this field seems to me less in doubt because, while his work is perhaps less technically inventive than Hapshash's, his ideas are more original.

Another point in his favour is that, whereas Waymouth and English are associated with *International Times,* Sharp is connected with the magazine *Oz,* and while *Oz* is extremely sympathetic to the Underground it has a less childlike confidence in mind expansion as the whole answer to the crisis in our society. As if to confirm this analysis, Sharp's posters seem divided between a bitter political disillusion and the more agreeable if hackneyed universe of the flower children. Yet in the latter field, his 'Dylan' poster is outstanding for its richness of imagination, and if such a deliberately transitory art form as the Underground poster can produce a work of permanent interest, this could well turn out to be it.

* Aldridge too is perfectly conscious of his sources, see *The Penguin Book of Comics.*

Firmly dedicated to a way of life which itself shows signs of dissolution, it will be interesting to see if the mind-expanding poster goes down with the scene or succeeds in clambering aboard whatever may be sailing towards us over the horizon.

The 'Nouveau Art-Nouveau' poster may have already begun to decline in popularity, but the idea of the 'mass-produced unsigned object' is probably here, if not to stay, then at least to be thrown away and replaced by its successor. The Underground poster has succeeded in destroying the myth that the visual imagination has to be kept locked up in museums or imprisoned in heavy frames. It has helped open the eyes of a whole generation in the most literal sense. It has succeeded, however briefly, in fulfilling the pop canon; it has operated in 'the gap between life and art'.

*

Although two years have passed since I wrote that piece, nothing has happened to change my views. The psychedelic poster moved predictably out of the Underground and spread across the walls of almost every middle-class teenage bedroom. The 'revolutionary' summer added only one image – the ubiquitous Ché.

A few posters, in particular Sharp's 'Dylan' and Hapshash's 'Legalize Pot Rally', have remained alive as images, on their own merits. Most of the rest have lost their immediacy and look as tatty as Christmas pub decorations half-way through January. There has been no major development, although a recent vogue for printing photographic images in black on a dull silvery background was certainly very pretty and chic and was consequently snapped up immediately by both the glossies and the designers of books and record sleeves. On the whole, though, the moment of the self-sufficient pop posters seems over. The interest has shifted, and that on a smaller scale, to genuine old posters chosen for either their aesthetic or camp qualities.

As a symbol of this decline I noticed only the other day that the makers of a breakfast cereal were offering on receipt of four carton tops 'Pop Posters in brilliant psychedelic colours'. Turn on each morning to a plate of Ipsy Pipsy.

But if the poster has lost its charisma as a desirable pop object, the record sleeve has gone up in the world becoming, in many cases, almost an independent *objet d'art.* Here again the Beatles were trail-blazers. It's true that even in the 50s there had been honourable covers especially in the jazz field; but they were hardly a genre in their own right, simply a combination of restrained lettering with either a sensitive drawing (David Stone Martin was usually responsible here), an interesting photograph or the reproduction of an old or modern masterpiece considered appropriate to the music they packaged. They had, as it were, no life of their own, and it could be maintained that the more aesthetically possible they were, the less effective commercially, for the general style was brash and glossy: the record racks a discordant clash of Day-glo and pastels exploding into stars and asterisks, pin-ups, pearly teeth, musical notes and crowded multi-coloured lettering.

Classical recordings were even worse served. If 'popular', they tended towards violins resting on veneered tables in front of satin curtains. If specialist, towards ugly Germanic lettering printed haphazardly on covers coloured in clever imitation of vomit.

The Beatles, or perhaps to begin with their advisers, changed all that. Their first LP cover, *Please Please Me,* was nothing startling, but their second, *With The Beatles,* was a genuine breakthrough. By this time, November 1963, they were so glamorous, so famous that there was no need to shout on their behalf. The sleeve was an almost black photograph by Robert Freeman in which only one side of their faces was visible and that in the *pointilliste* texture known as 'grainy' and soon to become an art editor's cliché. The minimum information was modestly if intelligently laid out in a thin white strip above the photograph. Among the vulgar fairground barking of the LP covers of its period, *With The Beatles* had the dramatic impact of a bomb in a bouquet of multi-coloured gladioli.

It was of course copied, usually badly, but the Beatles were always to remain one step ahead. *Rubber Soul* (1965), for example, had a distorted coloured photograph festooned with

the bulbous Disney-like lettering which was soon to become an Underground cliché, *Revolver* (1966) was a collage of tiny photographs infesting a Beardsleyesque drawing by a young German, Klaus Vooman. Then came *Pepper* and after that, in total contrast to all its brilliant elaboration, an LP called *The Beatles* in an absolutely plain shiny cover with the smallest legible lettering in stamped relief. Their most recent LP *Abbey Road*, a photograph again: a disturbing juxtaposition of a banal road with the Beatles marching across a zebra crossing like worrying hallucinations.

On their covers, as in their music, they seem unable to go wrong, but the same can hardly be said of their imitators. In particular the Stones, their nearest rivals, have limped along in more or less direct if ineffectual imitation. *Aftermath* aimed at the restrained graininess of *With The Beatles* and yet got it subtly but decidedly wrong. *Their Satanic Majesties* with its 3D cover photograph was better, but threw in everything but the psychedelic kitchen sink and lost its potential challenge to *Pepper* through its over-elaboration and a lack of an all-over style. *Beggars Banquet,* forced through trouble with the recording company to suppress its proposed lavatorial front cover, appeared in consequence to be a direct crib on *The Beatles,* although the orgiastic *Viridiana*-like double-spread photograph inside was in itself remarkable. No, up until now, the Beatles have led the field.

Yet it would be churlish to deny that the effect of the Beatles' pioneer work has been remarkable and entirely to the good. Especially in the Underground and blues field, record sleeves have improved out of all recognition in recent years and would seem, much more consistently than posters, to have stimulated a whole school of inventive if eclectic talent.

Surrealism has remained the most pervasive influence but not always on its obvious Dalinian level. (The cover for an LP from Blind Faith shows a photograph of a nude pubescent girl holding an aluminium object; a Balthus figure with a Bellmer fetish.) Among other sources have been nineteenth-century nonsense-book illustrations (*Stand Up* from Jethro Tull), early

American comic-strips (*Cheap Thrills:* Big Brother and the Holding Company) and 'art deco' (the Who's opera *Tommy*).

The record sleeve is at present the natural home of a visual pop style. The fact that it has a practical function, far from inhibiting its practitioners, appears to stimulate them. Through these twelve-inch squares of shiny cardboard a lot of young people have been exposed, admittedly at second hand in most cases, to all the more recent developments in modern art. They have become used, often without being aware of it, to the idea that the eye can be as great a source of pleasure or speculation as the ear. The method may be Pavlovian; the image on the cover is equated with the music inside; but it is effective, that's what counts.

A secondary effect of this use of the poster and the record sleeve as visual pop laboratories has been to establish with no conscious effort at all a tenet which almost every modern movement from cubism on has tried to impose on a reluctant *kunst*-struck public – that is the relative unimportance of the human hand in the creation of a work of art in the twentieth-century context.

Cubism's 'Papiers Collés', Dada's reliance on 'the laws of chance', Surrealism's insistence on 'inspiration to order' via the collage and the frottage, high pop's use of the silk screen have all, in their way, been attempts to dismantle the concept of human genius as the prerogative of the hand as the only true servant of the eye, but all have in the full sense failed.

There were two reasons for this. The first, and the less sympathetic, is the commercial value of the unique work of art; a viewpoint so engrained that, however mechanical the actual means involved in the creation of an image, its worth was established only by the addition of a 'hand-drawn' signature plus, in the case of multiples, a number defining their limitation.

The other reason is more sympathetic if, in pop terms, equally treasonable and that is the idea of the pathos of history – this long dead hand actually made these unique marks on this canvas or piece of paper and only once.

141

I must admit that, as part of a pre-pop generation, I am very seduced by this idea, very susceptible to this emotion, while at the same time aware of its irrelevance. An image is an image. It may be impossible to reproduce an oil painting accurately enough to rule out its uniqueness, but there is no limit to the number of silk-screen prints, and certainly no inherent reason why as many people as want them shouldn't be able to afford them. The poster and the record sleeve, unsigned, without value, are true pop.

But the main effect of this shift of emphasis has been to allow the photograph an equal weight and this has turned out to be pure gain. Up until now we have always felt ill at ease about the place of photography. In the last century, and to a lesser extent in this, there have been attempts to insist on it as 'an art' in the traditional sense – to produce limited editions and then destroy the negative, to imitate 'oil painting' and charge accordingly.

At the same time photography has been accepted as a maid-of-all-work in the employ of the instant and the transitory, a totally mechanical skill. Yet it is just this side of it which has most affected the way we see reality. Artists from Degas and Bonnard to Bacon and Warhol would presumably have painted in a totally different manner without the invention of the camera, an instrument capable simultaneously of exploiting chance and precision.

It is, however, visual pop which is best able (due to its lack of a traditional financial structure), to make use of photography without drawing any distinction between the photograph and the hand-painted image. On posters and record sleeves they are both accepted as equally valid, and furthermore this absence of the old prejudice coupled with the development of modern filters, lenses and cameras, has allowed photography to move closer to art without that self-conscious 'artiness' which so inhibited its earlier moves in this direction.

Side by side with the idea of the photograph as pop medium has arisen the concept of the photographer as pop hero.

Every idea about pop favours this myth: the balance between

technical expertise and intellectual indifference, the camera's amorality, the availability and disposability of the photograph, all those qualities which Richard Hamilton defined as the essence of pop: 'popular, transient, expendable, low cost, mass-produced, young, witty, sexy, gimmicky, glamorous, and last, but not least, Big Business'.

The personification of the photographer as pop hero is undoubtedly David Bailey: uneducated but sophisticated; charming and louche; elegant but a bit grubby; the Pygmalion of the walking-talking dolly; foul-mouthed but sensitive; arbitrary yet rigid; the openly sardonic historian of his time elevating a narrow circle of his own friends and acquaintances into a chic but deliberately frivolous pantheon; hard-working but ruled by pleasure.

The pop photographer mirrors his time with a rather touching awareness of his or its lack of weight. In doing so he has effected another interesting shift in meaning. He has transferred those qualities which, until the 60s, were thought of as essentially homosexual and made them available to what used to be known as 'red-blooded males'.

The classless (or to be more accurate class-aphrodisiac) acceptance of pre-war homosexual circles, their belief in the self-sufficiency of the chic, the 'amusing', the new; the love of glitter and danger; the belief in hard work at the service of sensation; these are now acceptable within a heterosexual context. To go further there has sprung up a tolerance of bisexuality so powerful as to constitute an ideal. Fashion photography has sold unisex on the widest possible front, and not only within the context of the sophisticated magazines.

On underground stations at the moment there is a huge poster for a shop connected with Harrods of all places, showing the back view of a couple in identical bathing trunks. They have their arms wrapped around each other's waists and it takes some time to work out which sex is which (the amount of body-hair and the shape of their bottoms are the only clues). The idea of the 'pretty boy' is no longer confined to queans alone. We have lost our sexual inflexibility and a good thing too. We are

no longer dragooned into a parody of the way we have been told our sex ought to behave. We can relax about our sexual roles.

It is not an accident that the photographer should have played so vital a role in pop cultural development. For a start he is in the position to move between two worlds, that of high fashion and the pop world, carrying the ideas and rage for the new from one to the other.

Through his authority he was able, almost single-handed, to break down the lady-like image of the fashion model with her matching bag, gloves and shoes and to substitute the childlike, sensual and unpredictable model girl. He too was in the van of the working-class breakthrough. His job helped here, needing technical expertise and visual sensitivity but none of the traditional props of education, neither an accent, a grounding in the classics, nor respect for the establishment.

Into an age increasingly obsessed with sexual voyeurism he seemed the ultimate eye. In an age determined to live for the moment he imported just that ethic from the dodgy club-and-pub ambit of the East End. Into a world bored with the puritanism of the 40s and early 50s he offered a total lack of exterior morality in favour of instinct ridden by style. Like a bee with fertilizing pollen on his bottom he flew from Cable Street to Chelsea, engaged in an act of visual cross-pollination.

*

Yet if the photographer sold the idea of the classless dolly, what she put on her back, the new extremity of pop fashion came from another quarter and here it was one girl alone who effected the breakthrough.

After all, the idea of the fashion photographer as an *outré* fashionable figure was not new. In Evelyn Waugh's *Decline and Fall* there is a photographer called 'Little David Lennox' and in real life Cecil Beaton had long been a synonym for talented frivolity. Even in the years immediately preceding the rise of

Bailey and his peers the photographer was an accepted role within a comparatively small circle occasionally, for reasons usually unconnected with his professional ability, becoming known to the public at large. Baron was famous for his friendship with Prince Philip, his pupil Armstrong-Jones was already famous before his marriage to Prince Philip's sister-in-law. In a way it could be said that Armstrong-Jones was the dry-run for Bailey. Admittedly upper-class, he nevertheless contained many of Bailey's qualities: a certain androgynous sexual appeal, great visual flair unbuttressed by any great academic distinction, a passion for work, a hatred of the slapdash, a total professionalism combined with an almost choreographic approach to what he was doing.

Bailey and his peers may have brought the working-class cachet into their profession, may have shifted its sexual emphasis, but they have ancestors. Mary Quant had none.

Fashion

Mary Quant and her husband, Alexander Plunket-Green, were pop children. They met at a post-war art school, Goldsmith's College in South London, in the very early 50s. Plunket-Green was of upper-class origin, very eccentric, keen on traditional jazz, coming on decadent in the post-war greenery-yallery manner. Mary Quant came from an originally working-class Welsh background with parents who were earnest believers in the merits of plain living and high-thinking, a very useful basis for the form her revolt took.

She was totally beglamoured by Plunket-Green's confident ability to *épater le bourgeois* but brought with her not only her inherent flair for fashion design but an as yet concealed steely determination to succeed on her own terms.

They opened Bazaar in the King's Road, Chelsea, on a comparative shoe-string in November 1955. They had no business experience but a lot of flair. Mary Quant's genius was to stylize the clothes of the poor but imaginative art students,

145

to throw a custard pie in the face of every rule of what up until then had constituted British fashion, to spell 'chic' as 'cheek'.

She was lucky in her moment. She and Plunket were at the centre of a small social group which became known as the Chelsea Set, and whose parties and general way of carrying on had won the total attention of the gossip-writers of that period. Quant's clothes received an extraordinary amount of publicity. She was seen and rightly as a concrete expression of something new. The Chelsea Set carried on in the classic smart upper-class way reminiscent of the 'Bright Young Things' of the 20s. It had many of the same traits: a tendency to tease the lower middle classes by showing off and to patronize the working classes. It too was a-political, believing a successful party was all that mattered, and as eager to make the gossip columns as the gossip columnists were to accommodate it.

There were, however, major differences. For a start the Chelsea Set, while largely well-connected, had on the whole less money than their predecessors. Most of them had to work, and when it came to parties and so on they were less able to subsidize fantasy on an extravagant scale. They were less socially exclusive too. Although working-class accents were not yet acceptable, social origin (if justified by beauty, wit or talent) was no drawback.

Nor was the idea of success ruled out as vulgar or irrelevant. It was the area in which success was possible that counted, and these were admittedly limited. Writing was all right, and painting, but both these were traditionally acceptable professions in smart bohemia.

The Chelsea Set accepted other possibilities, however: Little restaurants with a lot of brown sugar in the sauces, very camp waiters, and an ambiance of that particular cosy if slightly self-congratulatory intimacy which were the set's hallmarks. Its members were allowed to work in advertising or even in business although in this case it had to be a small business and if possible involving a certain manual skill like the design and manufacture of laminated furniture. Finally, if broke, it was

all right to work in a coffee-bar or run an illegal chemmy game or even to sell stories (about other members of the set) to the newspapers.

In consequence the Plunket-Greens' decision to open a boutique was not in itself remarkable. Even though they were the first to have thought of it, it was a very Chelsea Set thing to do. What was unprecedented, however, was its success. Mary Quant's flair for what people would accept next combined with Plunket-Green's aristocratic dandyism to produce a new alloy of talent and outrage. Bazaar was a banner, a battle-cry, a symbol of the new sophistication, and above all news. It was also the one true pop manifestation in the years between rock and the Beatles. It appalled and then seduced, a trick Mary Quant never forgot how to perform, and even now, an O.B.E. and head of an enormous business concern, the apparent antithesis of the inefficient if exciting little shop in the King's Road, she can take time off to predict that pubic hair will be the next move and to reveal that on one occasion Plunket shaved her own dainty bush into the shape of a heart.

But Quant did more than succeed on her own account. She changed the whole approach of the British to fashion. Up until then 'fashion' was French and for the rich and frivolous. English upper-class girls were expected to dress like their mothers, and only tarts or homosexuals wore clothes which reflected what they *were*.

Quant changed all this. She chucked lady-like accessories into the dustbin, recognized the irrelevancy of looking like a virgin, took into account that pavements and restaurants were not muddy hunting fields nor parties and dances the antechambers of morgues. Innocent and tough, she attacked the whole rigid structure of the rag trade and won hands down and skirts up.

After her came her imitators, some almost as clever, others less so. In imitation of Bazaar, boutiques spread like a rash, first through Chelsea and its environs, then through London in general, and finally to the provinces. She triumphed not only in Britain but in America, and even in Paris itself. For good or ill the embryonic concept of 'Swinging London' was conceived in

that small disorganized shop in the King's Road. Everything that came later: Biba's, for example, a brilliant mass-produced variation adjusted for a time when more girls with less money were ready for 'far out' clothes, and the recent installation of 'boutiques' in the one-time staid big stores, owe everything to Quant.

Still at least Mary Quant affected fashion from a comparatively traditional position, that of the couturier of genius able to translate the flavour of a particular era into colour, shape and texture. She and her successors drew on certain pop elements: the 'child-woman' whose first and most authoritative exemplar was Brigitte Bardot, the 'kinky' clothing of the recently suppressed street walkers, various camp revivals, new materials and clichés (like tartan or gingham) stood on their heads.

Male pop fashion was a different case. Admittedly by the late 60s it had assumed its place as parallel and almost interchangeable with its female counterpart; but at the beginning it was more of a genuine pop manifestation, a general upsurge rather than the work of any one man.

The Teddy Boy style of the middle 50s I have already described early in this book as an example of how pop culture operated in its primitive days. It is perhaps worth repeating and stressing, however, that what made it significant was that it represented one of the first successful attempts to establish a male working-class fashion with a symbolic rather than a functional *raison d'être*.

Yet not all the elements that fused together to make up male pop fashion came up from the tribal life of British working-class adolescents. The other principal source was based on the East End Jewish tradition of good tailoring, as exclusive in its way as Savile Row, if based on a different premise: the necessity to reveal conspicuous expenditure rather than to conceal it.

It was Mr Cecil Gee who was in the main responsible for moving this tradition West. He'd established himself in the Charing Cross Road just before the war, but it was austerity that made his name. People coming out of the services wanted individuality and Gee gave it them. He began by concentrating

on the American look: double-breasted suits, wide lapels, long pointed collars, coloured shirts. Later he was first to mass-produce the Italian look: the narrow ties, narrow lapels, turn-up-less tapered trousers. He has expanded and prospered ever since, but he has always avoided the 'crude' pop styles which have risen from below. He resisted both the Teddy-Boys and the more flamboyant sartorial revolt of the Mods. He was and is after the custom of the more successful show-biz side of pop culture. In the late 40s and 50s it was towards 'Cecil's' that the more clothes-conscious modern jazz musicians and rock stars turned. Today, transplanted down stretches of Shaftesbury Avenue and with a lot of emphasis on 'leisure' clothing and expensive leather and suède, he seems almost a conservative element – a ballast to pop extravagance.

If Cecil Gee moved out from the East End to cater for the new pop public who had made good, a similar service was needed to accommodate those who traditionally might have turned to Savile Row or at any rate its cheaper derivatives. The creation of the new communications industries, notably advertising and television, seemed to demand a new kind of flamboyance, and yet the largely middle-class origin of the recruits inhibited them from patronizing Cecil Gee's confident rejection of gentlemanly reticence.

It was to this clientele that the John Michael shops appealed. A kind of discreet-hip: quiet suits but with brilliant silk linings, pink shirts, but with small button-down collars, there was none of the flash excitement of the Charing Cross Road involved. It was all cleverly underplayed. The Italian style was grafted on to the central tradition of posh tailoring and at traditional prices too.

For a time these three separate elements in pop male fashions remained constant. Working-class tribal fashions for groups united by territorial interests. Flash show-biz fashion from the Charing Cross Road for those who had made it or aimed to make it. Gentlemanly flamboyance for the middle classes in the new professions. This *status quo* obtained throughout the 50s but then, in the early 60s the emergence of a new cult, the Mods,

149

and the flair of a new entrepreneur, John Stephen, produced a new synthesis – the Carnaby Street explosion.

*

Once again it is difficult to unravel the original elements that went into what was to become the 'Swinging London' style. For one thing it all happened fairly fast, but more important is the way that in pop slang a word, in this case 'mod', changes its meaning to accommodate a rapidly changing situation.

Initially for instance 'mod' meant a very small group of young working-class boys who, at the height of the trad boom, formed a small totally committed little mutual admiration society totally devoted to clothes.

There was no sense among the first Mods of using clothes as a form of aggression as the Teds had. They didn't want to fight or screw or smash anything. They were true dandies, interested in creating works of art – themselves. There had of course been dandies before but they'd always been upper-class dandies Now Macmillan's affluence had helped create working-class dandies – dedicated followers of fashion.

There was admittedly a strong homosexual element involved – but it was not so much overt homosexuality as narcissistic. Girls were irrelevant. The little Mods used each other as looking glasses. They were as cool as ice-cubes.

The original Mods had their clothes made, hunting down tailors and shoe-makers prepared to bend to their fantasies or, if they did admit something mass-produced they either modified it, took it out of context or insisted on certain stringent qualifi- cations – their jeans, for instance, had to be American.

But the main thing about the first Mods was that they were true purists. Clothes were their only interest, but at the same time, in that they were the forerunners of a general trend, they carried with them their own destruction. As the 'mod' thing spread it lost its purity. For the next generation of Mods, those who picked up the 'mod' thing around 1963, clothes, while still their central preoccupation, weren't enough. They needed music (Rhythm and Blues), transport (scooters) and drugs (pep pills).

What's more they needed fashion ready-made. They hadn't the time or the fanaticism to invent their own styles, and this is where Carnaby Street came in.

John Stephen, a Scotsman, had opened his first shop for men in London in 1957, only a year after Quant's first Bazaar. He'd done well but had attracted little general attention outside rather specialist circles. The point was that throughout the late 50s and early 60s any male fashion beyond John Michael's discreet splendour or Cecil Gee's continental 'casual' look tended to cater almost exclusively for butch trade.

I have for instance in my files a catalogue advertising an avant-garde men's shop of the very early 60s which illustrates its collection in story form. The tale is simple. A young man called Ted is picked up by a lean mature film director called Lance *en route* to the South of France. Their relationship is underplayed, but their clothes are described in almost pornographic detail. 'Ted,' reads one extract, 'is open to all offers so make your bids now for this season's slant on denim.' Finally, wearing 'Ticking slax; slim cut thigh huggers at £3 9s 6d', Ted decides to extend his holiday with Lance by accompanying him on to Rome . . . 'so take care Nero – they're on their way' is the sign-off line.

The growth of shops of this kind meant that when the 'mod' thing happened very little adjustment was necessary. Shepherd's Bush, the main launching-pad for the blast-off stage in the Mod explosion, discovered Stephen and put Carnaby Street on the map. In no time at all Soho at week-ends was full of Mods pilled up to the eyebrows, dressed like kaleidoscopes, and bouncing in and out of the cellar clubs like yoyos.

Stephen's clothes were and remained well-made. His imitators realized this to be unnecessary. It didn't matter how quickly everything fell to bits. The clothes weren't meant to last but to dazzle. Their shops, blaring pop music and vying with each other for the campest windows and décor, spread the length of Carnaby Street and its environs. The press picked it up and in no time at all it was world-famous – a London spectacle on a par with the Tower or the Changing of the Guard.

As always in such cases the original Mods were very put out at the spread of what they thought of, and rightly, as their own invention. They remained purists and for a time re-established their pre-eminence by quite coolly turning towards overt homosexuality and going to bed with any show-biz quean who was famous and smart enough to reinforce their tottering egos.

But the Carnaby Street Mods were not the final stage in the history of this particular movement. The word was taken over finally by a new and more violent sector, the urban working class at the gang-forming age, and this became quite sinister.

The gang stage rejected the wilder flights of Carnaby Street in favour of extreme sartorial neatness. Everything about them was neat, pretty and creepy: dark glasses, Nero hair-cuts, Chelsea boots, polo-necked sweaters worn under skinny V-necked pullovers, gleaming scooters and transistors. Even their offensive weapons were pretty – tiny hammers and screwdrivers. *En masse* they looked like a pack of weasels. By 1964 the whole Mod spirit had turned sour. They were squeaking for blood. That was where the Rockers came in.

The Rockers' life-style was in the main in the Ted tradition. Where Mods were cool and hip and hung around the centres of the great cities, Rockers occupied the smaller but loucher towns or, in the case of London, roared around the outer ring-roads, 'did a ton' up the motorways on their enormous motor-bikes or filled their favoured transport cafs eating fry-ups and drinking mugs of sweet tea. They were greasy, dirty and dressed largely in leather rather beautifully decorated with brass studs or naïve pictures. Their girls looked like men in drag. The Rockers were noisy too. There was nothing hip or cool about them. Their weapons were large spanners and lengths of heavy chain.

A Mod facing a Rocker was a spectacle not dissimilar in visual impact to the confrontation of armed gladiator and man with trident and net in the Roman Arena.

Most of the time their paths didn't cross; they stayed in their territories, but then in that summer of 1964, whether by accident or design, two large groups clashed one week-end in Margate.

The press and television seized on it, the papers exploded into huge headlines and from then on almost every week-end the word got around as to which unfortunate resort was to provide the next battlefield.

By the end of the autumn it was all over. The orgiastic violence was spent. The emphasis on fashion shifted from the male to the female principal. The mini-skirt had become the symbol of swinging Britain. The Mods lost their tribal identity. The Rockers went back to their cafs. There was comparative teenage peace for another five years.

*

While this lumpen-Mod escalation was taking place at one end of the pop social scale, Swinging London itself was in the process of revamping its image. For whereas the Mod revolution had started out as a totally male concept, the popocracy soon came to see that consorts were essential, not only to go to bed with, but to flatter and complete the newly emerged male splendour. To this end, taking the hint from those photographers who had brought their models with them, they invented the 'dolly'.

I suppose Jean Shrimpton was the proto-dolly, only she, like most pop prototypes, was very much a person in her own right. Her imitators, however, were almost interchangeable. All had long clean hair, preferably blonde, interchangeable pretty faces, interchangeable long legs. They represented girls as objects to an extraordinary degree. They produced a kind of generalized rather half-hearted lust triggered off by their ever-shortening mini-skirts.

They never spoke, the music was too loud, but they danced very well. They are almost extinct now except for a small reservation preserved apparently for use in TV advertisements.

They were replaced as a popular image by Twiggy, deliberately exaggerated, painfully thin ('Forget Oxfam: Feed Twiggy' read one of the 'sick' lapel badges of the period), and given to expressing her non-opinions in raucous mod-cockney. The fashion photographers, on the other hand, turned either to dreamy indolent aristocratic girls or mature *jolie-laide* women

with real bones and wrinkles. Negro models also, as 'African' as possible, have had a recent run.

Yet it was during the dolly-period that the pop world was forced to yield to at any rate a token of acceptance of feminine rights. Carnaby Street itself, originally an all-male preserve, opened its first shop for girls (its changing booths carried huge photostats of muscle-men).

Soon there were as many girls as boys, as many adolescents as adults and more tourists than anyone. The 'in' group wouldn't have been seen dead in Carnaby Street by 1966. Chelsea, after a period of decline, reasserted its role as the stage of fashion, and so it has remained ever since.

The hippy revolution of 1967 killed the Swinging London image of the pop dandy and dolly frugging in an 'in' discothèque stone dead, and even after the Kaftans and Red Indian drag were back in the dressing-up baskets there was no resurrection. The popocracy, older now and more private, formed an alliance with the pre-pop smart sets, and withdrew into a few exclusive bastions of privilege like the Arethusa Club in the King's Road. Their clothes returned to splendour, but to a more conventional splendour. Mr Fish, the dictator of fashion, is no John Stephen, no popularizer. In recent months even their hair has grown shorter.

Meanwhile the new groups, however successful, remain resolutely grubby while their admirers, adolescents to a man, come home from school, shed their uniforms and dress like tramps. 'Guilty at affluence', ran a recent explanation in a Sunday paper. 'They have invented a do-it-yourself depression.' Visual styles at root level are drab. Only the Hell's Angels, Americanized descendants of the Rockers, achieve a rather sinister panache. Their enemies, the Skinheads, caricature their proletarian lack of ambition. The Mods, their elder brothers, wanted a share of affluence, were not afraid to look pretty. Skinheads aim at a hideous anonymity. Pop fashion lies in splinters. There is no longer any centre.

*

Last month David Bailey published a book of photographs called *Goodbye Baby, and Farewell,* a bittersweet farewell to the frivolous fashion-conscious 60s. Bailey is also represented in *The Beatles Illustrated Lyrics,* another saraband for the pop decade edited and in all-over effect dominated by Alan Aldridge, the period's most inventive graphic recorder.

These two books are not bad epitaphs. Bailey's is the more determinedly detached, the more deliberately absurd. His pantheon sidesteps criticism by the arbitrary frivolity of its selection: no 'great men', only entertainers in one medium or another. Even its Savonarola, Muggeridge, is pure show biz.

Yet finally I prefer Aldridge's more ingenuous homage. He overestimates the Beatles' poetry on the page – they write songs, not poetry, and have never pretended otherwise – but the illustrations are the essence of the pop visual style at the moment of its apotheosis. Psychedelia, nursery surrealism, soft focus photography, false naïvety, a celebration of a kind of innocence and hope.

December 1969

Film, TV, Radio, Theatre

'Let's do the show here'
Musical–film cliché

Film and TV

First more definition: what makes a film or television pro-
gramme 'pop'? Is it a style or an attitude? Must it contain a
substantial proportion of pop music, or is it on the contrary a
visual style deriving from the theory and practice of pop paint-
ing? Is it a category on its own?

My feeling is that all these self-posed questions are to some
degree relevant. Initially at any rate the pop style was invented
to deal with the visual presentation of a new phenomenon – pop
music. Later it was seen that the fragmentary free-wheeling
method could be adapted for use in other fields: contemporary
documentary, certain fictional subjects, especially those with an
amoral or permissive slant, above all TV and cinema com-
mercials.

Yet pop style (and for the rest of the chapter I mean pop style
on film or TV unless otherwise stated or obvious in context),
didn't spring fully-armed from the sowing of Elvis Presley's
teeth.

It too was derivative and eclectic. It had to be for it was
created at speed to complement and illustrate what was already
a hot commercial property – pop music.

Advertising itself was an early influence; it was only later that
pop was able to repay its debt with interest. Both pop and
advertising shared in common the fact that they had something
to sell. Both offered 'dreams that money can buy', but while
able to provide a ready-made language, advertising had no
suggestions as to visual content. Here pop had to look else-
where.

The comic-strip was one of the earliest influences and it has remained potent. Here too was a form of instant magic; a sophisticated shorthand which had the two-fold advantage of lying outside traditional culture and yet appearing familiar and legible to a public who had absorbed its conventions since childhood.

A further important source of the British pop style (and it must be remembered that it was the British who evolved this branch of pop culture also) was the Goons. Eventually someone will have to write a whole book about the influence of the Goons. They have to some degree affected almost all contemporary Anglo-Saxon attitudes. They are our effective surrealists, our democratic Père Ubus, our sacred monsters. Behind the 'funny voices' (lingua franca of several generations of civilian NCOs), they have proved to be the agents of a profound subversion. They've destroyed our arrogance but at the same time our certainty. I personally believe this subversion to have been creative and healthy. We were still thinking of ourselves as a nineteenth-century power. It was past time to admit we were nothing of the sort, to stand back and start afresh. If the result of this stocktaking was to 'sink giggling into the sea' as hostile critics have suggested, it was the Goons who made it possible to giggle. Among other services rendered they provided pop with the key to its style – inconsequential and fluid.

But the main problem which faced pop in its search for a visual identity was how to invent a new language and yet find a way to draw on what was already available; the handy and effective conventions of the Hollywood musical, for instance, or the theatrical 'production number'. Here it was discovery of 'camp' that came to the rescue. I've already touched on camp and will do so again – it's central to almost every difficult transitional moment in the evolution of pop culture – but here is as good a place as any to try and define its meanings in pop terms.

Originally 'camp' was a purely homosexual term. It meant overtly and outrageously queer, implied transvestite clothing, and was also called into use to indicate the approval of a few

non-homosexual people, usually actresses who, for one reason or another, appealed universally to queans. 'Camp' meant 'knowing'. It had undertones of self-mockery. It seemed rooted in a certain theatricality.

In his novel *A World in the Evening* Christopher Isherwood gave the first literary definition. He divided camp into two schools, 'high' and 'low'. Low camp he defined very accurately as a female impersonator 'imitating Marlene in a seedy night-club', but by inventing high camp he liberated the word from its purely homosexual connexions and was thus perhaps responsible for its later availability as a general principle.

By high camp Isherwood meant art of a certain confident theatricality, not necessarily trivial (he named Mozart and the Baroque in general as the essence of high camp).

When, in its turn, pop turned to camp, it redefined the word for its own needs. Pop used camp neither in the high nor low sense. It retained, however, something of its implications of a send-up. Camp in the pop sense implied 'dated and/or ridiculous' and yet somehow available. By declaring pre-war musicals 'camp', the techniques of the pre-war musical became valid. So did the accidental speeding-up of the silent cinema. So did anything and everything.

Irritating as this often was, it had its uses. It allowed pop to expand its terms of reference, its bank of images. It gave it (and here remained true to camp's original definition), the confidence to 'come on outrageous'. In the end it came to be a repetitive and meaningless bore but, *en route*, it acted as a useful catalyst. It helped pop make a forced march around good taste. It brought vulgarity back into popular culture, a liberating vulgarity, before in its turn degenerating into a tiresome mannerism.

*

It took some time for these elements to gell into pop, and television was where it happened first. This was perhaps because the film industry was old and set in its ways. Its idea of a musical film about popular music was to repeat *Babes In Arms,* the Judy Garland–Micky Rooney vehicle which is one of the contenders

for the original source of the quote at the head of this chapter. The early Tommy Steele films were all Anglicized versions of *Babes In Arms,* so was an incredible film featuring Terry Dene which I caught recently on TV. This was called *The Golden Record* ('record' mark you – not disc), and is a prime example of the castration principle in full operation. For one thing, apart from Dene himself, all the 'goodies' were solidly middle class. There was an auntie, and her niece (Terry's girl-friend), and they ran a coffee-bar where Terry sang, and later the niece managed to get a tough and *slightly* crooked music publisher over a barrel and so Terry (who was called Terry in the film), sold a million records and married his bobby-soxed girl, and auntie was delighted and so were all the twenty-eight-year-old 'kids' who'd helped put him there. It had every cliché of the genre and seemed, from today's viewpoint, 'deliciously camp'.

On the same camp grounds I suppose in the not too distant future there'll be a season of early British pop films at the National Film Theatre. They were all very much the same, even *Expresso Bongo,* a film based on the stage musical and intended to expose the wicked pop world. It had Laurence Harvey acting very badly as a hustling ten-per-center in Shepperton's Soho jungle, and Cliff Richard doing surprisingly well as the bongo-playing boy who made the big-time and was corrupted by a rich lady with a suite in a hotel. Yet somehow the movie had the same air of unreality as all the others. It was simply less enjoyable.

Back in character and fairly predictably, it's been Cliff who's kept the tradition of the British school of coffee-bar musicals alive. Through a long series of films he's helped immortalize the wholesome legend of fun-loving boys and girls with pneumatic bodies but apparently no sex organs, dancing and singing their way to happiness and success. There have even been times when he's had to persuade cross old fathers that a pop singer can be an acceptable son-in-law. Presley made a similar string of films in America too.

It was in America, however, that the first truly inventive pop musical was made, but it was before its time and no one, either

162

here or there, followed it up. It was called *The Girl Can't Help It,* and was sexy and anarchic. It was directed by Frank Tashlin who was responsible for the best of the Jerry Lewis comedies. It treated pop as counterpoint to the fast rather violent plot, and had everybody in it but Elvis (they had to make do with several blatant imitators). It's stood up very well though, perhaps because no one latched on and hammered its approach into the ground.

There's no doubt in my mind, however, that television was the medium originally responsible for the invention of the pop style.

There were obvious reasons for this; it was newer and more flexible at that time, employing younger men and allowing them their heads almost at once. It had the confidence to experiment; a confidence rooted in its single-channel and still uncritical audience. What's more the B.B.C. had the right man under contract. I've mentioned him earlier in relation to Cliff Richard. He was a university graduate, visually inventive and single-minded. He was also what was in those days a very rare combination – an enthusiast for pop music in general and Elvis Presley in particular. His name was Jack Good and he virtually invented the pop style.

The first show he did was *6.5 Special.* It went out live from the B.B.C.'s riverside studios at Hammersmith and was deservedly popular. It also seemed immensely avant-garde in the middle 50s but I dare say, if there is any on film, it'd look hilariously quaint now.

Musically *6.5* was more varied than most people remember. It included not only rock and skiffle, but quite a lot of revivalist jazz too. Even so it was the rock stars who caught the public's imagination, and there was usually a little crowd of girls waiting outside the studios for a squeak-up when one of their heroes was appearing.

Stylistically Good was responsible for several innovations. A live audience who jived in the studio for one thing. At the same time his approach to pop was paternalistic. While his audience were encouraged to dress sharply they were not

encouraged to sartorial eccentricity, and nor were the perfor-
mers. As I pointed out earlier he made Cliff tone himself down
considerably before he'd have him on the show: a circumstance
for which, given the profitable way his career has gone since,
Mr Richard should be truly grateful.

Good's linkmen were decidedly avuncular: a tradition which
was to remain until pirate radio proved that it was possible to
present pop on its own terms, and which is by no means dead
today.

Neither Pete Murray nor Miss Jo Douglas was exactly a
teenage rebel, nor was Jim Dale, a later *6.5* regular. There were
other people around who helped reinforce the impression of a
rather open-minded youth-club: Sergeant-Major Britten, whose
claim to fame was his parade-ground bellow, and the boxer
Freddy Mills. Yet in terms of 'selling excitement' Good was,
and is, a master. He went on to make the commercial channel
shows *Wham* and *Oh Boy* and then left for America. He is the
D. W. Griffith of the pop style.

He came back here recently and wrote a strong attack on the
way pop music had gone. He spoke of the corruption of the
working-class rockers by Chelsea decadents, about the drugs
and sexual experimentation. He accused the pop world of
intellectual arrogance and phoney revolutionary meddling.

It was an irritating article, not because there wasn't a case to
be made but because Good suggested that the early days were
not only preferable on musical grounds but on a moral plane
also. This was nonsense. A great many early Rock idols entered
the business via the homosexual equivalent of a casting couch
and Good must have known this. It was difficult not to feel that
what he *really* meant was that the early rock 'n' rollers knew
their place, and were delighted to be told to go and get their hair
cut by an Oxbridge graduate.

But the article appeared in the *Radio Times* and was written
as an introduction to Good's return to British television with a
'spectacular' featuring the Monkees. The film itself proved that
he could still handle pop better than anyone else, his kind of pop
anyway. I wrote of it:

What made this film worthwhile was that it demonstrated with a certain brilliance how yesterday's revolutionary can turn into today's reactionary. Good's enthusiasm is reserved for rock 'n' roll: sexy, extrovert, good dirty fun. When pop went highbrow it lost him.

I dare say *Sergeant Pepper* was his Waterloo, and he used this film to make this point with considerable panache. The Monkees were originally computerized into existence as plastic Beatles but have become, not only adequate performers, but discontented with their lot. Good used this discontent as the vortex of an inventive piece of nostalgia and attack. The final sequence in which he evoked chaos with great discipline was remarkable . . .

The show was incidentally a brilliant piece of propaganda for Good's thesis. He used the best of the old-style American rockers: Fats Domino, Little Richard, and a middle-aged but still potent Jerry Lee Lewis, and in contrast Julie Driscoll at her most statuesque and unexpressive. Good is still *the* TV pop stylist.

If it took a long time for Good's lesson to sink in this was because he was not really concerned with surface, and there was very little that could be copied. It's true that the applauding, jiving audience became a cliché and so did the clubbish atmosphere, but his real message was that in order to find visual equivalents to the excitement of pop you've got to be excited by pop, and until Vicki Wickham and Rediffusion's *Ready, Steady, Go* in 1963 nobody connected with television really was. Jazz yes, Christian Simpson and later Terry Henebery both helped to find a way of using their cameras at the service of jazz, but pop music, no. *Juke Box Jury* added nothing to the pop vocabulary, and the other shows just set up their miming puppets in front of a 'modernistic' music-hall setting and left it at that.

Music aside, though, a great deal of pop's televisual language came out of Ned Sherrin's satirical shows, *That Was The Week That Was, Not So Much A Programme* and *BBC 3*. Sherrin virtually invented the new TV brutalism: the scaffolding, the sound booms blatantly probing towards the speakers instead of jerking guiltily out of sight when picked up accidentally, and

165

especially the cameras roaming around like purposeful Martians: the machinery as part of the spectacle it's responsible for. Indeed the whole satirical movement is part of pop, despite its dubious attitude towards it. The Establishment night club was an early home of mixed media: film and tape as part of the entertainment on an equal footing with live actors, and Sherrin popularized this device (admittedly as old as the 20s but up until then a purely avant-garde device) when he became responsible for satire 'going public'. Sherrin's 'invention' of David Frost was another stroke which was later to turn out to pop's advantage. Frost today is not really very pop: a near-establishment figure, a go-between linking show biz and politics, but in the early heady days of *TW3* he stood out as the first compère who, instead of helping to keep the children from becoming over-excited, seemed determined to make them behave even worse.

Yet despite the fact that satire spanned the period between Rock and the Beatles, despite its enrichment of pop's visual means and the licence for irreverence which it handed on to the popocracy, there are distinct differences between the two movements.

Satire's origins are Oxbridge, and it tends to find pop's incoherence and aspirations half-baked. To this day *Private Eye* remains hostile to pop culture, eager to jump on its pretensions and parody its solemnity. There is often a strong whiff of snobbery in this: a feeling that there is little more behind it than the contempt of the educated for the uneducated; but there is also a more honourable basis for the satirist's scorn. Satire* is at bottom moral in the old-fashioned sense. Its intentions are reformatory. It wants people to behave well. Pop really doesn't care about that at all.

Sherrin apart, and his contribution to the pop style was

* As it happens this is true of all satire, but it occurs to me that over and over in this book I am forced to use a general term for a particular manifestation. By 'satire' I mean the satirical movement from *Beyond the Fringe* on, but it would be impracticable to explain this each time.

involuntary, the next important visual innovator wasn't involved in television at all except as a maker of TV commercials. He was a film-man, an American expatriate called Dick Lester.

Lester looks like an amiable space-creature, very thin with a great domed bald head, tiny child-like features and large kind eyes. He brought to pop exactly the right qualifications: a sophisticated innocence, a brilliant technique, an encyclopedic knowledge of twentieth-century avant-garde experiments and a shameless, magpie-like eclecticism.

Lester's first famous film was very short. It was called *The Running, Jumping and Standing Still Film* and its cast were the Goons proper plus a few fringe or honorary goons from the British Underground like Professor Bruce Lacey. There was a strong flavour of Vigo and early Buñuel to the film (Lester admits to a large debt to surrealism), but the presence of Sellers, Milligan, Bentine and Secombe assured it a wider showing than would otherwise have been the case. It became a cult-object. People went to see it over and over again, and it is still frequently revived.

Lester's first feature film was a comparatively conventional job, or so I understand. It was called *It's Trad Dad* and cashed in on the trad boom. It included most of the more popular bands plus a few non-trad pop stars like Helen Shapiro. It made comparatively little stir although Lester enthusiasts, in retrospect, claim it contained hints of his later development. I'm unable to judge this as I never saw it, mostly out of pique. I was all but in it but was dropped at the last minute owing to a disagreement over material.

Then came *A Hard Day's Night,* the most seminal of all pop films.

Dick Lester has always said that he neither wants nor expects his films to last. In this he is an orthodox pop theorist and I believe him to be sincere. What he's after is to make the maximum impact *now,* to hold the moment, freeze it, show it, and let it melt. A great deal of his work has succeeded on this level, but with *A Hard Day's Night* I think he failed and created a classic. I write 'think' rather than 'know' because, up until

now, the film has yet to be reissued, but I did see the film several times at the moment of its release and each time I found it better, richer. In part this may have been due to Alun Owen's script. Owen, unlike Lester, is a traditional artist. He hopes his work will last and this may well have led to a fruitful tension between his and Lester's intentions. But whatever the reason, and it would be stupid not to acknowledge that the Beatles themselves may have played the major role, this film with its modest budget and in black and white, altered the whole concept of how to deal with pop on both film and television.

At the time its impact was believed to spring from its tricks: the speeded-up action, the unrelated songs over action, the famous escape sequence in the field with its cod silent film quotes. It was certainly these tricks which other, lesser talents fastened on to like leeches. In no time at all the formal vocabulary of *A Hard Day's Night* was everywhere. The Monkees, for instance, were specially manufactured to appear on TV in a weekly series which was a blatant steal. But what nobody seemed to understand was that Lester, while an unashamed ecelectic, put his tricks to work. He might claim to have no 'message' but he looked long and hard at what he was filming.

His second film, *Help,* was admittedly less successful. My own view is that the success of *A Hard Day's Night* threw him. He aimed at pure inconsequential fantasy and produced a pastiche of his own mannerisms. Nor was Charles Wood's script up to much. Wood is a very serious writer, obsessed, like the Goons, with our Imperial past. Here he was outside his range. *Help,* despite marvellously inventive moments, was a comparative failure.

On the other hand, sandwiched between the two Beatle films, Lester had made a feature film called *The Knack* and this, also scripted by Wood, was a very important pop film although it in fact contained no pop music as such.

The Knack was loosely based on a short, almost abstract play by Anne Jellicoe (who hated the film). Its theme was how a provincial girl and a sexually inhibited boy finally establish a

sexual relationship infinitely more real than the innumerable sexual conquests of the boy's friend, the one with 'the knack'.

A simple enough theme and far from new, but Lester and Wood used it to anatomize the whole approach of a generation to morality. Instead of preaching, or attempting to establish moral imperatives, the film proposed a steady sexual liaison (love is another word for it), on the grounds it was in the end more pleasurable, more sexy, but it didn't minimize the pleasures of promiscuity. The beautiful dollies queueing on the stairs up to the Don Juan's room were beautiful, as beautiful as the dollies in the advertising commercials on which Lester cut his teeth. It was a witty film, swinging between realism and fantasy with a dizzy sense of balance, but it was not an empty film. It was also optimistic. It believed in pleasure at its most intense. It proposed love and fucking because it felt that this was more pleasurable than fucking without love. Perhaps pleasurable is the wrong word – more joyful. *The Knack* was the new pop gospel, over-rosy in retrospect, but at the time a revelation, an exhilarating 'yes'. I saw it one morning and remember coming out afterwards into Piccadilly in a state of euphoria.

Since then Lester, following the comparative failure of *Help,* has turned towards the dark. With Wood he made *How I Won The War,* a bitter anti-militaristic essay, admirable in its way, but sour and angry.

He made an excellent and professional American film, *Petulia,* sick and glittering, an indictment of the banality of evil, and more recently he made an underrated version of Antiobus and Milligan's *The Bed Sitting Room* which was pure black humour, the nearest he had ever moved in the direction of classic surrealism in the ideological as well as the icono-graphic sense. Yet as an innovator I would still place *A Hard Day's Night* and *The Knack* as his most important films. In that their technique was there for anyone to borrow they carried their own destruction with them in the way Lester hoped they would; but in that, for all their surface coolness, they said something positive they have defeated his passion for built-in obsolescence. They heralded in the hopeful pop dawn. They

were the fanfares of swinging London. They weren't *about* pop. They were pop.

*

In August 1963 the independent television company, Rediffusion, inaugurated a new pop programme called *Ready, Steady, Go,* and this was the next stage in the development of a pop style.

Not just style either. In the McLuhanesque sense *RSG* was an important breakthrough. It plugged in direct to the centre of the scene and only a week later transmitted information as to clothes, dances, gestures, even slang to the whole British teenage Isles. When I was touring in the 50s fashions took an almost incredible time to spread. Even the large provincial centres like Liverpool and Manchester were at least six months behind, while in small Yorkshire mining communities as late as 1960 it was still possible to find Teddy Boy suits, and not only that. They were tailored in ruby red or billiard-table green cloth. As for the borders of Scotland the girls' dresses had hardly altered since the middle 30s. *RSG* changed all that. It made pop work on a truly national scale.

It was fortunate in its timing of course. British pop music was at its most vivid. The Beatles, the Stones, the Who and others were ready, willing and able, but the music was only part of it. The whole chemistry of *RSG* was right. So was its timing. Friday night just after work. 'Your Weekend begins here' was its slogan. It was almost possible to feel a tremor of pubescent excitement from Land's End to John o' Groats.

In February of that year I tried to analyse its strength in my pop column.

. . . Whatever the quality of its contents, this programme is technically and emotionally very exciting. The new telly-brutalism, with cameras and technicians casually in evidence, is clearly derived from *TW3* in the first place, but it's used intelligently to destroy the sense of a *performance* and suggests the idea of people enjoying themselves in a studio. In fact this is all very contrived; most of the audience are picked for their dancing or appearance; but it works.

Ready, Steady, Go has its clichés – the moody descent of that iron staircase, for example – and I find its compère, Keith Fordyce, too bossy, and his colleague, Kathy McGowan, coy and breathy; but it's the only pop programme to generate an alternating current between its viewers and itself.

New trends in dancing, clothes, even erotic habits (a tendency to tug gently at the legs of the singers has recently become common) appear on this programme at the same time – or even in advance of – what's going on in the teenage clubs. It all *happens*, and the rest of the pop shows – A.B.C.'s *Thank Your Lucky Stars* and the B.B.C.'s *Top of The Pops* limp painfully after it.

So they did and, interestingly, they both lasted longer than *RSG*. Indeed, *Top of The Pops* is still 'limping along' at the time of writing: a museum piece wondering why, considering that it's 'The only regular pop show on TV' its ratings are so low. The reason is simple. Not only was *RSG* in advance of its time. It knew when its moment was over. It was true to pop even in this.

Re-reading my review there's not much I'd want to change except for my rather slighting reference to Cathy McGowan. Apart from spelling her name wrong I misunderstood what she was for. Coy and breathy yes, hopelessly amateur perhaps, but she *was RSG*. The bridge between pop and its audience. Her clothes, her *jolie-laide* sex-appeal totally transformed the girls of Britain. She was the prototype dolly. She destroyed the class basis of fashion, gesture and speech. 'Smashing,' she said.

Ready, Steady, Go was fluid, that was its strength. It showed unknown groups, Americans no one had heard of outside 'in' circles, it allowed people to over-run if they'd caught fire. When forced to go live due to a Musicians' Union ban on miming it pretended it had thought of the idea itself and made a virtue of it. It used experimental 'far out' film. It fizzed and crackled.

It's difficult to say exactly who was responsible. Its producer Francis Hitching, its director Vicki Wickham, or its eminence rouge, Elkan Allan, Rediffusion's Head of Entertainment. Middle-aged as I was, I never missed it if I could help it, and

171

after a time I noticed something else rather interesting. Its settings, within the general *TW3* framework, were beginning to show the influence of the other wing of pop – pop art. The show's scene designer was a young man called Nicholas Ferguson and, quite consciously, he was drawing on pop art as a source of inspiration. The two cultures were moving closer. I remember going to a live *RSG* at the Wembley studios to hear James Brown, and meeting the British pop artist Derek Boshier. He, a keen pop music fan, was starry-eyed. 'I've just met the designer,' he said, 'and he *knew* me. He said, "What a pity you weren't here last week. We did you last week."'

They'd done him last week. Copied his striped barber's-pole-shaped pictures as a framework for the groups and he was knocked out. It was very different from when Pears Soap had used *Bubbles* as a poster – Millais* was furious.

Pop Style Triumphant: 1966

Boshier, in his pleasure, was by no means unique. Suddenly the two wings of pop seemed almost interchangeable. The word itself was applied indiscriminately to colours, Union Jacks, mini-skirts, PVC, supermarkets, tin advertisements for Virol etc., petrol pumps and especially an extraordinarily wide range of film covering a spectrum from Jean-Luc Godard to James Bond.

In the *Observer Colour Supplement* for 7 August 1966, the drama critic Ronald Bryden contributed a brilliant essay on the spy cult. It was called 'Spies who came into camp' and was largely an analysis of the underlying perversity, fetishism and sado-masochism of the Bond films and their imitators. Bryden ingeniously but convincingly traced the new pornography back to Genet, the 'forbidden' writer of the 50s, but he attacked it for its hypocrisy. His concern was moral rather than stylistic. Even so he was very perceptive about the language of these films,

*A sardonic note. In Ken Russell's film about Rossetti and the Pre-Raphaelites Boshier acted Millais.

the visual language, and cited in particular the influence of the comic-strip.

The Bond of *Thunderball* leaping into the sky, streaking in primary colours through empty blue seas, has more in common with Superman and Flash Gordon than with the puzzled grey hirelings of Greene and Ambler. It is, of course, a source of private satisfaction that this technique of popularization also happens to be the most up-to-the-minute enthusiasm of cinematic insiders. Starting with Jean-Luc Godard . . .

Later he says something else I find very much to the point:

The majority of young British and American directors nowadays cut their teeth on advertising films for cinemas and television. What advertisers want is the shortest possible transition from the image of need to the image of their product, the image of satisfaction to that of their brand name. The technique of the commercial, you might say, is the jump-cut from wish to fulfilment. It has become the technique of the new international pop cinema.

The whole article was full of such insights. Bryden recognized the parallel with the tradition of the Arabian Nights. He pointed out how the spy, because he is working for his country, is allowed to break taboos in the field of both sex and murder. Writing at a time when the 'straight' Bond films were giving way to the send-ups like *Casino Royale* and *Modesty Blaise,* he was able to recognize that this too was simply another form of evasion. The genre subscribed to the false maxim that if a thing is ridiculous it can't be pornographic. This just isn't true. You can laugh with an erection, and the overtly camp sadism of *Modesty Blaise* – in particular the breaking of the clown's neck between the legs of a glamorous redhead – is nastier and more effectively sado-masochistic than anything in Bond.

What Bryden didn't recognize, or at any rate didn't choose to point out, was that the send-up spy film was in the end self-defeating. Parody, whether camp or not, is parasitic. When the host dies the parasite dies with it.

173

Pop camp, to put it another way, is a contradictory concept. Camp is an 'in' idea, the property of a minority. Once public property, once everybody is in on the joke it stops being funny. In the middle-60s we all became fetishists at any rate vicariously. We all knew Robin and Batman were pouves. 'Kinky' was a word everybody applied to everything except perhaps brussels sprouts. In the end it palled.

Films, too, illustrated this decline step by step. The earliest Bond films were the most interesting because they were the least self-conscious. *Modesty Blaise* was intermittently amusing, in particular Dirk Bogarde's villain 'Gabriel' was a genuinely bizarre creation, but then *Modesty Blaise* was based on a straight strip-cartoon, knowing but straight-faced. *Barbarella,* on the other hand, was a film based on a French strip-cartoon which was already a send-up of the American primitive tradition.

I'm only too aware that in the pop context words like 'primitive' and 'sophisticated' are inaccurate. As the original definition at the I.C.A. made clear 'pop' was not the opposite of 'sophisticated'. It did, however, imply artifacts made *by* sophisticates but for a mass audience. In the middle-60s what changed was that suddenly it seemed important to make sure that everybody understood the kinky joke. Finally 'low camp' stood up better. It's a pleasant coincidence that a recent *Carry On* film should be called *Carry On Camping,* and why not? There's nothing wrong with camp if it doesn't put on airs.

Yet it would be churlish and inaccurate to deny that the mid-60s inflated camp-cult succeeded in producing a few really enjoyable and elegant films and TV series.

On television I'd rate *The Avengers* as the most consistently intelligent use of the pop camp tradition. Its sexual ambivalence was without psychotic undertones. Its violence was balletic. Its stories poetic and absurd. It succumbed in the end to its own myth, becoming over-elaborate, over-jokey, but in its early and middle periods it was undeniably fetching. In comparison *The Man From U.N.C.L.E.* seemed clumsy and obvious.

The whole Batman affair, on the other hand, was an almost

classic example of the limitations of the giggle as an art form. The real Batman series were beautiful because of their unself-conscious absurdity. The remakes too at first worked on a double level. Over the absorbed children's heads we winked and nudged, but in the end what were we laughing at? The fact they didn't know that Batman had it off with Robin.

Finally the commercial 'pop' cinema turned moral, and began to rend and tear at its own flesh. *Darling* and *Blow-Up* (typically the latter was the work of a highbrow director) both set out to expose the empty hedonism at the heart of Swinging London in general and the alienated voyeurism of fashionable photography in particular. Of course like most illustrative works of popular morality they weren't totally successful in making vice repulsive – on the contrary – but that was their intention anyway. *Alfie,* on the other hand, was a superior analysis of the promiscuous trap, but this was because it played it straighter, less glossy, less 'pop' in fact.

By 1967 morality, albeit more situationalist, less authoritarian, was back.

The Swinging London pop style soon became obsolete and tatty, of use only to the laziest and least talented picture director. It lies in mothballs, ready no doubt for a revival in let's say the early 80s. The only medium which in any way still relies on it is the short advertising film, and that only marginally. Here too the Bond approach, usually ironic, has the most life left in it. There is a current telly commercial for St Bruno's tobacco which is pure Bond. A handsome man, smoking a pipe and accompanied by a bald bodyguard in dark glasses strolls through a Mediterranean town pursued by dollies all apparently 'turned on' by the smell of his pipe. He enters a walled garden and his minder slams the gates in the face of the sexually disappointed girls, but at the last minute, with a nod of his yachting-capped head, he indicates his choice, the darkest and most sophisticated, and she's let through and hurries after him to share his St Bruno-scented favours. It's quite funny in a rather tiresome way.

Less selfconsciously amusing, in fact grotesquely, hopelessly

passé, is a cinema commercial for gas-fires. This shows the whole Swinging London paraphernalia: the suggestion of a nice clean orgy among the blow-up plastic furniture, followed by some gas-fired bacon and eggs and a good frug to a Beach-boys LP.

As a friend of mine said, as one of the Ad-Lib-type girls finally moved out of the way to let the camera zoom in on the glowing product, 'It could only have been made for a national-ized industry.' Swinging London at the service of the gas board. *Tout passe. Tout casse. Tout lasse.*

*

Looking at a page in the *Melody Maker* for March 1968 I was struck by the way that the photograph illustrating an article on the British blues revival at that time clashed so emphatically with a half-page advertisement for Selmer amplifiers beneath it.

The blues heroes: John Mayall, Eric Clapton, Fleetwood Mac, Chicken Shack, were bearded, hairy, dishevelled, weary and meticulously grubby, and the two groups were actually photographed outside a West Kensington slum doorway with an overflowing dustbin on the steps. The intention, the image, was of urban poverty, a deliberate rejection of anything smacking of prosperity or compromise.

The advertisement, on the other hand, suggested a totally different life-style. It was headed 'Those Who Reach the Top Demand the Best', and most of it was taken up with a drawing of a pop group about to climb into a Rolls. They are neatly dressed in Carnaby Street-type clothes and are watching a uniformed chauffeur carrying their amplifiers out to put them in the boot. 'The Selmer Sound is the Sweet Sound of Success' reads a sub-heading.

This juxtaposition neatly illustrates the difficulty of pinning down the changes in pop style. The rejection of Swinging London as an ideal was already dying in the spring and summer of 1967, but there were already a lot of old-style pop films in production or queueing for release, a number of television series committed to that style; in other words a great deal of money

was striving, commercially, to keep Swinging London alive. What's more, for the first time in pop history the mood was superficially anti-materialist and in consequence unenthusiastically received by the commercial exploiters of pop fashions. There were at first sight no rich pickings to be got out of second-hand clothes (however exotic), bare feet and the minimum possessions. Yet in the end they needn't have worried. The apparent tramp-like leanings among the popocracy were about as genuine as when the court of Marie Antoinette played at shepherds and milkmaids. Although the emphasis had changed, there were still plenty of things to spend money on. For a start the pop world had decided to aim beyond the music itself: to try and create (and more importantly record) a total environment. For this they needed more than instruments and uniforms, more than ready-made clothes. They needed all the expensive toys of modern image-making, film cameras, tape recorders, electronic equipment on an enormous scale. They turned too, and for the first time, to other worlds: they commissioned record covers from established artists, they went to art galleries, subsidized mad inventors, embraced beat poets, created a whole court committed to living out the dream.

In a chemical trance they set out to hunt the visionary snark. To paraphrase Carroll:

> They sought it with day-glo, they sought it with love,
> They pursued it with light-shows and bells,
> They threatened its life with a nine till five job.
> They charmed it with smoke and smells . . .

At the time a great deal of this hunt was transitory. The 'Learn to Love Your Sperm Test' patterns of the light shows undulated over the walls and ceilings in monotonous if unrepeatable patterns; the dancers freaked-out and came down again; spontaneity was honoured; professionalism (outside music) was despised. Yet the aesthetic feel of that summer did gradually seep into the commercial media. With the banning of miming on TV, groups took to making little films to plug their new records and these tended to echo psychedelia although on

an increasingly innocuous nursery-rhyme level. The most ambitious attempt to present this vision, to turn on the square-eyed public in front of their sets, was a full-length film. The Beatles made it, and it was shown around Christmas 1967. It was a brave try but a failure in my view. It was called *Magical Mystery Tour*.

In the title song are the words 'We've got everything you need/Satisfaction guaranteed'. In the event, and at every level, they were to prove false.

Admass hated *Magical Mystery Tour*. It was perhaps the successful if accidental turning point in the Beatles' struggle to escape from the strait-jackets of popular favour. On the other hand the intellectuals didn't like it either. They felt, and rightly, that it was slack and self-indulgent. A passable home movie which would never have been shown without the Beatles' imprimatur. As a film, and despite a few remarkable sequences and some happy accidents, it came over as a bag of mismanaged tricks, and imitative tricks at that.

Yet it's not without interest. To begin with the music is admirable (if the songs had been realeased before the film and had had time to become familiar, the film might well have aroused less irritation). Yet again it emphasized how British the Beatles were. What worked in the film was not the fantasy or the jump-cuts but a feeling for British working-class folk-law: fat cross aunties, musical films of the 30s, music-hall comics and circus dwarfs, a Liverpudlian child's-eye-view of the war.

At the same time *MMT* is a fascinating piece in the pop jigsaw puzzle, an important if unsolved clue in the global crossword. It represents a trip in a bus, and one of the two sources of the psychedelic river was a trans-American bus trip organized and led by the novelist and acidhead, Ken Kesey. Around 1964, according to Tom Wolfe,* Kesey, leader of the non-mystic hedonist branch of 'the experience' loaded up his followers into a Day-glo'd bus and set off on this split-level 'trip'. They filmed and taped everything too. Now, were the Beatles aware of this? Did it form the seed from which *MMT*

* *The Electric Kool-Aid Acid Test.*

sprouted or was it an accident? Incidentally Kesey and his group, the Merry Pranksters, went with high hopes to see the Beatles performing at the Cow Palace, San Francisco, during their touring days and, despite their admiration for their music, found them, in that context, meaningless, 'little vinyl dolls' as Wolfe called them. Yet later, when the Beatles pulled out of standing there like four detonators to thousands of prepubescent orgasms, they took hold of all Kesey's dicta; they made a film about being 'on the bus', they were 'in the movie'. Conscious or unconscious? I don't know, but it was curious.

After a while the décor and surface of flower power and acid-trips duly filtered through into the mass media. The strobes and light-shows were added to the rest of the vocabulary available to telly-pop directors and designers. Products like drinking chocolate latched on to the beads and Hendrix hairdos to push their image. But the impact in no way equalled that of Swinging London, and for several reasons. For one thing the consuming classes felt little sympathy with the drop-out bias of the love generation. For another the press had almost from the start taken a censorious attitude to drug culture, an attitude rein-forced by the wave of prosecutions. On the other hand the notion of an involuntary 'trip' (LSD in a coke) became a popular device in the feature films of the next few years, allowing the directors the same licence for fantasy as had the 'dream sequence' in the 40s and 50s. Even so the psychedelic vision has never died completely; the current successful film, *Easy Rider,* is a proof of its vitality; but the emphasis has changed. The triumph of love has become a forlorn hope. The drop-outs seem like victims, forlorn frontiersmen of an alternative 'America' threatened by the oncoming tide of a grey conformist civilization.

*

Back in 1968, though, there was still optimism, and the next expression of this spirit, the next step in the development of pop style, appeared to speak out unequivocally in defence of the slogan 'All you need is love'. It was a full-length animated

179

cartoon called *Yellow Submarine:* a symbolic fairy-story telling how the Beatles set out from Liverpool, braving many dangers, in order to rescue the ossified inhabitants of Pepperland from the domination of the music-hating Blue Meanies.

Yet for all its admirable intentions, this film was perhaps in the end more damaging to pop in its revolutionary role than the most direct frontal assault. This was because, despite its eclectic visual style and neat symbolism, it drew heavily on the Beatles' past. It forced us to evaluate their music from every period. It placed them in a perspective, presented a kind of animated potted history.

The characterization of the Beatles themselves was the give-away. They were drawn more or less as they looked at that time, but they talked (or to be more precise the actors who dubbed their voices talked), in the flat punning patois of their early press conferences. For all the visual brilliance of the film, for all its designer's eclectic daring: the Hieronymus Bosch birds, the op art 'Sea of Holes', the Klee-like monsters, the images drawn from Ernst, Magritte, Chirico and Dali; for all the inventive animation: the strobe effects, the superimposition of photographic images, the use of words as objects – for all this it was in the end an anti-pop film: an animated museum. A modern museum certainly, cunningly lit, without clutter, its tableaux extraordinarily lifelike and with suitable period music to establish the mood, but a museum for all that, and the pop fans knew it.

Yellow Submarine wasn't in the present tense. It offered instant nostalgia for the day before its release and that at the very moment pop had rejected mind expansion and was beginning to make threatening anti-social noises again.

All My Hating

The summer of *Yellow Submarine* was the summer of the student revolt. By that autumn the harsh, heavily amplified urban blues were back in town. Only the Beatles stayed

loyal to the gentle mantra-like ambiance of the previous year.

The next startling shift in pop style was on television, and couldn't have been more different. The pretty whimsicalities of the previous year were stamped underfoot. Pop itself might refuse to commit itself but its intellectual champions were going to make quite sure it played its part in the revolution. In November, to the accompaniment of outraged noises from Mrs Whitehouse, Tony Palmer's *All My Loving* exploded all over our living-rooms. This is what I felt about it at the time.

A Personal Pop Credo

Presumably to absolve it from any didactic intentions, *All My Loving* (B.B.C.1) was subtitled 'A film of pop music'. This was essential. The film was more in the nature of an act of faith; Tony Palmer's own credo.

Palmer, as *Observer* readers will know, is fiercely committed to the pop canon as he understands it. He dismisses the shallow end almost entirely. For him it's the avant-garde who count, the Rimbauds of the music, who deliberately set out to derange the senses.

His film followed suit. It was a montage of images: musicians playing, talking, smashing their equipment. Girls shrieked, shrines were visited – Admiral Street, Liverpool, where Ringo saw the light, the gates of 'Strawberry Field' – and at the end we whizzed through the lot again at near-subliminal speed.

There were also a few words from the opposition: the Durante-like Mr Eddie Rodgers, ex-song plugger and advocate of 'bonhommie' and the days when 'moon' rhymed with June, emoted by the Thames. Anthony Burgess smiled with weary cynicism under a glittering chandelier. Youth knew nothing about life, he told us. Music can only be judged aesthetically, and in that case pop . . .

Yet what the young musicians had to say themselves didn't do much to redress the balance. Most of it was serious but naïve. Eric Burdon, for example, equated LSD with war – after you've lived through it, you're an adult. Really? Donovan was touching but ingenuous. McCartney made Beatle noises, and I'm afraid that Hunter Davies has over-exposed *that* market for all time. No, from what they said, sympathetic as most of it was, you'd have to be very young to feel they held the key to anything more than how to pull

birds; and indeed Jimi Hendrix who, after a very bold performance on stage, dealt exclusively with these particular perks, came over as rather more interesting than any of the mini-pundits.

The only theorist who I felt rated serious attention was the ageing hairy American, Frank Zappa, and he *hates* most pop music with all the special venom the Dadaists reserved for 'Art'. Like them he uses it as an offensive weapon, and he described how he would invite United States Marines up on stage and get them to mutilate a doll to the music. 'They really mess it up,' he said with gloomy relish. This leads us into the most controversial area of Palmer's film, the clips of atrocities: the napalm victim, the concentration camp corpses, the execution, the police beatings.

I take it for granted that Palmer was trying to say something he thinks to be important to justify these moments, but personally I didn't feel they were in any way justified. Zappa's mutilated doll is still a doll: a symbolic object he uses to prove his thesis. No doubt the young pop musicians do feel angry at the way the world goes, and express that anger through their music (for me it's a pretty negative activity, this taking it out on electronic equipment, but that's beside the point). But *real* men on fire, real blood, real corpses are something entirely different. They're not props. They shouldn't be used to try and bolster up an art form. It's not a question of 'good taste' but of human sensibility. Nor will it do to justify it by saying that *if* I am shocked, Palmer has succeeded in what he set out to do. I was shocked only by the equation that pop equals a man on fire screaming. No art equals this. It may be a cry of protest against it, but it's never the same thing, and here it *was* equated both technically and emotionally.

Yet this lapse aside, *All My Loving* was an inventive personal film. It said more about pop than a year of *Top of the Pops,* that dated weekly essay in nubility and careless superlatives. It managed to get across both the incoherent frustration and the child-like yearning of the best of the music. But next time no chic violence. It threatens to become the new pornography, and personally I much prefer the old.

Palmer rang up to complain I'd misunderstood his intentions and misinterpreted his film. I argued with him, imagining his bulky bear-like person and heavy bespectacled face, convinced as always that there was some unbridgeable gap (the famous generation gap?) between us. Tony Palmer always seems extraordinary to me. He is puzzled for instance by the reaction

people have to his pop writing. He will do a piece on a girl-singer making it quite clear that she is insecure and has bad legs and then wonder why she's angry when after all he's praised her voice. I sometimes suspect he's a Martian computerized to deceive us that he's a human being but with something subtly wrong fed into his reactions. There is no question, however, as to his conviction nor his technical brilliance. For better or worse, *All My Loving* had an enormous influence.

It was not, however, the only film in this spirit to appear at that time. Within the month Granada released a film almost identical in technique and spirit but too close in time to suggest the least suspicion of plagiarism. It was called *The Doors are Open,* was directed by John Shepherd, and provided a convincing example of what I think of as the epidemic principle in pop.

The Doors are an American 'heavy' group led by a singer called Jim Morrison and much rated by the Underground. Shepherd, too, cut between music, interviews and clips of world violence, but in fairness I didn't find the intercut horrors quite so offensive. This may have been because I'd used up my moral indignation on the earlier film or become more used to the idea, but I don't think so. Palmer's film concentrated on British pop and here, despite police harassment and the rumble on the far right, there has been less real sense of confrontation. To cut from a British pop group to, say, Vietnam seemed easy sensationalism. The Doors are American, though. There the crunch is nearer. The Chicago Convention, for example, and what they're doing seem part of the same picture.

Yet for all that I remained suspicious. In this film too the black leather and self-love seemed not so much a protest as an extension of violence into musical terms. Better to caress yourself than beat people to the ground, but that was all. Palmer's film, horrors apart, was the more thoughtful. *The Doors Are Open* seemed to confuse a symptom of the disease with its cure.

Between them these two films established the pop style still in use. The recent Granada film *Stones In The Park,* an essay on the free concert held in Hyde Park in July 1969, was

almost identical in technique: a rapid editing job using zoom lens, interviews, subliminal shots and ignoring any logical time sequence in favour of a jagged excitement. It didn't say anything or try to, in that it differed from its stylistic ancestors, but that too is typical.

*

Predictably the various pop styles, both cinematographic and televisual, have been fed back into the media from which they come. Comedy shows in particular have drawn on pop. The American series *Rowan and Martin's Laugh-In,* to take one example, is presented visually in a straight Carnaby-Street-period format with a few psychedelic trimmings. Children's programmes, too, have been strongly influenced. There is a series called *Zokko* which is totally pop in the modern self-conscious sense, while at the same time giving the feeling that all the items have been vetted to avoid damaging psychological effects (perhaps it ought to be called *Spokko*).

The format is a series of short items: a couple roller-skating perhaps, or some frogmen shooting rapids. But what my children like best is a weekly serial called 'Skane'. This in itself is a very nice example of the AC/DC effect of pop. The stories concern a rather pi spaceman, but are told through the medium of authentic-looking imitation comic-book frames blown up to look like Lichtensteins and acted out by disembodied voices. After the animated sophistication of series like *Thunderbirds* I would have imagined that children would have found this economical solution as rather a cheat but they don't seem to. There are also snatches of the history-is-camp syndrome in action: a few feet of *Felix the Cat* and a modern cartoon boy equally given to expressing himself through punctuation marks. Yet the pop genii of *Zokko* are its linking device, a pin-ball table (the pin-table is one of the gods in the pop pantheon), with a stylized mechanical face and the voice of a sad baby Dalek. The bull scores a number, the 'eyes' of the robot record it, and the voice having identified itself as if it were a minor tragedy, announces the next item.

184

Zokko is a curious hybrid in that it sets out to give children some visual and imaginative stimulation on their own terms. The Underground culture of the comics, having been made respectable by the pop artists, is here used to sell what progressive parents feel is good for children. While not against this in principle it does raise another problem: where can children go now to hide from us?

This same problem is presented but more acutely when it comes to programmes aimed, not at very young children, but at adolescents. How to convince them that they're not being brainwashed from behind a pop mask?

One of the most convincing attempts was almost predictably the work of Tony Palmer in the days before he and the B.B.C. parted company. It was called *How It Is,* a magazine programme, pop-flavoured but also dedicated to what was happening in both the arts and the more dramatic end of politics. Palmer always insisted it wasn't aimed at teenagers and it was finally moved to a later spot, retitled *How Late It Is* and then done away with, but despite his strictures it was one of the few recent TV shows which did attract adolescents not only because it was on at the right time (6 PM) but because it tended to identify with them without patronizing.

Not that it was by any means flawless. While not going as far as a contemporary of mine who always referred to it as 'How it is – wish it wasn't', it did present everything in terms of trendy excitement. On the other hand this is how most teenagers I know judge things anyway, and at least, in its scope if not in its treatment, it suggested that there were other figures worth paying attention to other than Che (He has risen) and the Stones.

But Palmer's most cunning stroke was in using people like John Peel and Richard Neville (the editor of *Oz*) as linkmen. This more than anything helped to convince his audience he was not out to con them. It's true that Peel's flat air of cultural infallibility and Neville's needling sneer irritated grown-ups, but that was why they were the right people in this context. Adolescents are frightful conformists. They need the imprimatur of people

they trust before they'll look at anything outside their own terms of reference. It is, however, significant that since *How Late It Is* disappeared no attempt to replace a programme of this sort has been made. For all its faults Palmer's approach was serious. The new puritan climate at the Television Centre (and Broadcasting House come to that) will allow pop music within limits, but seems totally against allowing any overt display of teenage revolt. Modified psychedelia is acceptable. The *Late Night Line-Up* show *Colour Me Pop* is a pretty but rather empty exercise in this genre and the film made to present the Beatles' new LP, *Abbey Road,* was equally innocuous, but the ideas seem, for the moment at any rate, back under lock and key. The pop manner has become respectable, pop matter is suspect. In the mass media too the revolt has turned into a style.

September 1969

Radio

'Radio 1 Is Wonderful'
B.B.C. jingle

The radio, or as my generation if not consciously anti-archaic is still liable to call it, the wireless, has been central to the spread of pop. At the same time there seems to be less to say about it than about television or even film.

This is partially because it has only one dimension – sound – and has had no need to develop a visual equivalent to pop music, only to relay it. Yet perhaps more important is the way it has been used by the pop generation. It's above all a form of mobile-pop, the equivalent of the bells on the fingers and toes of the young lady from Banbury Cross, that ur-hippy.

This couldn't have happened though without the development of the transistor. The old wireless-set, that solid and heavy object with its acid-filled batteries and elaborate fretwork face, even the post-war 'portable', a dumpy object weighing about as much as a small suitcase, would have been of little use to pop. They were still family objects, but the invention and mass

production of the transistor radio changed all this. It evolved at the same time as pop, another illustration of the chicken-or-egg rule which seems to operate so consistently in pop culture, and the transistor is a personal object like a wrist-watch or fountain pen. It both transmits and reflects the life-style of its owner.

Reyner Banham once wrote a brilliant analysis of the design of various pop-objects including the transistor at a certain moment in time.* He pointed out how the various features of the machine frequently embody fantasy disguised as technology. In function the transistor was at the service of fantasy. Held close to the ear or turned up full blast on work bench or in the study it coloured reality, distanced boredom, acted as a film-score to the teenage dream.

It belonged, however, to the time of classic pop. It's no longer anything like so powerful a fetish. With the coming of 'heavy pop' and elaborate electronic effects the swing has been towards the transistors' antithesis – the hi-fi record-player. The transistor is now little more than the housewives' comforter, a fact confirmed by the pattern of the aural wallpaper it churns out from the crack of the commuter's dawn to the small hours of the insomniac's night. Heavy pop, holy grail of the comprehensive top stream, is increasingly less represented. The West Indian-flavoured rock favoured by the Skinheads is seldom if ever heard. Radio I has a little jazz (jazz shows up also on Radio 4), but for the rest caters to a nation of kiddies and their mums, with a few programmes at the appropriate times for Dad sitting in his 1100 in a traffic jam on the way home.

Of all media, radio has been most persistent in isolating the pop spirit, in admitting it to exist as a separate entity. This is a comparatively recent development; in Lord Reith's day it would never have been countenanced, but with the division of sound radio first into Light, Home and Third, and more recently into Radios 1, 2, 3 and 4, the structure was there even if the use it was put to was the reflection of pop as the corporation would *like* it to be, rather than what it is.

*The Review Front of the *Observer*, 10 November 1963.

Even in Reith's day there was considerable concession to popular taste; from its beginning radio was recognized as a democratic instrument. Yet it was then a fairly grudging concession (the contemptuous way that Reith rolled the words 'dance-band leader' round his mouth was one of the keener pleasures of the famous two-part interview with Muggeridge). The general principle in the early days was educative and informative.

Reith's strange and dramatic retirement made some difference, the war an enormous difference. *Itma* paved the way for the Goons. *Music While You Work* was perhaps the first programme to provide a total environment. Like the electronic equivalent of a Negro work song or field holler the continuous music was aimed to encourage the flagging munitions workers to put their backs into it.

After the war the trend towards a less inflexible approach to popular taste continued. The unrelieved gloom of the Reithian Sunday lightened a little. There was a less rigid line drawn as to what was permissible. Yet the precursor of compartmental radio came originally not from the popular but from the highbrow fringe. It was the introduction of the Third Programme in 1946 that established the idea of a programme aimed at a particular group. The Home and the Light, while slightly differentiated in tone, were still close to each other: a hotchpotch of comedy, dance-music, plays and talks. It was true that you didn't get programmes like *The Critics* on the Light, or modern dance music on the Home, but there was still considerable overlap. It was a question of shading – of emphasis.

Up until rock 'n' roll, in broadcasting, as in everything else, popular music, whether played by dance-bands or disc-jockeys, was aimed at a comparatively mature audience. The feeling was of rugs rolled back. Edmundo Ros was the prototype of the immediate post-war years.

It's sometimes forgotten, however, that an alternative to the B.B.C. was in existence well before the war. Radio Luxemburg, especially on Sundays, provided an alternative to Reith, and while no doubt decorous enough by present standards, appeared

extraordinarily louche in those days, particularly as it included advertisements. As its object was solely commercial it was un- doubtedly the first true pop programme and the model for pirate radio when it came along in 1964. Yet Luxemburg too was slow in understanding the pop revolution of the middle 50s. It aimed at a consumer audience and it took some time for the realization that the new consumers were teenagers to sink in. It was the record boom that altered that. The recording companies bought air-space on Radio Luxemburg. Its musical output began to alter.

In Britain, too, but rather later, radio slowly acknowledged the new audience of the middle-50s. The request programmes, *Forces Favourites, Housewives Choice,* the personalized disc-jockey shows of the period (Jack Payne's *Off the Record* was perhaps the best) began to make room for the odd rock 'n' roll or skiffle record. In this they were helped by the dropping in 1955 of the mysteriously corrupt plugging system which guaranteed to those powerful music publishers who had paid a set fee, that fifty per cent of every programme of contemporary dance music would be devoted to the list of tunes they were interested in pushing. It's true that the removal of this legal strangle-hold led to an outbreak of bribery and near-bribery of disc jockeys and radio producers but at the same time, coupled with the shift of emphasis from music sheets to re- cordings as the mainplank in popular music, it also allowed the Corporation to reflect more accurately the public's taste in pop music and that public was to become increasingly younger.

Even so, in relation to pop, radio was to prove a more conservative medium than television. The ghost of Reith still walked the corridors of Broadcasting House (it never material- ized at Lime Grove), and it was not until October 1958 that a radio programme entirely devoted to pop music was given a large and regular dollop of airtime. This was *Saturday Club,* two hours of records, live groups and interviews which, for over eleven years, faithfully interpreted pop according to its lights. For all but the last two of those eleven years its M.C. was Brian

Mathew. I knew him well and worked with him (the trad boom was perhaps his happiest time; its exponents were about his own age, liked jokes and drinking in pubs), but in 1963 I went and talked to him for a piece I was writing. These were my conclusions:

Brian Mathew is an ex-actor who has established himself as the most professional and busy pop compère in the country. He links the whole of *Saturday Club*, the two-hour pop marathon recorded in bits throughout the week, compères *Easy Beat* which is a live show sandwiched between the omnibus edition of *The Archers* and *The People's Service* on Sunday morning, but recorded the previous Wednesday evening, introduces the artists on *Thank Your Lucky Stars* on Commercial Television, and has a Radio Luxemburg stint as well.

He has developed a definite persona. He doesn't pretend to be a teenager like the fascinatingly dreadful Jimmy Saville. Rather he seems like a young uncle who is on the kids' side, and who can put their point of view to disapproving parents. He has developed a completely classless accent, and refers to his audience as 'me old mates'. He introduces everything with controlled enthusiasm, but, rather sympathetically, will draw attention to good artists outside the current fashion. We met and chatted in the Sherlock Holmes, the nearest pub to the Playhouse Theatre where *Easy Beat* is recorded.

Pop was his job not his real life. The scene changed slowly, but it had to change because the kids wanted something new and exciting all the time. Of course this meant things came round again. In ten years there'd probably be another trad boom. It would be all new to that generation of kids.

Why, I asked him, was he so much more American on his Luxemburg stint? Because he didn't write his own scripts for Luxemburg, and they were written in that idiom.

I walked back to the Playhouse to watch *Easy Beat*. The show was its usual slick mildly enjoyable self. The gig musicians in the house band played through the backing arrangement with cool competence. They knew they would always be there whatever came and went.

Even in 1963 'the fascinatingly dreadful Jimmy Saville' showed the way that pop was moving but until Auntie made her disastrous attempt to go hip in 1967 Mathew held on. Then he

retired from the pop-end of the spectrum. He is still in evidence on Radio 2.

<center>*</center>

Brian Mathew was not the only member of Auntie's pop family. There was his older brother, Uncle David Jacobs. He had a lovely speaking voice and a ready smile, but he wouldn't stand for any nonsense. To be quite frank he didn't get on too well with his nephew, young Pete Murray. This became a family joke but it was rather sad really because although Pete was a bit wild, there was a lot of good in the boy; but everybody liked their Australian cousin, Alan Freeman. He had such a jolly chuckle in his voice. 'Hello pop-pickers,' he'd say. On the other hand everyone was a bit doubtful when another rather distant cousin came down from the North. Jimmy Saville did look a bit peculiar with his dyed hair and funny clothes. He had a regional accent too, not classless but regional, and he seemed at first to identify a bit too much with the kids. It was all right though. For all his flamboyance he was very strict about sex and things like that. He was very religious too which was a good thing, even if he went on about it rather a lot. He was soon accepted as one of the family and very cosy it all was.*

The big pop explosion of 1963–4 made comparatively little difference to the B.B.C.'s approach, it was just that there was more of it. Trad dwindled slowly away, the groups took over. On the Light at lunchtime every day there was a solid hour of live pop usually featuring a technically expert dance-band able to reproduce the records of the period and in many cases featuring two or three vocalists who could not only sing but mimic. There'd be guest stars as well, both groups and artists, who in general were less skilful at sounding like their own discs, and a tendency to invite giggling if inaudible girls from the audience up on stage to ask them to name a request. The B.B.C. had it all sewn up, their only worry the amount of screaming

*It was indicative of Saville's acceptance that he should have been chosen, at the end of 1969, to act as linkman on a B.B.C. TV programme called *Summing up the Sixties* and in this capacity should have interviewed not only pop stars but leading politicians.

that greeted the more charismatic guests. Then, in April 1964, the first pirate radio ship opened fire.

The pirate fleet, led by Caroline and London, acted as a focus for two separate brands of discontent. On the one hand they aroused the enthusiasm of those who resented the paternalism of Harold Wilson (the rear windows of cars owned by the more raffish members of the foulard scarf brigade carried stickers proclaiming their love of Caroline), while on the other they won the loyalty of the young Mods who rejected the paternalism of the B.B.C. The pirate ships, and later the pirate forts, by a mixture of cheek and legal loopholes held out for almost three years.

To be personal they weren't for me. It's true they played a lot of good records including the smaller and more experimental labels. (This had the effect of enraging the heads of the giant companies who claimed that the uncontrolled playing of recorded music by the pirates damaged sales whereas what in fact they meant was that it damaged *their* sales.) It's equally likely that by concentrating on tracks from LPs quite a lot of the time they were instrumental in shifting the taste of a wide section of the pop public away from the top twenty and towards the possibilities of pop music as a more profound means of expression. They were, anyway, less chart-fixated than the B.B.C.

Yet their deep loathing of silence, their collage of nonsense jingles and news flashes, with full echo chamber and an absurd 'March of Time' boom, their overworked, seasick, personality-cult-orientated DJs rattling almost audibly with pep-pills and jabbering compulsive nonsense produced, on me at any rate, a sensation of vertigo in three minutes flat. There were it's true incidental pleasures in the realm of sick humour. I shall not easily forget hearing on the car radio a pirate disc jockey in a state of what I can only suppose to be chemical euphoria explaining that the leader of the group he'd just played had been recently killed in a car crash. 'Bad luck,' he cried, adding, before announcing the next disc, 'Still, that's the way it goes.'

But then pirate radio wasn't aimed at people tottering on the

edge of forty and cynical with it. It was for the kids and not only gave them what they wanted but projected it with a certain evangelistic conviction. Nor was it all mid-Atlantic hype. There was room for excellent specialist programmes, on the blues for instance. More important, however, was its lack of predetermined formula. It was willing to experiment and by so doing it discovered a trend of a surprising and unlikely nature. Radio London was responsible. It put out a late show called *The Perfumed Garden* and its M C was called John Peel.

Peel is old by pop- standards; he was born in 1936. He has a curiously flat tired manner and a faint, but apparently acquired, Liverpudlian accent. He'd had his experience as a D J in the States, the Shangri La of most of his colleagues, but in his case had thrown away everything he'd learnt. His originality is to play not just pop (although he played a great deal of that usually from the end which was to become known as Underground a year or two later), but also classical music, both occidental and oriental, old records from the 20s, Satie, and even poets reading their poems. What's more he introduced everything as though he took it for granted that his public would find it all interesting and relevant, and so they do. There's none of the hearty do-gooder, none of the 'Chaucer could be jolly hip' approach about Peel. He's won over many thousands of young and up-until-then determinedly anti-cultural young people to the idea of a general culture.

Criticism can be made, indeed should be. What Peel offers is very much a predigested culture, very available. His audience aren't required to make any effort on their own account. He does their selection for them. Still it has been, in its way, a remarkable breakthrough.

*

Eventually the pirate radio stations were outlawed. They had long been a thorn in the government's side, a kind of caricature of free enterprise; but there was an unsavoury side to them, and the Postmaster General's hand was strengthened by a genuine boarding-party leading to a death by shooting on a pirate radio

station called 'Radio City' in the Thames Estuary. This, more than any of the earlier arguments against taking up air-channels that might be needed by sinking ships or crashed airplanes, gave the authorities a popular excuse to act and by the late autumn of 1966 the pirate stations were outlawed and forced to shut up ship.

Then the B.B.C., having regained their monopoly with government assistance, appeared overcome by guilt and determined to try and replace exactly what they had destroyed.

To this end they ditched the old Light/Home/Third structure in favour of Radios 1, 2, 3 and 4, of which Radio 1 was intended to provide a faithful equivalent to the late pirates.

The Corporation's first step was to sign up, on admittedly judiciously short contracts, almost all the ex-pirate DJs and then to photograph them, as a proof of good intent, on the steps of the Georgian church directly opposite Broadcasting House. Then the day was chopped up into sections, each allocated to one of the new whizz-kids, the old hands were either dismissed or put out to grass on the squarer pastures of Radio 2, and a series of pseudo-jingles extolling the new wavelength were taped in readiness. The results were dire.

The reasons aren't hard to pin down. The heart of pirate radio, its *raison d'être,* its main attraction, was its illegality. Everything else stemmed from that. Its jockeys might stammer and stutter and get things wrong, its equipment break down, its ships go off the air for hours at a time, but none of this mattered. Listening to pirate radio had the same kind of appeal as going to speak-easies during prohibition or drinking in a Pembroke-shire pub on a Sunday before they changed the Welsh licensing laws. Now it seemed fake, the equivalent of watching Buffalo Bill galloping round a circus ring.

In particular the jingles seemed totally meaningless. In the pirate days they had a function as clearly defined as hoisting the Jolly Roger; they identified the station. Now that the only station was the B.B.C. this identification was unnecessary.

Finally Radio 1 made another thing clear, that most of the pirate DJs were hopeless at their jobs, being dismissed at the end of their trial period, and soon the old faithfuls – Jacobs,

Pete Murray and Jimmy Saville – were back aboard. Gradually the imitation of pirate radio was watered down, and for long portions of the day Radio 1 was indistinguishable from the old Light Programme.

There were successes, however, even though from the B.B.C.'s point of view these may have resulted from the discovery that among those recruited from the mutineers there were several only too willing and eager to conform.

Simon Dee was one. His friendly public-school-cum-classless accent, his boyish good looks which, despite the trendy hair-do and floral shirt, were reassuringly wholesome, his easy near-indolent manner were an instant hit. His charisma was powerful enough to carry him out of sound broadcasting into television. Here it's true there were a few months of doubt. He looked initially almost painfully ill-at-ease. In the end this did him no harm; it made the public feel protective, and before it could become irritating he'd learnt confidence. In an interview show of staggering banality he soon established himself as a solid addition to the personality pantheon. There was even some talk of his entering politics as a Tory candidate, but this is now unlikely. At the time of writing he has just signed a remunerative two-year contract with I.T.V.

In the same field Tony Blackburn prospered, a blue-eyed boy next door uncommitted to anything beyond a totally acceptable charm, while for the rest, with the exception of a few mavericks, those pirates who held on peddle low-grade pop in the frantic mindless accents of Mid-Atlantica. Each searches desperately for an identifying gimmick – the dreadful child who says 'groovy baby' is one of the few successes in this supremely asinine sphere – there is an emphasis on cups of coffee and en-raged producers, bursts of taped rubbish, 'funny voices', tired superlatives. It's a desert and even Jimmy Young, the house-wives' phantom lover, comes as something of a relief. Of the two styles I find the rather prim pre-Radio 1 approach infinitely preferable.

Yet there are exceptions, three at any rate, and the first is a proof that even in this realm nothing succeeds like excess.

'The Emperor Rosco', né Mike (son-of-Joe) Pasternak, brings to this approach to disc-jockeying a near genius. His wild alliterative freewheeling punning ego creates before our very ears an extraordinary pop monster. What's more he plays good records. He only has an hour a week (too expensive? too disturbing?), but there's no question that within the limits of what is at best the flimsiest of all art forms his self-awarded honorary title is deserved. To listen to him is an unnerving experience, but it is a real experience. He is, in relation to this country's pale imitators, a true poet of pop-hype.

The other two originals rely on the contrary on their own native originality. They bring to pop their very British sensibilities. They win out by rejecting all traces of the hectic American tradition. One of them, John Peel, has already been mentioned in relation to his *Perfumed Garden* days. Transplanted in Auntie's window-box he would seem to be something of an embarrassment.

For a long time they gave him one of the *Night Ride* slots and, in marked contrast to the would-be sophisticated approach of his late-night colleagues, he continued to play his usual eclectic variety of records and to interview a gallery of bizarre people outside the usual show-biz range.

He eventually got into hot water by allowing John Wells, the *Private Eye* satirist, to express his very low opinion of the government's Biafran policy (there was even a cry of protest from 10 Downing Street itself). He was attacked on this instance on the grounds that it is always necessary on the air to present the opposite view on a controversial issue, but this was not the only reason that the B.B.C. find him difficult to accommodate.

Peel's main defect in Auntie's eyes is his total innocent honesty. He admitted for instance to having caught VD, an admission acceptable, even desirable, on *Man Alive*, but believed to be tactless in a member of the Corporation's permanent staff.

Yet at the same time, with clap or without, it's impossible to deny that, alone among the DJs, he has won an enormous committed following. Only he has any meaning for the thous-

ands of young people who, for example, go to the free concerts in Hyde Park.

My last hero is no reformist, and yet for me personally one of the few real pleasures offered on Radio 1 (for to be perfectly frank, at my age I find Peel's belief in his own infallibility more than a little trying). I refer to Kenny Everett, an original humorist who uses pop music as the launching pad for the rocket of his surreal sense of fantasy. Aided by two familiars: a hip grannie (derived from Tweety Pie's owner?) and a respectful Jeevesian butler, he turns Saturday morning into a manic happening. He too though is not the B.B.C.'s favourite; he is over-independent and anarchic for their taste, and has been frequently under a cloud for irreverence. D Js are meant to know their place.

Yet these three swallows are the only claims that Radio 1 has to a pop summer. There is no sign either that the new and more rigid programme proposed in that sad document, 'Broadcasting in the Seventies', will lead to a more imaginative approach in the future. The B.B.C. has pop safely under control, or at least on parole.

October 1969

Theatre

'Smoking is not permitted in the auditorium'
Announcement in most theatre programmes

If I've placed theatre last among the performing pop arts it's because I have a feeling that it hardly exists. There are several reasons for this, probably the most important being the fact that, unlike music-hall, theatre has always been a largely middle-class art form or at any rate since the invention of the cinema. To go to the theatre is a social rite. It means planning in advance, anticipation, arriving on time, clapping at a given time, passivity on the part of the audience: all very anti-pop notions.

Theatre in fact drags its past around like a ball and chain,

and every attack on its traditions from within: eccentrically shaped stages, improvisation, the use of back projection, film and tape, only succeed in emphasizing its stubborn traditionalism. To make it work it's essential to be aware of and accept those traditions. When John Lennon's play, *In His Own Write,* was shown at the National and he and his party arrived halfway through the play which preceded it, everybody in the theatre bristled with irritation including the avant-garde. 'Bad manners' was the phrase circling the foyer during the interval, but good manners are not a pop preoccupation.

In a way all pop is theatre, but theatre of a very different kind. It is by nature fluid, timeless, able to alternate between moments of hysterical excitement and long periods of boredom. It has no linear or narrative structure. Its celebrants must feel free to cut off, to 'do their own thing'. Quite apart from its class role, the cinema is much closer to pop in that it is both more and less real. Its images, speed, editing, abrupt changes of scale are nearer to the way we think, or at any rate think we think. A good film seems like the projection of our dreams and fantasies. A play remains a performance.

Stage actors are clearly real people doing a job. They say the same words every night, and make the same moves and gestures. We clap them because they are clever at pretending to be other people. In pop terms this is an irrelevant skill. Hamlet spoke admiringly about the tears of the actor lamenting the death of Hecuba. For the pop generation the question 'What's he to Hecuba?' would carry a dismissive meaning.

Recognizing their inability to reach a generation, and correctly analysing its causes, certain theatrical directors have tried to find a way through, and the most usual solution has been the attempt to involve the audience in the play. We have grown used in recent years to the invasion of the auditorium, to demands for comments or ideas from the stalls, to the sudden realization that the man sitting next to you is wearing stage make-up and is about to intervene. This activity is always embarrassing. For me at any rate it has something of the effect of an unwelcome sexual advance varying of course in intensity

from the equivalent of a hand on the knee to rape. Nor do I find it any excuse to say that this is its intention. I don't want to pay to be raped, and besides it isn't even real rape. When the audience do react and shout back or feel up the actresses, the actors are nonplussed. It's my belief that the point of theatre lies in its distance from its audience. Brecht was right. It works through preserving our alienation. Ken Tynan's sardonic cry from the stalls on the first night of the Royal Shakespeare Company's production of *US* was a very witty put-down of the actors' newfound pretensions.

After an evening during which the cast had spent far too much time crawling about the aisles with bags over their heads pretending to be wounded Vietnamese and so on, they were standing in a row with their heads bent looking very silent and humble. Although everyone was pretty sure it was the end of the performance it was difficult to be sure. It was obvious anyway that the curtain wasn't going to fall and if anybody moved they felt they'd probably be insulted for bourgeois complacency. At last Tynan could bear it no longer.

'Do we applaud you,' he shouted, 'or do you applaud us?'

I'm sure that Tynan didn't wish to suggest that an actor has no right to feel strongly about social or political issues, but he was irritated, and rightly so, by the basic frivolity inherent in the idea that it's possible for an actor to feel identically committed every night and twice on Saturdays. Tynan was after all the most fervent champion of Lennie Bruce, and Bruce didn't hesitate to tackle serious subjects, but then Lennie was out there on his own. He really improvised. It's true he made use of certain fixed reference points but he was different every night. He was his own playwright, his own director. But once you have a stage full of actors they can only pretend to improvise or at best improvise only within strict limits. The audience know this and resent it. They know they are at a disadvantage in having no lines to say. They resent their lack of rehearsal.

The further from traditional theatre the nearer to the happening, and the happening is admittedly a pop form. The trouble is that the happening at its purest tends to monotony.

Once you've flashed your privates at the audience and shouted a few insults, there's not much left to do and the temptation is to stage fake happenings. Julian Beck's Living Theatre are in essence a very talented and disciplined troupe who stage fake happenings but in their case – and at least they fake with great conviction – I have the feeling they were more interesting in the days of *The Connection*: a real play in a real theatre, and more of a genuine experience than all that writhing about and shrieking and naming of holy parts.

The last generation of British avant-garde, led by Joan Littlewood, have recognized the nihilism of the happening. Littlewood may have reduced the playwright to a subsidiary position and stressed the importance of improvisation at rehearsal, but once the play was open it was set, and Miss Littlewood's unannounced visits were followed by terrifying interviews with those who had presumed to act on their own initiative.

Even Charles Marowitz's experimental Open Space theatre is subject to its own conventions, but then Marowitz has attacked the Underground from the inside, taking it to task for its nihilism, self-indulgence and refusal to think or act.

As to the traditional theatre, *US* apart, it has recognized pop as a useful decorative convention which is available, among other conventions, as a way to tart-up certain plays. An all-male *As You Like It* with a Habitat-style Forest of Arden may be amusing, even stimulating, but it has nothing to do with pop.

Is there no British pop theatre then? Very little, but to my mind one of the few successful stabs at it has been the work of a group of eccentrics called the Alberts. For one thing their theatrical performances are simply an extension of their ordinary lives. The impression is that they have happened to find themselves on a stage facing an audience, but are not going to allow this to affect them in any way. Luckily for their audiences their ordinary lives are very odd indeed.

The strange thing about the Alberts (their basic personnel, the brothers Tony and Dougie Grey and 'Professor' Bruce Lacey has remained unchanged from the early 50s) is that while

their influence has been widespread, they themselves, despite moments of popular favour, have remained comparatively obscure.

Among other innovations, the Alberts were the originators of what might be called satiric pop music and therefore the putative fathers of the Temperance Seven during the trad days and the Bonzo Dog Doo Dah Band in more recent times. They were on the fringe of the Goons, and have appeared, either collectively or individually, in several TV and cinema films directed by Ken Russell and Dick Lester. As to why they have survived in the shadows while whose they engendered swam out into the light, I believe the reason is that they are totally serious. Surrounded by extinct musical instruments and ancient machinery, dressed in daily life as if they were Victorian lifeboat skippers or First World War German pilots, they preserve a grave courtesy which holds mockery at bay, but at the same time worries people. They are pop figures all right but, like the painter Peter Blake, they are 100 per cent British pop figures. This too makes them suspect.

Their rare theatrical performances – *An Evening of British Rubbish* had a respectable West End run – seemed to me one of the very few successful examples of native pop theatre. Surrounded by an insane clutter dominated by a penny-farthing bicycle they held a remarkable balance between chaos and order. They made no attempt to bully or seduce their audience but succeeded (on good nights) in drawing them in to share their obsessions. Miraculously they avoided the inherent whimsy which tends to attack this kind of eccentricity. Here there was no question that it was Professor Bruce Lacey who was responsible. Unlike the Grey brothers who are romantic optimists, he is barely in control of his hatred for whatever seems to him to be unloving or morally dead. He expresses this hatred through a series of explosive and dangerous machines built largely from the detritus of earlier stages of technology. With his rolling eyes and filthy Edwardian evening clothes, speaking in the affected rasp of a failed conjurer, he gives off an aura of real if ludicrous menace. Among his other targets are actors, whom he despises.

To symbolize his scorn he has invented some mechanical actors who, with the aid of built-in tape-machines, perform certain inane plays before blowing themselves to pieces.

Lacey has also worked in conjunction with Jeff Nuttall, but it is his association with the Alberts that has served his histrionic talents best. He is, however, a brilliant and disturbing maker of assemblages and robots.

Nuttall himself is another contender in the British pop theatre stakes.

Yet finally there is more real theatre in a performance by say the Who than in any conscious attempt to graft pop into the theatre proper. For reasons I have tried to suggest the theatre rejects the new form and pop itself is not all that interested anyway. The final irony is *Hair*, the negation of pop, a completely traditional theatrical presentation sailing under false colours. Here everything, including the invasion of the audience, has been rehearsed with the precision of a military parade. The four-letter words and the famous naked scene are minutely adjusted to shock nobody. The middle-class audience sit bathed in a self-congratulatory glow at its own tolerance.

At the end the more convinced spirits can get up on the stage and dance with the cast, but not for too long of course.

October 1969

Pop Literature

'But I've gotta use words when I talk to you'
T. S. ELIOT *'Sweeney Agonistes'*

As to pop literature the question is more whether there is any. Pop has been consistently prejudiced against the written word in favour of that which is spoken or sung. This is consistent. The written word, at any rate 'between hard covers', represents permanence of a sort. Thought is trapped there. It can be referred back to, evaluated, used in evidence. It's true that a gramophone record is equally concrete (Dylan's denial of his earlier political commitment is proved nonsense because his early records still exist), but at least the LP or 45 remains a comparatively modern object; it lacks that historical authority which the book represents. Literature suggests a continuum.

There is a further objection: to write and to read are solitary activities. Pop is communal, tribal, a shared experience. A man who reads is alone with the author. A serious book demands sustained concentration: the retention of an argument. Pop, at its purest, works like a laser-beam. It penetrates the moment like a burning point of light, leaving both past and future in total darkness.

Pop has created another if incidental defence against literature: its deliberate impoverishment of vocabulary. Those committed to it are in many cases literate and educated, but, voluntarily, they have reduced their word power to a few basic and nebulous expressions. Pop slang, unlike that of earlier closed societies such as the jazz world or the underworld, is without colour, without vivid or racy metaphor, without room for personal improvisation.

It changes of course. Its sense of exclusivity demands that as soon as the media have made its passwords public knowledge they must be rejected, but even here it tends to revert back to

earlier expressions rather than to invent or take over new ones from other sources. It's more the way in which this basic language is put together that counts. It's the rhythm which acts as the signal by which one member of the pop society recognizes another.

The original source of pop language is largely that of the American beat movement of the 50s which itself came directly out of that invented by the Negro hipsters of the bebop era. Very little has been added, a great deal has been taken away. To the outside ear, for a short period, pop (as language) sounds both exotic and incomprehensible, but in the minimal time it comes to seem infuriatingly and perversely limited. Here for example is a short list of current expressions.

guy, a man
chick, a girl (or, since the advent of unisex, a 'guy')
beautiful, sympathetic, admirable, excellent
weird, strange but admirable
pig, policeman (this has partly replaced 'fuzz')
a straight, a non-pop person. Anyone over thirty. A supporter of the establishment etc. (This word had many if not all the connotations of the outmoded 'square')
cool, a word of almost innumerable meanings, most of them favourable. It implies the ability to conceal emotion or anger in the face of official provocation. (Hence 'to lose one's cool' is considered a bad if sometimes forgivable lapse.) Used as an adjective as in 'He's cool', it means that his behaviour, clothes, tastes etc. add up to an acceptable or admirable whole. But, in a more specialized sense, 'to be cool' means to be without drugs on one's person
a freak, a strange but admirable person within the current mores of pop and (conversely) one whose appearance or behaviour especially infuriates the 'straights'. Hence also 'Acid freak'. One whose excessive use of LSD or one of the new hallucinogenic drugs is considered to form the basis of his behaviour or appearance
a head, virtually interchangeable with a 'freak'
to freak out, to behave in an exaggerated manner due to the effect of music, drugs or any other extreme stimuli
to blow your mind, ditto, although originally it had a purely chemical connotation

to turn on, to use a drug in order to 'blow your mind'. Therefore it has also come to be used in relation to music, poetry, light shows etc.

to groove, a groove, a word of general commendation. It can be used musically, sexually or in any other relevant context

to be busted, to be raided and/or charged by the fuzz for an offence, usually connected with either drugs or pornography

scene, the place where anything is going on. Thus where good music is being played is described as 'a good scene'. When the police burst in accompanied by their pot-trained dogs is decidedly 'a bad scene'. There are also weird and freak scenes and draggy scenes. 'Scene', like so many other pop terms, is of jazz origin

drag, so is 'drag'. It means boring, and may be used as an adjective or a noun, e.g. 'He is a drag. She's a drag chick man'. Its other meaning, women's clothes worn by transvestites, and, by accepted usage, any exaggerated clothes, is also fairly common

man, another jazz mode of address

Sexual metaphor, an area which above all has exercised the ingenuity of earlier enclosed groups, is noticeably uninventive. Certain Americanisms: 'to ball' (copulate), 'a blow job' (an elaborated version of fellatio) have become acceptable, but for the rest 'to plate', 'to screw' (also used in an aggressive and non-sexual sense as in 'to screw the system'), 'to make' or 'make it' – these are all long established euphemisms.

A further negative peculiarity connected with pop speech patterns is the all-pervasive use of the meaningless phrase 'You know'. My own view is that this is of Liverpool origin (I remember noticing its linguistic ubiquity from my childhood), and was injected into pop phraseology by the Beatles. In all events it is now obligatory, even among American pop musicians.

From America itself, however, comes the replacement of 'Yeah' for 'Yes'. This has passed far beyond the frontiers of the pop world and is used a great deal by the younger upper classes, especially when in conversation with their social inferiors in the belief (mistaken) that it makes them appear more friendly.

There is also a graveyard of pop expressions for, like the

population of one of the Hebrides, although the vocabulary was small to start with it's getting even smaller. Here is a short list: gear, with it, swinging, switched on, in.

'Grotty' too, and yet 'grotty', while gaining currency at one period was in fact the invention of Alun Owen. He wrote it into the script of *A Hard Day's Night*.

The final mark of verbal pop is its pronunciation. This is classless, in that it is used by people irrespective of their class origin, but is based on cockney, not in the old 'gor blimey' sense, but by its rejection, wherever possible, of all consonants. Thus:

I went up to the Roundhouse and heard the Soft Machine. Then I came home and played the latest Jethro Tull L P

becomes:

I wen other Row How y'no, unher the Sof Mushen y'no, un the ah cummo un pluther lurus Jurrentll Ulpee y'no.

Of course, not all pop people talk like this; the Soft Machine for a start are not only verbally precise but exceptionally literate, with a keen and specialized interest in pataphysics, dada and surrealism. Furthermore as the age group interested in high pop music takes its usual swoop towards the early teens, this deliberate slurring is seen to act as a parent-irritant and prized for that too. Nevertheless, in the main the pop voice and vocabulary is used as a matter of course, and has led to a culture basically anti-literate in the traditional sense.

At the same time poetry, as the expression of revolt, is honoured, and this has led to a certain amount of double-think. At the famous Rolling Stones Free Concert in Hyde Park Mick Jagger (the epitome of the pop voice and vocabulary) read a poem in memory of Brian Jones whose death had taken place a day or two before. A fourteen-year-old who had been at the concert told me about this the same evening. I asked him who the poem was by. He said it was by Che. I was perplexed by this in that as far as I knew Guevara had never written a poem. The next day in the papers I read that the poem was in fact by

Shelley, but when a month or two later I saw the film about the concert on TV Jagger indeed said, 'n' here for Bry is a pome by Che'. The poem was followed by the release of clouds of butterflies. Many of the audience were moved. How many adults who can pronounce 'Shelley', and even know his first names were Percy Bysshe, have been as moved by his poetry?

The definition of inferior poetry given by a friend of mine as 'what people write who are too lazy to write prose' is certainly applicable to a large body of recent pop poetry. Much of it is sloppy and imitative, relying on predictable emotional response, placing far too much dependence on earlier models as a justification of the rejection of a need for second thoughts or indeed of any self-criticism at all.

In particular many pop poets have wilfully chosen to mis-understand surrealism, seizing on that movement's early belief in automation as the true key to poetry, as a licence for their own lack of discrimination. In this they obstinately choose to ignore that the surrealists themselves soon realized that, while automatism may be a useful poetic tool, the subconscious allowed its head is liable to gabble nonsense. What's more, in recent years some pop poets have compounded the offence by subscribing to the belief that the imagination can cover more ground on chemical crutches; that a poem written under the influence of pot or LSD must be of more significance than a poem produced in full consciousness. This is nonsense. When drunk or drugged everything certainly appears more significant (so do those absurd statements which spring into the mind on the borders of sleep). Re-read later, most of these discoveries usually turn out as dull as those stones which small children insist on bringing home from the seaside because, wet with spray and reflecting the marine light, they had seemed the essence of mysterious and meaningful beauty.

This is not to put down the reality of such experiences, how-ever. The mistake is to imagine that all that is necessary is the belief that their transmission is an effortless activity. A poem is a reconstruction of experience, not a slipshod description of it. Wordsworth's definition of poetry as 'Emotion recollected in

tranquillity' remains valid. It is, however, much easier to write in a state of high. Rimbaud's 'derangement of the senses', Ernst's 'inspiration to order' remain seductive imperatives. What many pop poets ignore is that Rimbaud, Blake and their other heroes were geniuses. Anyone can believe they have gained access to the artificial paradises simply by turning on, but a straight description of what they find there is not in itself enough and usually seems as boring to those who were not with them as other people's holiday snaps. Furthermore the subconscious is a curiously conscious mimic. Most psychedelic pop poetry reads like weak imitation of the great originals. There is in fact no easy access to poetry and it is the pop poets' refusal to admit to this which has driven the traditional critics to dismiss pop poetry out of hand. Conceiving the poem as something wrought and finished, they have become beside themselves with rage at the pop poets' insistence that a poem is the equivalent of bird song. In their terms the critics are justified, yet they choose to ignore pop poetry in its social context. The pop poem is not initially designed to be read on the page, but to be read aloud in front of an audience. Like pop music it is intended to work immediately and, also as in the case of pop music, it depends as much on its performance as on its content. If there is to be a criterion it must be different.

This trouble has arisen largely because the pop poets have been seduced into traditional publication, gathered into anthologies, flattered into betraying their aims. What's more, helping to confuse the issue is the fact that among the true pop poets are several poets of traditional qualities, and these have been used by the critics as handy sticks to belay the others. Among the 'Liverpool School', for example, Brian Patten is usually conceded some qualities, while in recent months the Birmingham poet Roy Fisher has attracted a great deal of favourable attention. Rightly too, both these poets 'work' on the page, but there is a false emphasis in this grudging selectivity, a misunderstanding of the context of pop poetry and worse, a distortion of its historical development.

What has been ignored is that the Underground entrance to

poetry has been available to everyone and that the 'real poets' who used it may have done so quite deliberately in that they sympathized with pop's attempts to reach an audience traditionally deprived of poetry. There is also perhaps another, less idealistic, explanation. Most of these young men were provincial, without the social or educational qualifications necessary to stake out one of the limited claims on the metropolitan slopes of Parnassus. They were, however, welcomed by the little Underground magazines, and when both pop culture and provincial origins became fashionable they were naturally among the company.

The attacks of the critics have led to another fake situation. Instead of refusing to defend pop poetry, its champions have tried to reply in kind. Michael Horovitz's recent Penguin anthology *Children of Albion*: *Poetry of the Underground in Britain* is a representative collection displaying both the qualities and faults of the Underground school, but his long, constipated defence written in sub-Blakean prose which, however genuinely felt, set my shit-detector ringing like a fire station's alarm bell, not only played the traditional critics' game but played into their hands.

What is needed in fact is not a justification of pop or Underground poetry in relation to 'high' poetry but a sympathetic analysis of the needs which produced it. Here lies not only its origins, but its glory. It came, after all, out of a yearning for the marvellous, out of a need on the part of the educationally deprived to find a voice. It postulated, like the surrealists, that it was possible, through thought, to transform our perception of reality. Out of the material to hand – revivalist jazz, comics, movies – they constructed an iconography. Through serendipity, uncanny in its widespread and originally unconnected uniformity, they rediscovered the surrealists and dadaists, and discovered the American beat poets like Ginsberg and Corso.

Today with surrealism reinstated, jazz accepted by the establishment, pop imagery in the museums and a certain amount of what was to become known as pop poetry published

(despite the opposition of the traditional critics) in respectable literary papers, it's difficult to recognize the originality of this development in its time. Throughout the 50s and early 60s the British Underground, like a system of forgotten canals, carried its pioneers from centre to centre. Folk singers, poets, musicians travelled the country to a seasonal itinerary. The little poetry magazines spread the word.

Yet it's necessary to insist that, to begin with, Underground poetry was not pop poetry. To be pop is to act as a reflection for a mass audience. To start with, the Underground, while widespread, was still very much a minority concern although a growing one. It became pop in the full sense on 11 June 1965 when an Underground committee called the Poets' Co-operative booked the Albert Hall, 6,000 people read the smoke signals and turned up, and the media, who until then had shown no marked excitement at the existence of the British Underground, turned on the arc-lamps.

This concert brought together many elements which, up until then, had remained separate from British Underground poetry proper. In particular the American-orientated metropolitan flower-powered Underground tended to dominate, drug culture was emphasized, and so on, but this remains the moment when the British provincial Underground could be said (with certain obstinate exceptions) to have gone pop.

As is always the case in pop manifestations, this great explosion was the result of pressure building up over a period, and there is no doubt in my mind that the crater of the volcano was not London, but Liverpool.

There were several reasons for this. For one thing there was that city's freedom from metropolitan envy. As Alun Owen has pointed out, the 'Pool feels itself closer to Dublin, New York, even Buenos Aires, than it does to London. There is none of Manchester's competitive jealousy or Birmingham's lack of cultural identity. Liverpool's maritime tradition has been cultural as well as practical. Its predominantly Irish immigrant population has given it a love of rhetoric. It's very aware of its own myth and eager to project it.

Another favourable condition was the ready-made existence of a bohemian quarter, Liverpool 8, a district of decaying Georgian squares and terraces at the centre of the city, an area which in London would certainly have been reclaimed by the trendier middle classes. This provided cheap rooms and flats for a colony of native artists, musicians, poets and layabouts, many of whom were prepared to welcome the itinerant Underground on its annual peregrinations.* Liverpool 8 had a seedy but decided style; its own pubs and meeting places; it was small enough to provide an enclosed stage for the cultivation of its own legend.

Yet all these favourable portents might have come to nothing without the presence of a figure charismatic enough to act as a scouse equivalent of Apollinaire, Adrian Henri, painter, poet, creator of very early 'happenings', was there to fulfil this role. This bearded, bespectacled, pear-shaped, polymath talent was as central to the metamorphosis of British Underground into pop as the Beatles were in relation to beat music. By the very early 60s he had imposed Liverpool as the Underground Capital. He was responsible too for spreading the gospel according to St Jarry, St Breton, St Magritte and St Apollinaire himself with such evangelist fervour that they permeated, however superficially, the thinking of a whole generation. Around him he gathered a colony of talents: the painter Sam Welsh, the satirist, poet and musician Roger McGough, the poet Brian Patten. He recruited from outside people like Pete Brown who, together with Mike Horovitz, had for several years been experimenting with jazz and poetry, and he adapted their ideas to accommodate pop and poetry in the emerging canon. He corresponded with other like minds all over the north. He collected visiting celebrities whom he felt might be sympathetic to his ideas. He waited his moment.

Henri, like his idol Apollinaire, is eclectic. To my mind what he does best is paint, but it's also what he does least of. It reaches fewer people, and he is obsessed with communicating.

*See *A Picture to Hang on the Wall* by Sean Hignett and *All Night Stand* by Thom Keyes.

213

He is generous though in pushing others. He is a formidable entrepreneur.

Edward Lucie-Smith's anthology, *The Liverpool Scene* (1967) is dedicated 'To the Beatles without whom &c' and rightly so. The success of the Beatles directed the attention of the mass-media towards Liverpool and Henri, true heir to pop, was not one to hang about. But before this happened, before the Liverpool scene became public property, at a time when the Beatles were still for the most part local heroes, Henri had invited Ginsberg up to Liverpool and Ginsberg had written:

Liverpool is at the present moment the centre of the consciousness of the human universe.

A typical exaggeration, just the thing to set the middle-aged teeth on edge, and yet if you substitute 'the young' for 'the human universe' it was surprisingly accurate.

And so the provincial Underground became public property. The pop poets were published and appeared on television and were attacked and defended from within the ranks of traditional culture. They formed an uneasy alliance with the U.S.–London axis and reaffirmed their treaty with a few of the older poets of protest like Adrian Mitchell and Christopher Logue. Finally, and logically, Henri, McGough and that honorary freeman of the Liverpool scene, Pete Brown, went truly pop and formed and led straight Underground pop groups. The Liverpool adventure was at an end.

But not all the provincial Underground chose to ascend the pop escalator. Some preferred to remain below cultivating their own mushrooms.

They provide an alternative rather than a pop culture, and yet they earn their place here in that, not only do they share the same roots, but, in their writing, they have in many cases analysed from the inside the origins of the pop Underground. Writers like Eric Thacker and Tony Earnshaw in Leeds, the previously mentioned Roy Fisher in Birmingham, the art-school teacher Albert Hunt in Bradford, these are all important abstainers. Above all in this context, Ray Gosling, social

anthropologist gone native, and Jeff Nuttall, the author of *Bomb Culture,* are essential to the understanding of the pressures and aspirations of the true underground in its formative pre-pop years. They are prepared to face the full implications of what they and their generation have brought about, to re-examine, however painful it may be, how their demands for absolute freedom without any imposed moral strictures stand up in the light of, say, the Moors murders. They are the conscience of the British Underground, unsentimental and admirable.

*

Pop journalism, on the other hand, is not concerned with roots but with fruits. It may be divided into two sections: a few journalists, notably the *Observer's* Tony Palmer and the *Guardian's* Geoffrey Cannon, who feel their job is to press the claims of pop as a serious art form on the straights, to establish a critical apparatus in fact. Palmer tends to be tough, dispensing more kicks than ha'pence, turning ferociously on those he feels to have strayed from the oath of pop righteousness. Cannon, on the other hand, praises extravagantly where he can, and in a mandarin style which frequently earns him a place in *Private Eye's* 'Pseuds Corner'.

Less self-conscious than either and frequently more to the point, are the staff reporters of the *Melody Maker,* by far the most serious of the traditional musical papers. This is extremely well-written, has built-in shit detectors, and goes in for admirable interviews in depth as well as general coverage and comment on trends, however transitory. It's streets ahead of its teeny-bopper rivals, *Disc* and the *New Musical Express.* As a detached but sympathetic guide to the pop world, although naturally with an emphasis on its musical side, the *Melody Maker* remains unbeaten.

The Underground itself has its own organs, principally *International Times* and *Oz.* Both are produced with difficulty. Printers refuse to print. The police harass them on the grounds of obscenity or because of their attitude towards soft drugs;

newsagents refuse to stock them, and yet somehow they carry on. Neither has much to recommend it to a generation over twenty. *IT*, in particular, is written, deliberately written, in hippyese at its most basic. Its attitudes are totally predictable. It's in favour of soft drugs, free love, screwing the system, avant-garde pop. It's faithfully present at the christening of every pop trend and is conspicuously absent at the funeral. It really does read as if it were produced by a hairy computer. Only its courage and obstinacy are admirable.

Oz is a different case. It at least suggests it's produced by human beings and its editor, the Australian, Richard Neville, seems to be both bright and verbally lucid. In print his provocation of the authorities is humorous and mischievous, his obscenity life-enhancing, his advice (when it springs from his own experience) is realistic. Yet the prose style of *Oz* is pretty sloppy (although I suspect that this too may be deliberate), and its typography, while inventive aesthetically, makes it extremely difficult to read. Neville himself claims that this is to make sure that no one over thirty reads it. Well that's fine by me as, even when I have persevered with an article (printed as like as not in pink on orange), the content has struck me as distinctly on the thin side. *Oz*, like most true pop manifestations, is against the written word, and anti-newspapers, but its imagery is remarkably original. Every issue I've seen has been at any rate a beautiful visual object: an image-bank.

Finally, catering for the flying saucer set, there's *Gandalf's Garden*. It's gentle, pretty and nonsensical: that is, unless you happen to believe (as I do not), that Jesus and/or King Arthur are hovering in a UFO over Glastonbury waiting for the right vibes . . .

*

Although pop culture tends to despise the printed word, recognizing it quite correctly as the centre stone of the arch of traditional culture, there is nevertheless a growing body of work related to pop, and although most of this has been already

mentioned in context somewhere in this book it would be illogical to ignore it here.

Literature about British pop culture divides into three sections: fictional, sociological and straight documentary. As yet the fiction would occupy the smallest space on the shelf. Indeed after MacInnes's brilliant start with *Absolute Beginners* in 1959 there was a surprisingly long gap. The few modern examples, what might be called post-Beatle pop fiction, favour sensationalism, providing vicarious kicks for straights with lots of drugs and sex.

Sean Hignett's *A Picture to Hang on the Wall* (1966) described the milieu from which the Liverpool scene emerged.

Thom Keyes's *All Night Stand* (1966) also begins there, but follows the fortunes of a Beatle-like group to international acclaim and the recognition that 'nothing is real'. A traditional moral tale in fact, but enlivened every five or six pages by a short burst on the pornograph. It's not bad though, written very much from the inside and displaying not only a wide knowledge of the pop music scene, but considerable imitative talent. The book is divided into four sections, one for each member of the group, and catches the intonations and thought patterns of four well-defined Liverpudlians.

A more recent example of the same formula is *Groupie*, a joint effort from Jenny Fabian who was one and Johnnie Byrne who helped her describe what it felt like on paper. A groupie is a girl who sleeps with groups, and although as yet I've only glanced at the book it was enough to take in that there's a lot of plating, balling and turning on. Not enough, however, to stop several eminent critics on the posh papers including it among their 'Books of The Year' for 1969, but then it's a long time since the *Sunday Times* tried to get *The Naked and the Dead* banned and it may be very worthwhile. They all said it was sad though.

The sociological books have until now been written from a committed position, most of the writers having spent at least some time on the inside of pop culture. As Nik Cohn writes in *Pop from the Beginning* (1969): 'Myself, I was ten when it [pop music] started. I'm twenty-two now, and it has bossed my life.'

217

This approach has tended to rule out objectivity, but has saved pop from the dead hand of the academic embalmer. There is in fact a considerable overlap in this area between sociology and autobiography. For anyone who wants to know about the British Underground when it still was underground, Ray Gosling's *Sum Total* (1962) is a key work although superficially it's about him. More explicit but also in parts autobiographical is Jeff Nuttall's *Bomb Culture* (1968). Nuttall is old by pop culture standards: he was born in 1933, but he's lived through it all. His first premise, that it's the existence of the bomb that made pop culture possible, is in my view a bit slick, but his detailed dissection of all the elements which have gone into it are remarkably perceptive. His search for truth and freedom, his refusal to compromise in any way, led him at times to the edge of the abyss. He comes out of it as a proud if tubby Lucifer. He conducts us round hell. Surprisingly the book finishes with a rather moving plea for a new classicism, a rejection of pop on the grounds that it's time 'to turn away from Nothingness'. 'Too great a pre-occupation with mobility,' he writes, 'constitutes a refusal of existence.'

Finally from the school of straight reportage: the inside job written by professional journalists. Here I've always felt that Michael Braun's *Love Me Do* was not only underestimated at the time, but has been unjustly forgotten since. As an account of the Beatles' meteoric rise during the early sixties, it has both an immediacy and a strong grasp of the implications of what was happening without the reverence which turned Hunter Davies's much larger and more ambitious book into an exercise in hagiography.

December 1969

Postscript
For My Next Trick

'They stopped singing because
they remembered why they had started'
ROY FISHER 'Why they stopped singing'

I have completed the last third of this book at a steady pace during the autumn and winter of 1969, but the first two chapters were written as early as the summer and autumn of 1966. As for the pop music section which forms the heart of the book, I began this in the early summer of 1967 but then put it aside for a year. As a result, things have changed so much, that I felt obliged to scrap it and begin again. Even so it took me almost nine months.

I have no excuses to offer for this long and irregular progress; laziness, remunerative work in other fields, a welcome attack of writer's block were my only reasons, but reading back over what I've written, I feel that this alternation between the technique of hare and tortoise may have given the book an extra if accidental dimension. Over the last three and a half years pop culture has changed a great deal and, however inadequately, the book has echoed these changes.

Inevitably my own attitude in relation to pop has also undergone modifications. I reach my conclusion less optimistic about pop's future, less involved also, and yet looking back to my early attempt to chart a pop explosion, I find myself able to stand by my first tentative ideas. Indeed there were times in the intervening periods when I would have felt less in agreement. The opening stages of some new development, Flower Power for instance, seemed so different from what had gone before, that I suspected the repeating pattern had been broken. I'd have been wrong. Within a month or two the teeny-boppers were tinkling like grazing Swiss cattle, and the smell of joss-sticks floated down the stair of innumerable suburban houses.

At this moment, too, a cycle is reaching its end. The audiences at the 'implosions' are getting younger. The groups break up and reform with neurotic frequency. The Stones' last British public concert was full, but the audience so unmoved as to arouse Jagger's ire. The top twenty is dominated currently by unbelievable schmaltz. A song by Rolf Harris of Victorian lachrymosity is at Number 1, while at Number 2 'Sugar, Sugar' by the Archies is not only pure kiddypop but vintage kiddypop ,and could have been both written and performed in 1958.

Furthermore, just as the Rockers showed their resentment at the increasing complexity of pop music during the Beatles' early period and turned back to rock 'n' roll at its most basic to demonstrate their rejection, so the Skinheads or Agroboys have shown their distaste for current developments by championing the claims of reggae, a rhythmically insistent, melodically impoverished form of bluebeat of West Indian origin.

There are, of course, a few differences. There always are: the liaison between the more experimental fringe of recent pop music and the exponents of modern jazz is unprecedented development; still on the whole it's very much as usual. Pop music is at the edge of a depression and there'll be a pause, perhaps short; as was the case between the first decline of the Beatles and the emergence of the Stones, perhaps long; as during the four-year gap between the end of British rock 'n' roll and the trad boom. One thing is certain though. Sooner or later a new generation of teenagers will adopt some form of music with its accompanying lifestyle to symbolize and reflect their revolt. It may even be that at this moment, in a cellar or church hall in Runcorn or Middlesbrough, in the back room of a pub in Slough or Welwyn Garden City, a movement is gestating and will soon slouch towards the Roundhouse to be born.

Yet it's not really the form the next pop explosion takes which matters. Nor, in the final analysis, is it the history of preceding movements which is important. The real question is whether pop culture as a whole has had a lasting effect on traditional

culture in this country and, if it has, whether that influence has been a healthy thing or a disaster.

As to the first part of this question, I think there must be few people who would disagree that pop culture has profoundly affected the way we live now.

I am finishing this book in a cottage in West Wales in the first month of 1970 where, as it happens, I've written quite a lot of it including the first chapter. On the radio is *Pick of The Pops:* the choice of records is very much more avant-garde than it would have been even six months ago.

Outside it's just getting dark. It's been a beautiful day, frosty but sunny. At lunchtime we went up to the pub with the children including my fourteen-year-old son, and two young men in their late teens. Both my son and the two young men had shoulder-length hair, but this was taken absolutely for granted by the three farm workers and the local estate agent in the bar.

Later

My wife just called me from my study to watch a new religious programme on the telly. This not only included extracts from interviews with Marianne Faithfull and Caroline Coon (the founder of Release, an organization which gives advice to those arrested on drug charges), but contained favourable references to pop culture from several clerics and theologians, many of whom endorsed or proposed moral attitudes which until recently were confined to the Underground or pop worlds.

Looking back at the times I have spent at the cottage over the last ten years, I have seen the spread of pop culture happening more clearly than in London.

The Beatle wallpaper in the pub in that summer of 1964, the 'two hippies' at the fancy dress village carnival of 1967, have already been noted but, on a more general level, I have several times visited the Black Lion, Cardigan, on a Saturday night where, in the hall at the back of the pub, there is always a visiting group, and the farmers' children and the summer visitors

from the big cities dance side by side, indistinguishable in both expertise and appearance. And yet this is a very conservative area. The chapels are full and it's only a year since they voted for Sunday opening.

A final bizarre note: at the Cilgeran coracle races last year, (the coracle is a boat of prehistoric origin but still used by the licensed salmon-netters on the river Teivy), there was, among the other spectators, a solitary Hell's Angel in full drag. Here pop and traditional culture co-exist.

*

In choosing this microcosm I feel no need to spread the net wider. There are, after all, many widespread examples elsewhere in this book. All I want to establish here is that on a day-to-day level and when unexacerbated by resentment on the one side or intolerance on the other, pop culture and traditional culture appear to be able to establish a *modus vivendi*.

In the public sphere too over the last five years 'doing your own thing', living openly with someone without marrying him, having a child out of wedlock and so on, lead to no general public outcry as would have been the case not so long ago. Films and theatres are able to show scenes which previously would have been confined to blue films or erotic 'exhibitions'. On television the first male frontal nude has just put in a rather tentative appearance, but naked breasts and bottoms are a commonplace. On Jimmy Saville's pop-cum-discussion programme, *Speakeasy,* teenagers put the case for and against pot or promiscuity with an unselfconscious ease and blunt vocabulary which would have rocked even the more liberal-minded public back on its heels at the beginning of the 60s. Permissiveness, while not total, is nearly complete, in the sexual field at any rate.

It's true that the police sometimes use sex as an excuse to move in. The advertisements in *IT* – mostly people of rather special tastes seeking their opposite numbers – were given as the pretext for confiscating the files, and there have been other comparatively recent examples: the removal of Jim Dine's

innocently erotic pictures from the walls of Robert Frazer's Gallery, the prosecution of certain booksellers on grounds of obscenity; but if these cases are examined it's interesting that there are certain other factors present. A month or two after the Dine case, Frazer was arrested on a heroin charge. *IT* has always been openly contemptuous of authority in general and the fuzz in particular. The bookshops which are most often prosecuted these days are those whose stock is more anarchistic than pornographic in the traditional sense. Sex is not really the issue. It is when sex is combined with anti-authoritarianism that the law steps in.

Drugs or at any rate soft drugs have also been used as a weapon: an excuse for pushing long-haired young people about. The judiciary on the other hand have become more lenient. The spread of pot-smoking among the middle classes, the rage of the liberal establishment at their suspicions that some kind of grudge lay behind the hounding of the Stones, has tended to substitute fines for imprisonment in cases of this kind. The situation is unsatisfactory, not unlike the situation of homosexuals before the homosexuals reform Act, but the climate is still permissive, and the law, whatever its own feelings, is extremely sensitive to the moral climate.

At this moment too there is perhaps less overt opposition to authority than at any time during the last five years. Confrontations during the winter months are always less common and even the demonstrations against the Springboks have seemed more respectable, nearer to the old C.N.D. days.

It's significant too that those most ready for militant action at the beginning of the 70s are figures of traditional authority or service; teachers, nurses, firemen. The present emphasis is not against the system *per se*, but an attempt to make it fairer. That beloved cliché 'the National cake' is bandied about. For the moment, at any rate, reformism seems to have replaced revolutionary ferment.

There are signs, however, that if the long-forecast swing against permissiveness takes place there are plenty of people eager to lend the action.

In the lower depths the Agro-boys have already emerged to present a caricature of working-class conservatism and prejudice. Anti-intellectual, anti-layabout, anti-foreign (the exception they have made in favour of West Indians more than compensated by their hatred and persecution of Pakistanis). The Agro-boys are remarkably like 'the Gamas' in Huxley's *Brave New World*. They accept their place at the bottom of the ladder, appear to welcome dead-end jobs, and have placed association football at the centre of their culture, not for its own sake but as an excuse for violence and vandalism.

Lower-middle-class puritanism, supported and comforted by the odd upper-class authoritarian, has rallied behind the formidable Mrs Whitehouse, a clever woman well able to adjust the presentation of her basic anti-permissive attitude to suit the premises of her audiences. Among others who have come out in her favour is Malcolm Muggeridge.

Muggeridge, a one-time radical, whose views, tempered by a healthy cynicism, were rational and whose behaviour was all too human, has transferred his undeniable wit and professionalism to the service of a form of Christianity based on the rejection of pleasure, the suppression of sex and the denial of appetites. Where once he puffed smoke across the studio like a steam train, he now sits tobaccoless and celibate, castigating the whole age with an obsessive relish. Everything is equated and systematized: the pill, broiler chickens, bunny girls, jet planes, Mick Jagger, student protest, abortion, *Oh, Calcutta*. He creates a kind of nauseating curry of it and ladles it out through every medium. At times he can be sharp and perspicacious; in his attack on the ridiculous way in which sex is used to sell everything, or in his analysis of the inflated language of trend-setting journalists, but his position is basically untenable because, while he may have relinquished sex, gourmandizing, alcohol and drink, he is absolutely hooked on his main target: television. There are indeed times when he appears in different contexts two or three times in an evening. Furthermore, as time goes on his views become more and more exaggerated. He is convinced he can recognize women who are on the pill by a lack of lustre in

their eyes and the dead look of their complexion. He tends to distort in order to emphasize his point of view. He has several times stated in print that, after the Stones' trial, the editor of *The Times,* the Bishop of Woolwich and a Jesuit flew to interview Mick Jagger, whereas in fact the reverse is true. He flew to be interviewed by them, but then of course it is less ludicrous an image that way round. He can also, for all his Christian affirmation, show himself remarkably uncharitable. He once said he couldn't see why the fathers of homeless families were incensed at being separated from their institutionalized wives and children when most people would be only too delighted.

But St Mug at least remains readable. However silly he can be at times, he can still be witty and acute in his analysis of the lower human motives, especially in politics. None of these qualities can be assigned to his disciple Christopher Booker whose book, *The Neophiliacs,* was rightly dismissed at almost every level. Booker carries Muggeridge's religious obsessions into the realm of fantasy, believing that the 60s were a decade in which the devil literally took over England, busying himself at every level from mini-skirts to the legalization of homosexuality.

Combing press-cuttings, he put together a collage of events in which everything is equated including bad weather and plane crashes to suggest the worst of all possible worlds. Like Muggeridge he too believes it strengthens his case to represent himself as a reformed loose-liver, listing among other former sins, a liking for jazz, editing *Private Eye,* and writing sketches for *That Was The Week That Was.* He too cries for a return to sackcloth and ashes, to respect for authority, to 'tradition'. His book emits an undeniable aura of social snobbery.

In politics there are other signs of a potential anti-permissive backlash. Enoch Powell waits in the wings. Duncan Sandys recently did his best to bring back capital punishment, that happily defunct institution which I once heard a supporter of Mrs Whitehouse describe as 'the hinge of British justice'.

All these people would certainly welcome a swing towards a repressive society and most would recognize, rightly, that pop

culture has been in part responsible for our current permissiveness. There is, however, no proof at present that they will succeed in swinging the pendulum to more than a limited extent.

If pop culture is threatened, and I believe it may be, it's not really because of opposition from without; most movements are confirmed and strengthened under attack; but because of a flaw in its own structure, and it's this I must try and define.

*

The defects of pop as I see it are as follows. Primarily it is the fact that it is essentially exclusive, tied only to the young and therefore incapable of development beyond a certain point. The revolt of each generation may differ in style and detail but is based on the same need: the escape from the family. Once this is achieved, and pop is a very successful way of making the break, it loses its impetus. Furthermore its success at imposing its demands on society as a whole, in changing society, mean that the next pop explosion has to go further and in consequence eventually a point must be reached where only the psychopathic or disturbed can accept its more extreme propositions.

There is another built-in difficulty. Pop's anti-intellectualism, its rejection of a cultural heritage in favour of instant creativity, means that its executants rely entirely on their instincts. Most pop talent is, in the traditional sense, under-educated, improvisational rather than thoughtful. Given such inspiration, it can move brilliantly and rapidly along a path but eventually it finds itself facing a brick wall without the means to climb over it. Its reaction at this point is to lose confidence, to turn desperately to unreal solutions. John Lennon, for example, has tried to advance beyond pop and, in conjunction with Yoko Ono, offers a series of gestures of increasing desperation expressed in the vocabulary of a clapped-out avant-garde.

His motives are admirable, but his means are childish. The years of worship have given him a sense of omnipotence, and it just won't do to arrive on the steps of a cathedral to fast on behalf of the starving Biafrans in a custom-built White Rolls. A film of his penis is an exhibitionist rather than a revolutionary

act. He seems unable to dissassociate indignation from self-advertisement. He and Yoko Ono trivialize. They sit down in front of the wall which blocks the advance of pop culture and by turning their backs on it pretend it's not there.

If Lennon is the saddest, and most talented, of pop's failures in the absolute sense, there are others who indicate just as clearly the defects of the culture's premises. Jagger and Marianne perform the role of demon lovers under the arc lamps. George Harrison and Ringo Starr embrace the impossible, subscribing to dotty theories of time and believing that the Government are suppressing the presence of flying saucers. The party is, temporarily at any rate, over. It can only begin again at root level and even then it can only develop, although perhaps along different paths, to the same point.

Yet it would be ungrateful to dismiss the adventure. It has affected all our sensibilities and to the good. We are more open, less stuffy, less intellectually snobbish, more loving because of pop.

It has frightened the monsters too. The stupid hypocrisy of the Ward trial could no longer take place. We have become less scared of our feelings, less concerned with imprisoning conventions, less respectable, less easily duped, more spontaneous.

I think it's done for now though, temporarily at any rate. It's turned pretentious or sour. Become either an intellectual and exclusive concern, or been forced into an alliance with violence or the fat men in suits.

If it could be saved it would only be through accepting this piece of advice: 'Don't blow your mind – use it', but then it would be something else. It's done its job after all. It must be true to itself and die. As Roger McGough wrote:

> Let me die a young man's death
> Not a free-from-sin, tiptoe-in
> Candle-wax-and-waning death
> not a curtains-drawn, by-angels-borne
> what a nice way to go death.

January 1970

Index